Joyous Occasions:

A Collection of Heirloom Hardanger Designs

by Emie Bishop

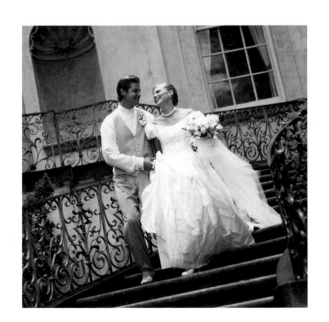

symbol of excellence publishers, inc.

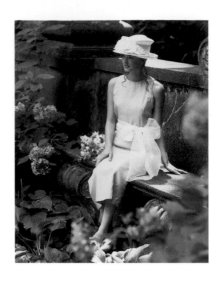

Joyous Occasions
A Collection Of Heirloom Hardanger Designs
By Emie Bishop

© 1996 by Symbol of Excellence Publishers, Inc.
405 Riverhills Business Park
Birmingham, AL 35242

Published by Symbol of Excellence Publishers, Inc., a division of PJS Publications,
A K▸III Communications Company

Library of Congress
Catalog Card Number: 95-071956
Hardcover ISBN: 0932437-06-0
Printed in the United States of America
First Printing 1996

Symbol of Excellence Publishers, Inc.
Vice President and C.O.O.: Len Eberwein
Creative Director/Editor: Michael W. Jolly
Art Director/Graphic Designer: Randy Johnson
Production Director: Joy Henderson
Writers: Laura Franck and Julie Burch
Illustrator: Marie Barber
Associate Production Artist: Charles Long

Fashion Photography: Liz VonHoene
Still Life/Product Photography: Jeff VonHoene
Fashion Stylist: Darcie Packard
Product Stylist: Rena Stambuck
Hair & Make-up: Denise Gamble

Color Separations and Prepress: Capitol/Birmingham, a division of Capitol Engraving Co.

Printing: Quebecor Printing, Kingsport, Tennessee.

We make every effort to present these designs error free. However, human and mechanical errors
can occur. We invite your comments. Call 1-800-634-7720

INTRODUCTION

Your wedding day, a baby's christening, magical Christmas holidays—all are very special times in your life. For many of us, the memories surrounding wonderful events such as these are attached to the needlework and sewing projects diligently being worked on during these times. Joyous Occasions is a special reminder of so many of the chapters in Emie Bishop's family life, and we know that the projects in this book will

For Life's Celebrations...

help you mark your own. Needlework is a form of expression and it can serve as a way of sharing ourselves with someone else. Use Emie's exquisite new collection of heirloom Hardanger designs with the step-by-step guidelines for pulled-thread embroidery, cross stitch, ribbon embroidery and other various stitches to create your own beautiful wedding apparel and accessories, baby garments, ornaments and framed designs. Let these pieces not only be adornments for you, your family and your home, but allow them to become symbols of the most important and memorable times in your life. This book is dedicated to helping you create your own beautiful needlework heirlooms. Enjoy.

Contents

Section One

YOUR WEDDING DAY

Section Two

YOUR HOME

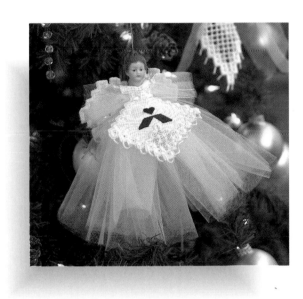

Section Four

YOUR BABY

Section Three

THE HOLIDAYS

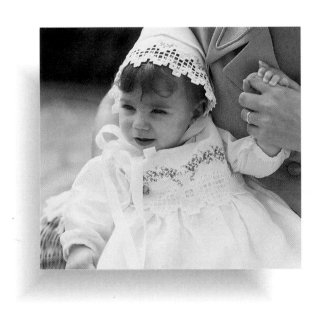

Hardanger:
A Living Tradition

by Julie Burch

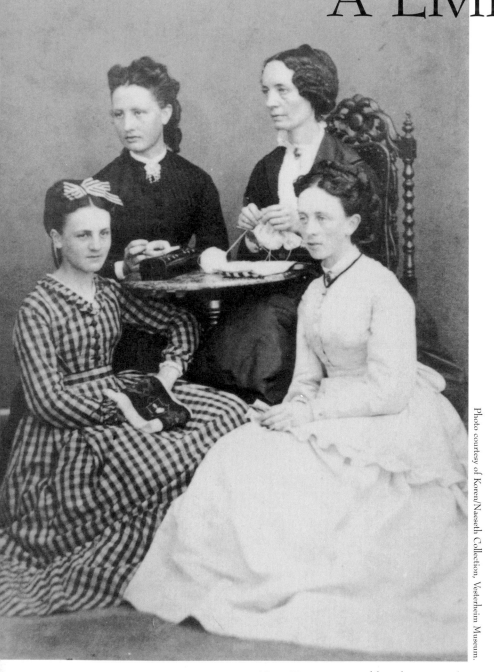

Photo courtesy of Koren/Naeseth Collection, Vesterheim Museum.

Marie Koren is pictured here knitting with her three daughters, Margarethe, Lina, and Christiane. The photograph was taken in Mandal, Norway in the late 1860s or early 1870s, only a short time before their emigration to America.

Hardanger, the technique that designer Emie Bishop has used in all of the exquisite designs in this book, originated in a town on the west coast of Norway, called, not surprisingly, Hardanger. Its lacy, openwork designs and geometric patterns have decorated the traditional costumes and table linens of Norwegians since the early eighteenth century. Today, stitchers enjoy the versatility of the technique, as well as the history behind it.

Laurann Figg, the curator of textiles at the Vesterheim Museum in Decorah, Iowa, says that the origins of Hardanger are difficult to trace. Her knowledge of Hardanger designs is extensive, since the Vesterheim is a museum that collects and exhibits examples of the culture of Norwegian immigrant groups in the Midwest and elsewhere in America. Vesterheim is Norwegian for "western home," and in the United States the women of Norway created some of the loveliest Hardanger embroidery in the world.

Before the massive immigration of Norwegians to America between the mid-nineteenth and early-twentieth centuries, Hardanger was a relatively unknown, isolated embroidery technique. Needlework historians have speculated that Hardanger's roots may lie in Persia

or other areas of the Middle East, where many of the motifs that are used in Hardanger have been found on ancient garments, embroidered in colored silks on fine gauze netting for the nobility. Others see similarities between Italian reticular work and the stitches of Hardanger, as well as in Danish Hedebo. Reticella and Hedebo are openwork techniques in which stitches are worked on a mesh ground from which threads have been withdrawn. Groups of threads are pulled tightly together, and additional stitches are worked in the open spaces that remain.

Hardanger may be a version of the laces and openwork embroidery that have been created around the Mediterranean for centuries. Viking expeditions, as well as the Crusades of the Middle Ages, could have been the means by which the openwork embroidery was transported to Scandanavian countries such as Norway and Denmark, providing the impetus that inspired Hardanger and Hedebo. Figg notes that

because the origins of Hardanger are obscure, it is possible that the technique "may have arrived relatively late." Carolyn Ambuter agrees, arguing that Hardanger "reached Scandinavia just prior to 1800." Figg says it is difficult for any needlework scholar to determine with certainty when Hardanger was first produced, because "there are not many surviving examples. [The Vesterheim's] earliest piece is from the eighteenth century," right about the time Ambuter says that Norwegians began to create Hardangersøm (Hardanger sewing).

Traditionally, Hardanger was used only on blouses, aprons and other folk costumes of the people who lived in two western areas of Norway: Hardanger and Voss. Figg says that in the pre-Victorian era, "Clothing with Hardanger was used for festive occasions, like baptismal garments." Lanto Synge notes that Hardanger "was also used widely for decorating items such as the neck and wristbands of traditional

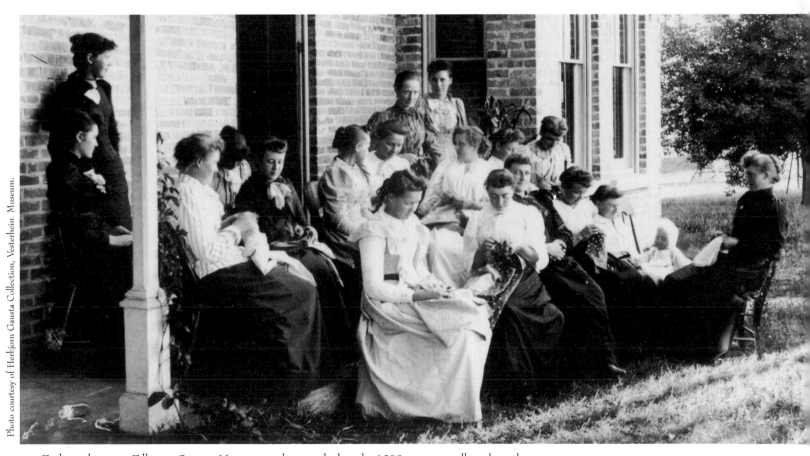

Photo courtesy of Herbjorn Gausta Collection, Vesterheim Museum.

Early settlers near Fillmore County, Minnesota, photographed in the 1890s, enjoy needlework outdoors.
As it did in many communities, needlework brought groups of Norwegian-American women
together to share stories, advice and techniques.

wedding shirts." Later, when Victorian interest in lavish decors spread to Scandinavia, urban Norwegians expanded their use of Hardanger, embroidering on tablecloths and doilies. In rural, isolated areas, Figg says, Hardanger was only used on clothing, not for household linens.

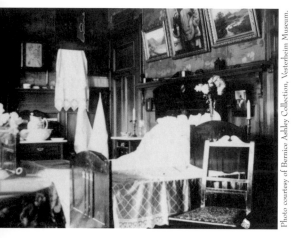

A Norwegian bedroom from the late Victorian period. Notice the elaborate decor, including the use of Hardanger on the textile hanging near the door. During the Victorian era, Hardanger appeared on household linens and other decor items in urban homes.

The earliest examples of Hardanger embroidery were always worked in fine white thread on white linen, some with a thread count as high as 50 per inch. Consequently, it is often classified as a "whitework" technique. Some of the oldest pieces of Hardanger, including those owned by the Vesterheim, are delicate, airy pieces that are almost completely covered in stitches. Unlike many modern Hardanger embroideries, which often leave a substantial amount of the ground fabric unstitched, older pieces have so much stitching, and

have so many threads cut away, that they resemble techniques such as crochet, tatting, or needlelace. If Hardanger was used as the finished border for a piece, such as the eighteenth-century doily in the Vesterheim's collection, buttonhole stitches and blocks of satin stitches called kloster blocks were carried out to the very edge, with open spaces between them filled with embellishing stitches like dove's eyes and spider webs. These fine old pieces look fragile, but the kloster blocks and buttonhole stitches bind the open areas securely, anchoring the decorative embroidery worked in the spaces.

An apron from a traditional folk costume from Hardanger, Norway is shown alongside one of four 11"-square doilies owned by the Vesterheim Museum.

After Norwegians began to immigrate to the United States around 1840, Hardanger changed. Figg says that, "In American adaptations, color was used for the first time, perhaps as a reaction to

all sorts of recently available products, like colored thread. The immigrants incorporated new ideas, but their designs and motifs are the same." As a symbol of the combination of their new life in America, and their heritage as Norwegians, the Norwegian-Americans embroidered Hardanger that was traditional in design, but newly colorful.

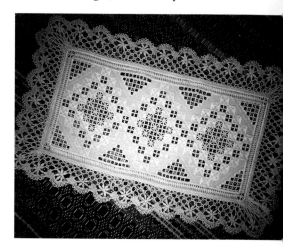

This delicate centerpiece features a large area of fine Hardangersøm and a border of needlelace. It was originally owned by a shipping captain, and is now a part of the Vesterheim's collection.

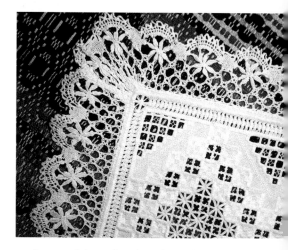

A closeup of the embroidery shows the elaborate needlework as well as the background woven coverlet from Telemark, Norway.

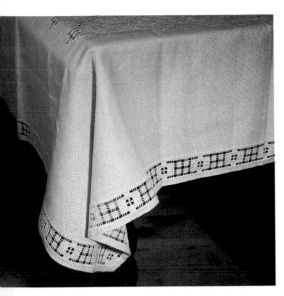

A tablecloth from the Vesterheim has a large area of embroidery at its center and a border of Hardangersøm.

The familiar Hardanger fabric most modern stitchers choose for the technique was first used in America. Previously embroidered on plain-weave linen, Norwegians found the coarser cloth easier to find in the western frontier where they settled. High-count linen was more expensive, too, so the 22-count basketweave fabric became the most popular. Because of the change in fabric, the stitches appear bolder, and the embroidery is a little stiffer than the fine, lacy pieces worked in Norway.

Immigrants changed Hardanger in other ways, too. Figg says that in the United States, Norwegians combined other techniques with Hardanger, such as crochet or tatting, to create insertions, edgings and trims. As other techniques were employed in Hardangersøm, the use for Hardanger continued to expand. Pincushions, table linens, trims for bed linens, samplers and purses

were embroidered along with the traditional clothing, such as aprons, baby clothing and garments for other special occasions. Norwegian-Americans, as they had done with colored thread, added new elements to their native technique, while still adhering to the patterns they had inherited. One of the items in the Vesterheim's collection, for example, is an Edwardian blouse, with a high neck and full sleeves, that features Hardangersøm. The style of the blouse, of course, is not one that would be worn with folk

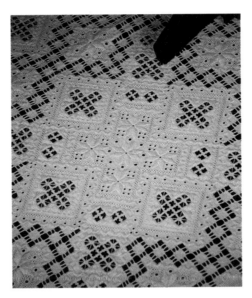

A closer view of the center of the tablecloth shows the variety of stitches used by the needleworker.

costumes, but the stitches on it certainly appeared on garments worn for centuries in Norwegian villages.

Figg finds such changes in Hardanger fascinating and refreshing, because they represent the eagerness Norwegian immigrants had to maintain their culture while embracing their Americanness.

"Some purists dislike the newer work," she says, "but I see Hardanger as a living tradition. The immigrants wanted to be Americans, and they wanted to combine their heritage with the new things they saw."

The Vesterheim, because it commemmorates and exhibits Norwegian culture in America, has a wonderful collection of these "American adaptations" in its possession. Figg says that the museum owns "about 300 artifacts of or with Hardanger embroidery," including collars for children's clothing, a 13 1/2" doily with green, red, yellow and blue made in North Dakota in 1936, a nicely stitched runner with golden yellow thread, and a pincushion in red, blues, pink, yellow and green with satin and lace trim." She also says the Vesterheim has "perhaps the earliest example of Hardangersøm butterflies on a tablecloth

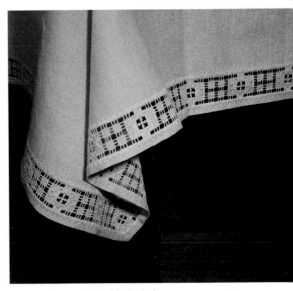

The border of the tablecloth features geometric designs that frame the entire piece, and balances the ornate embroidery at the tablecloth center.

made by Josephine Larson Mathiesen before 1916 for her trousseau." Josephine immigrated from Stavanger, Norway to Tacoma, WA.

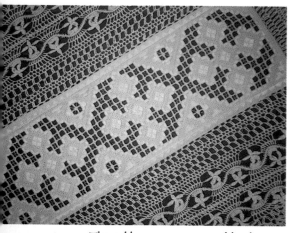

This tablerunner, now owned by the Vesterheim, was displayed over a colored tablecloth at Christmastime. The long panel of Hardanger embroidery is trimmed by a wide border of crocheted lace.

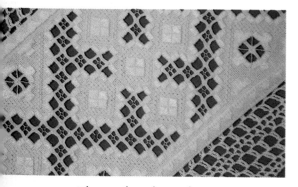

The motifs in the Hardangersøm suggest crosses and snowflakes, appropriate images for a Christmas table decoration.

Hardanger is "easy to recognize," Ambuter says. Always geometric in appearance, it is "based completely on right angles and squares." Kloster blocks "reinforce the cut edges of the open spaces and may be filled with lacy stitches like webs and wheels." The outer edge of embroidery may be cut along the right angles of the

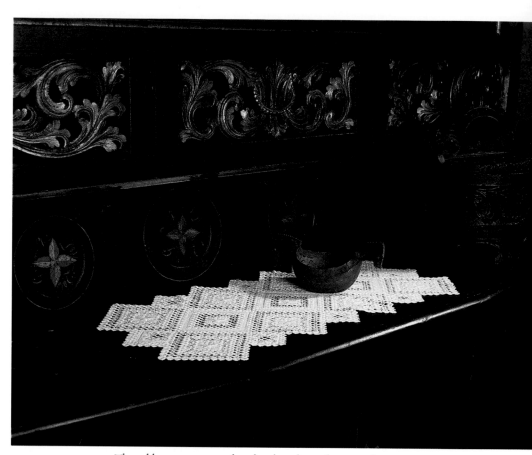

The tablerunner was embroidered in the mid-twentieth century and is solid Hardangersøm. It is one of many runners in the Vesterheim's collection.

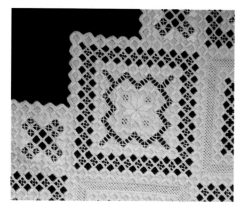

The excess linen has been cut away from the edge of the embroidery, giving the runner its unique shape. The squares are symmetrically arranged and feature a myriad of Hardanger stitches.

blocks, or the stitching can remain within the fabric itself, as in insertion. "Easily mastered," Ambuter says, "the major requirement [to

work Hardanger] is that you are accurate in counting."

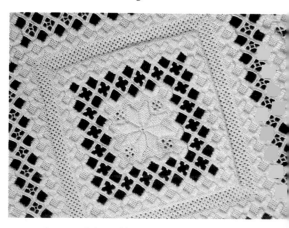

A closeup of the table runner shows the kloster blocks, dove's eyes, eyelets, needleweaving and picots that were used to embroider the runner.

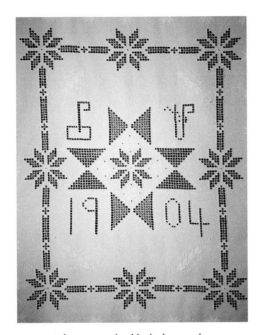

This unusual tablecloth provides the embroiderer's initials as well as the year in which the needlework was completed, important information for the museum's historians. The large eight-petaled flower at the center encircles a smaller eight-petaled flower, which appears elsewhere around the center panel.

Hardanger, as whitework, or as a colorful compliment to other needlework techniques, is an evolving, living embroidery method. It's rich history and simplicity attract stitchers of all types, and its versatility ensures its continued popularity. This link to a specific country, a specific people, is a window into a culture filled with tradition and symbolism. Used today, Hardanger is a beautiful embellishment that perpetuates the patterns and motifs that have been handed down for over two hundred years. It is elegant and graceful, and is a wonderful gift from Norway to the world.

References

Ambuter, Carolyn. The Open Canvas. New York: Workman Publishing, 1982.

Figg, Laurann. Telephone conversation with author. August 7, 1995.

Synge, Lanto, ed. The Royal School of Needlework Book of Needlework and E Embroidery. London: William Collins Sons and Co., Ltd., 1986.

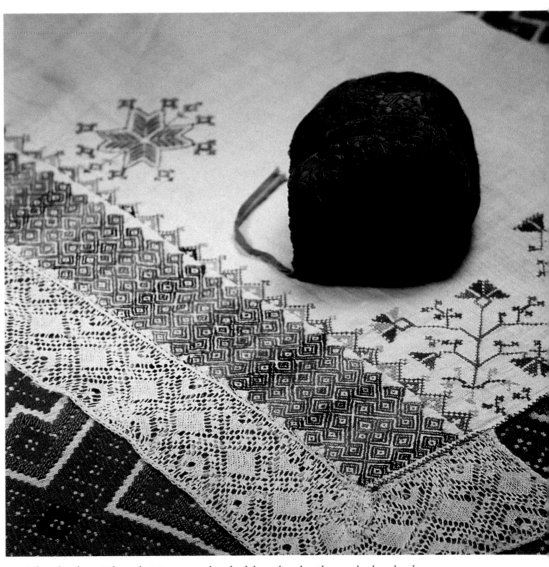

A kinnlag from Telemark, Norway, with colorful wool embroidery and a lace border is shown with an overshot coverlet and a Norwegian christening cap from the 1800s. The cap is embroidered in red and green silk on a brown silk fabric to resemble brocade.

YOUR
WEDDING
DAY

WEDDING SAMPLER

DESIGN 154W X 192H
28 count 11 X 13.71, cut fabric 17 X 20
32 count 9.62 X 12, cut fabric 15.50 X 18
The model was stitched on 32 count Antique White Belfast Linen from Zweigart®

ADDITIONAL MATERIALS:
1 spool 4mm. Mokuba Heirloom Sylk 491
#00123 Cream Mill Hill Pearl Beads (represented on chart by • symbol)
DMC Ecru Pearl Cotton, sizes #8 and #12
10 Mother of Pearl Hearts (#BDS2222) from Access Commodities (represented on chart by open heart symbols)
DMC floss

•	225	Pale Pink
∕	224	Lt. Pink
X	223	Md. Pink
♥	221	Dk. Pink
V	3053	Lt. Green
■	3051	Dk. Green
ss	822	Pale Tan
bs	644	Lt. Tan

DESIGN NOTES
1. Each square on the chart represents two fabric threads.
2. This design uses a variety of needlework techniques including Cross Stitch, Backstitch, Ladder Hemstitching, Satin, Four-sided, Interlace, Algerian Eye, Kloster, Woven Bar, Dove's Eye, Buttonhole Bar, French Knot, Stem Stitch Rose and Loop Stitch.
3. Personalize this design by using your favorite alphabet, or the alphabets provided. Use the capital letters found in the "Bless This House" sampler for the last name. For the other names, city and date, use the Backstitch alphabet provided on page 137.

INSTRUCTIONS
1. Complete all Cross Stitches using two strands of floss over two fabric threads.
2. Satin stitch (ss) the large alphabet used for the last name using two strands of DMC 822 Pale Tan. Backstitch (bs) these letters using one strand DMC 644 Lt. Tan. Use one strand of DMC 644 Lt. Tan for all other Backstitch letters.
3. Complete all Klosters using #8 DMC Ecru Pearl Cotton.
4. Using #12 DMC Ecru Pearl Cotton, complete the Algerian Eye stitches between the Klosters in each heart.
5. Using #12 DMC Ecru Pearl Cotton, complete the Ladder Hemstitch at each side of the heart and down each side. Cut and remove the eight horizontal fabric threads that are between Klosters at either side of the hearts at the top of the design. Cut and remove the eight vertical fabric threads that extend between Klosters on both sides of the design. Gather four threads together and go two threads deep. These four areas will be laced with silk ribbon later.
6. Using #8 DMC Ecru Pearl Cotton, complete the Four-sided stitch in the Hardanger section at the base of design.
7. Add all beads and the Mother of Pearl Hearts.
8. Cut and remove the marked fabric threads in the Kloster Square at the top center of the design. Using #12 DMC Ecru Pearl Cotton, work the pattern of Woven Bars and Buttonhole Bars.
9. Cut and remove the marked fabric threads in each heart. Using #12 Ecru Pearl Cotton, complete the pattern of Woven Bars and Dove's Eyes.
10. Cut and remove the marked fabric threads in the Hardanger section at the base of the design. Using #12 DMC Ecru Pearl Cotton, complete the pattern of Woven Bars, Dove's Eyes and Buttonhole Bars.
11. When all stitching is complete and the piece has been cleaned and pressed, work the following Ribbon Embroidery:
 a. Using 4 mm. Mokuba Heirloom Sylk 491, complete the Interlace Stitch over the threads gathered together in the Ladder Hemstitch along the top and sides of the design.
 b. Using 4 mm. Mokuba Heirloom Sylk 491, complete each Stem Stitch Rose. Placement of the rose is represented on the graph by a circle. Begin each flower with a French Knot Center. Working out from the center, create petals of the rose by working Stem Stitches within the area of the circle. Keep the stitches loose and allow the ribbon to twist and turn.
 c. Using 4mm. Mokuba Heirloom Sylk 491, complete the ribbon ties at the top left and top right. Use a Loop Stitch to form the bow. Add a length of ribbon for the ribbon tails.

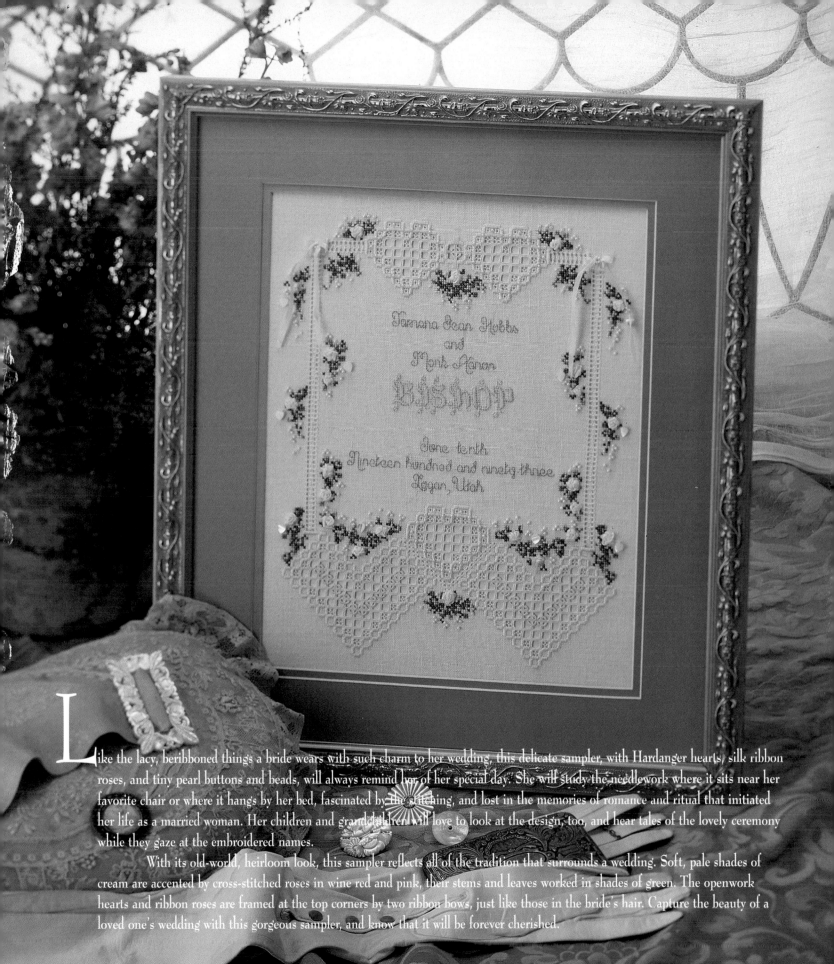

L ike the lacy, beribboned things a bride wears with such charm to her wedding, this delicate sampler, with Hardanger hearts, silk ribbon roses, and tiny pearl buttons and beads, will always remind her of her special day. She will study the needlework where it sits near her favorite chair or where it hangs by her bed, fascinated by the stitching, and lost in the memories of romance and ritual that initiated her life as a married woman. Her children and grandchildren will love to look at the design, too, and hear tales of the lovely ceremony while they gaze at the embroidered names.

With its old-world, heirloom look, this sampler reflects all of the tradition that surrounds a wedding. Soft, pale shades of cream are accented by cross-stitched roses in wine red and pink, their stems and leaves worked in shades of green. The openwork hearts and ribbon roses are framed at the top corners by two ribbon bows, just like those in the bride's hair. Capture the beauty of a loved one's wedding with this gorgeous sampler, and know that it will be forever cherished.

WEDDING SAMPLER

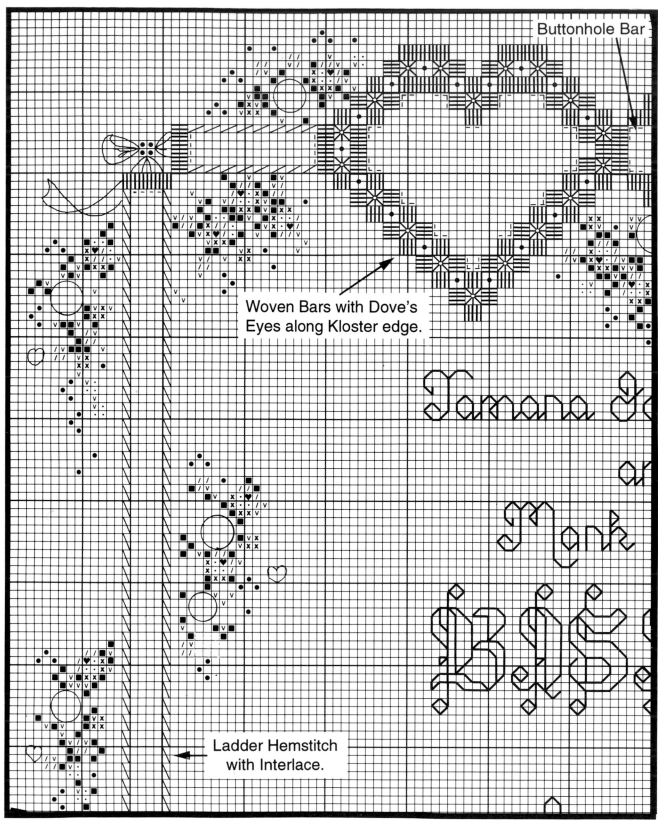

Buttonhole Bar

Woven Bars with Dove's Eyes along Kloster edge.

Ladder Hemstitch with Interlace.

•	225 Pale Pink	V	3053 Lt. Green
/	224 Lt. Pink	■	3051 Dk. Green
X	223 Md. Pink	ss	822 Pale Tan
♥	221 Dk. Pink	bs	644 Lt. Tan

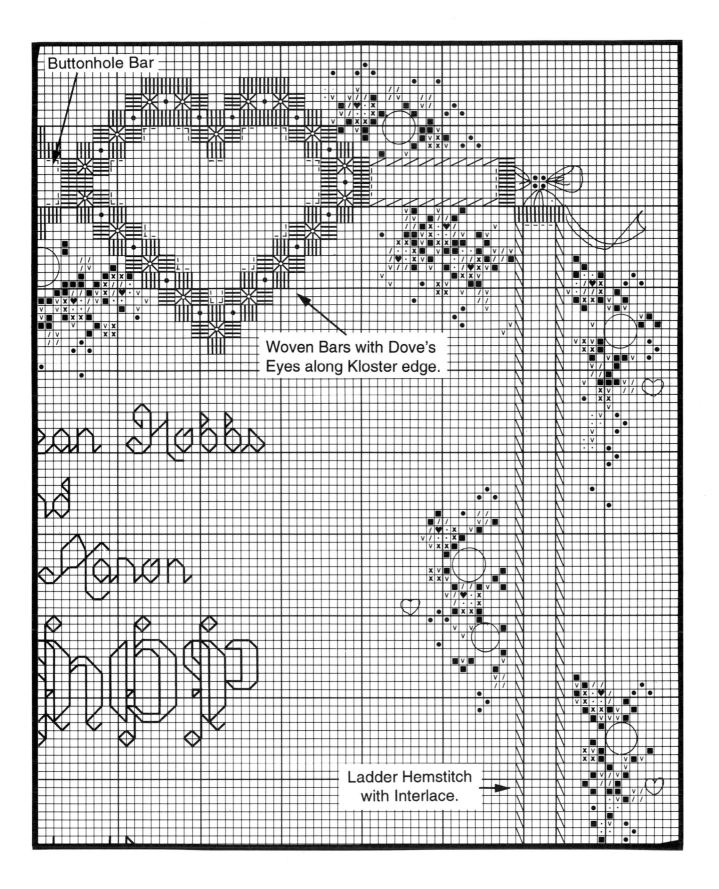

Buttonhole Bar

Woven Bars with Dove's
Eyes along Kloster edge.

Ladder Hemstitch
with Interlace.

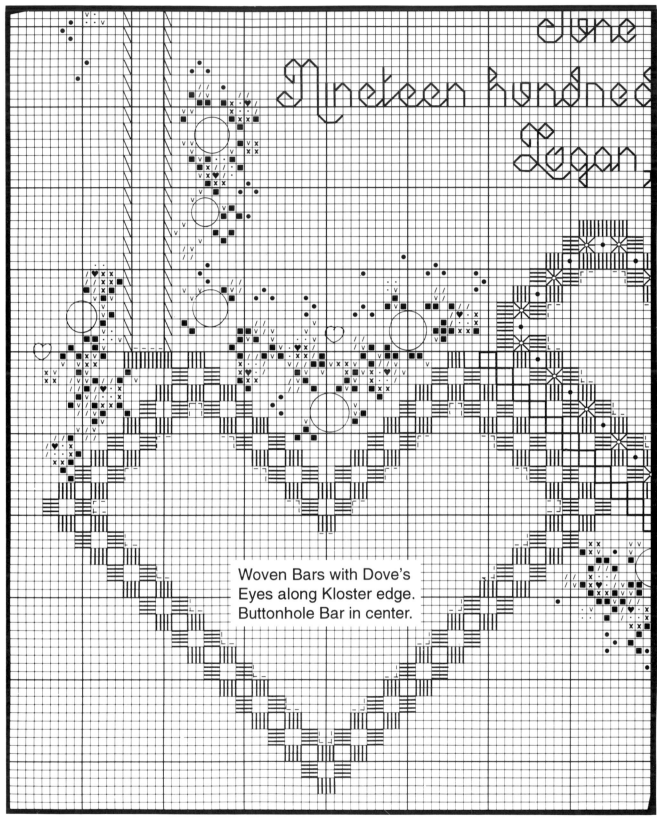

Woven Bars with Dove's
Eyes along Kloster edge.
Buttonhole Bar in center.

•	225 Pale Pink	V	3053 Lt. Green
/	224 Lt. Pink	■	3051 Dk. Green
X	223 Md. Pink	ss	822 Pale Tan
♥	221 Dk. Pink	bs	644 Lt. Tan

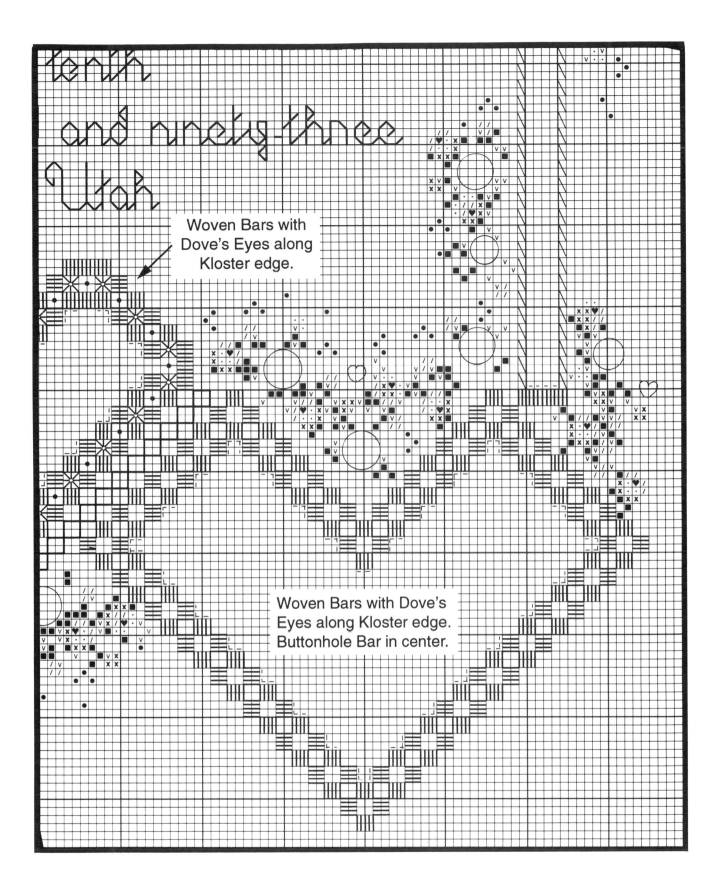

Woven Bars with
Dove's Eyes along
Kloster edge.

Woven Bars with Dove's
Eyes along Kloster edge.
Buttonhole Bar in center.

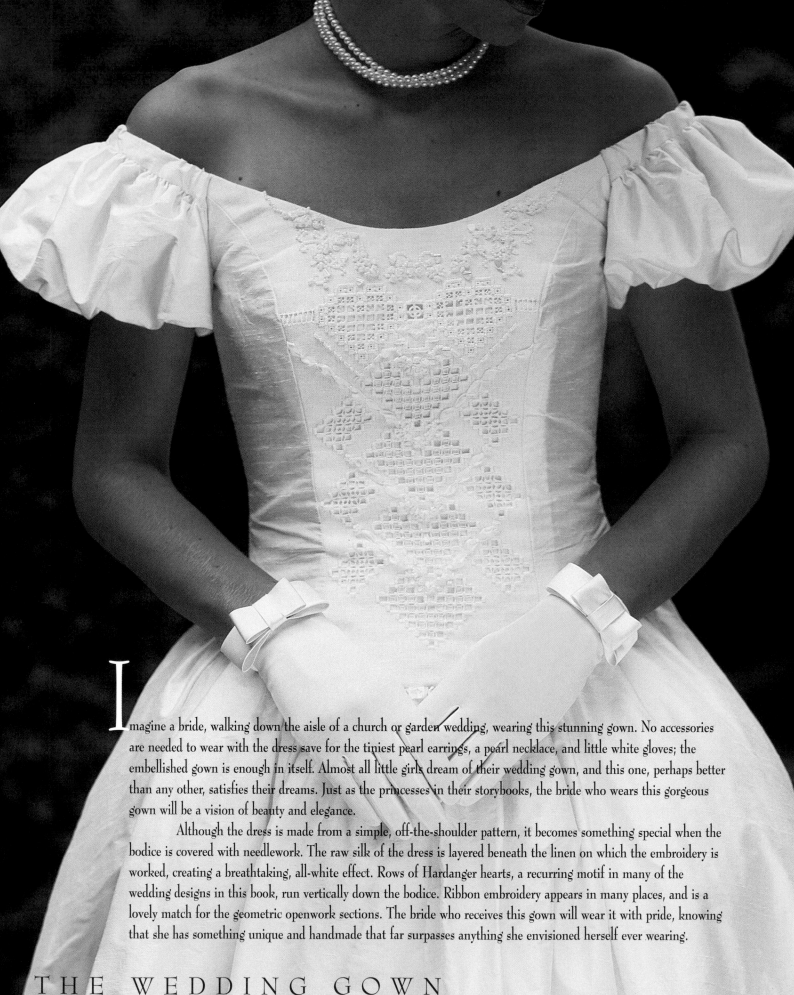

Imagine a bride, walking down the aisle of a church or garden wedding, wearing this stunning gown. No accessories are needed to wear with the dress save for the tiniest pearl earrings, a pearl necklace, and little white gloves; the embellished gown is enough in itself. Almost all little girls dream of their wedding gown, and this one, perhaps better than any other, satisfies their dreams. Just as the princesses in their storybooks, the bride who wears this gorgeous gown will be a vision of beauty and elegance.

Although the dress is made from a simple, off-the-shoulder pattern, it becomes something special when the bodice is covered with needlework. The raw silk of the dress is layered beneath the linen on which the embroidery is worked, creating a breathtaking, all-white effect. Rows of Hardanger hearts, a recurring motif in many of the wedding designs in this book, run vertically down the bodice. Ribbon embroidery appears in many places, and is a lovely match for the geometric openwork sections. The bride who receives this gown will wear it with pride, knowing that she has something unique and handmade that far surpasses anything she envisioned herself ever wearing.

THE WEDDING GOWN

THE WEDDING GOWN

DESIGN 118W X 182H
28 count 8.43 X 13
32 count 7.38 X 11.37
Cut linen larger than the bodice pattern piece. This design has been created to be worked on the bodice of the McCall's pattern number 6390, View C.
The model was stitched on 28-count white Charles Craft linen. The fabric used for our model was raw silk.

ADDITIONAL MATERIALS
Anchor #2 White Pearl Cotton, sizes 8 and 12
#00479 Mill Hill White Seed Beads (represented on chart by the symbol ●)
YLI silk ribbon #1 White: 2 spools of 4mm. and 1 spool of 7mm.
Access Commodities Mother of Pearl Hearts (BDS 2222) indicated on chart by open heart symbols, and Access Commodities 4 mm. beads (BDS 220) indicated on chart by the smallest circle symbols. Note: These small circles surround one cross stitch square on chart.

DESIGN NOTES
1. Each square on the chart represents two fabric threads.
2. This design employs a variety of needlework techniques including Algerian Eye, Bullion, Buttonhole, Satin, Ladder Hemstitch, Kloster, Dove's Eye, Corner Dove's Eye, Woven Bars, Wrapped Bars, Connected Wrapped Bars, Picots, Buttonhole Bars, Couching, French Knot, Japanese Stitch, Loop Stitch and the Stem Stitch Rose.
3. Begin the top row of Klosters of the two hearts 1 1/2" below the neck opening.

INSTRUCTIONS
1. Complete all Satin, Buttonhole stitches and Klosters using Size 8 Anchor #2 White Pearl Cotton. You may wish to add additional repeats of the center and diamond patterns. The large X at the bottom right and bottom left indicate the top Kloster of the diamond.
2. Use Size 12 Anchor #2 White Pearl Cotton for the Algerian Eye, Bullion stitches and the Ladder Hemstitch at the side of the top hearts. Remove the eight horizontal fabric threads. Work the Ladder Hemstitch to the seam.
3. Cut and remove the marked fabric threads in the two hearts at the top of the bodice. Using Size 12 Anchor #2 White Pearl Cotton, complete the pattern of Woven Bars, Picots and Dove's Eyes.
4. Cut and remove the marked fabric threads inside the Hardanger Square between the two hearts. Using Size 12 Anchor #2 White Pearl Cotton, complete the pattern of Woven Bars and Buttonhole Bars.
5. Cut and remove the marked fabric threads in each of the three center areas. Using Size 12 Anchor #2 White Pearl Cotton, complete the pattern of beads, Wrapped Bars, Corner Dove's Eyes. The beads may be added at each fabric intersection as you work the Wrapped Bars and Dove's Eyes.
6. Cut and remove the marked fabric threads in each of the four diamond areas. Using Size 12 Anchor #2 White Pearl Cotton, complete the pattern of Connected Wrapped Bars.
7. Add all seed beads and Access Commodities Mother of Pearl Hearts and beads.
8. When all stitching is complete, clean and press the bodice before adding the ribbon. Complete the Ribbon Embroidery as follows:
 a. Lay the 7mm. YLI #1 White along the length of the ribbon to be couched. You may wish to continue the pattern to the seam. Use the #00479 seed beads to gather the ribbon into the Couching Stitch.
 b. Use 4mm. YLI #1 White for all Japanese and Loop Stitches.
 c. Use 4mm. YLI #1 White for the French Knots and the Stem Stitch roses. Begin each rose with a French Knot Center then work a Stem Stitch as you work toward the outside of the flower. Each rose is stitched within the diameter of the circle. Allow the ribbon to twist and turn.

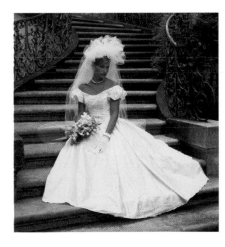

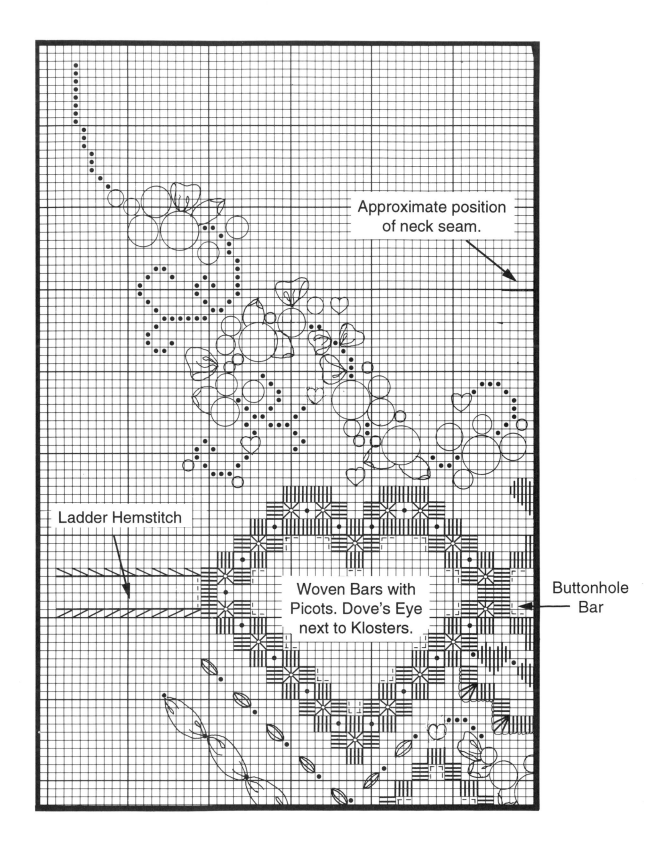

Approximate position of neck seam.

Ladder Hemstitch

Woven Bars with Picots. Dove's Eye next to Klosters.

Buttonhole Bar

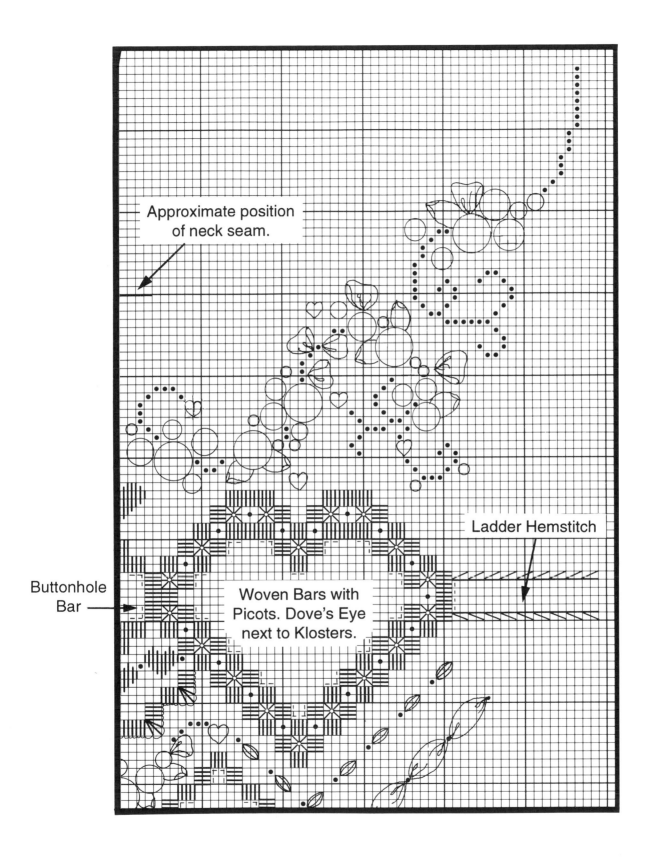

Approximate position of neck seam.

Ladder Hemstitch

Buttonhole Bar

Woven Bars with Picots. Dove's Eye next to Klosters.

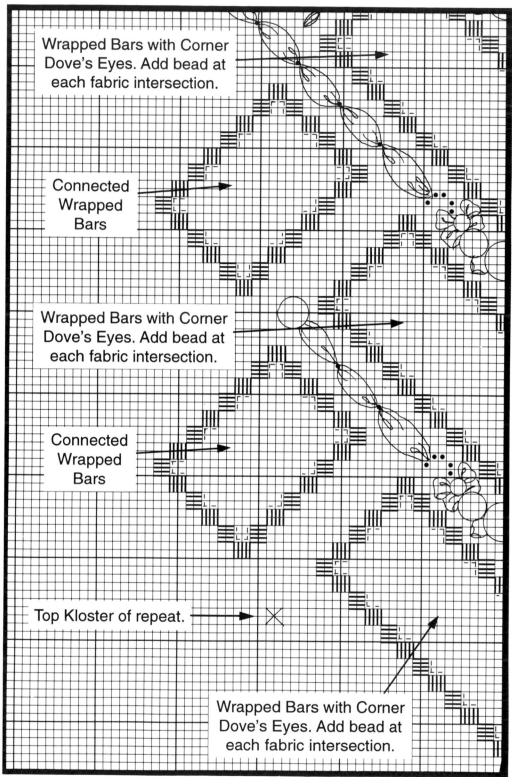

Wrapped Bars with Corner Dove's Eyes. Add bead at each fabric intersection.

Connected Wrapped Bars

Wrapped Bars with Corner Dove's Eyes. Add bead at each fabric intersection.

Connected Wrapped Bars

Top Kloster of repeat.

Wrapped Bars with Corner Dove's Eyes. Add bead at each fabric intersection.

Additional repeats of the pattern may be necessary. Begin a repeat at the X.

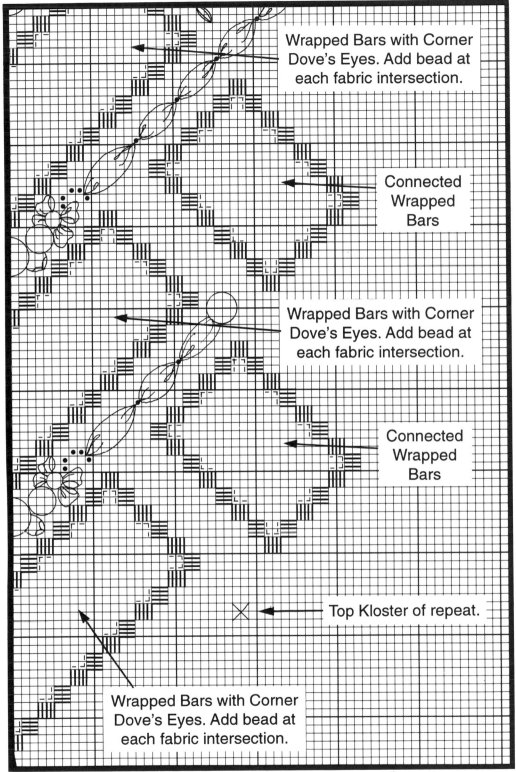

Wrapped Bars with Corner Dove's Eyes. Add bead at each fabric intersection.

Connected Wrapped Bars

Wrapped Bars with Corner Dove's Eyes. Add bead at each fabric intersection.

Connected Wrapped Bars

Top Kloster of repeat.

Wrapped Bars with Corner Dove's Eyes. Add bead at each fabric intersection.

Additional repeats of the pattern may be necessary. Begin a repeat at the X.

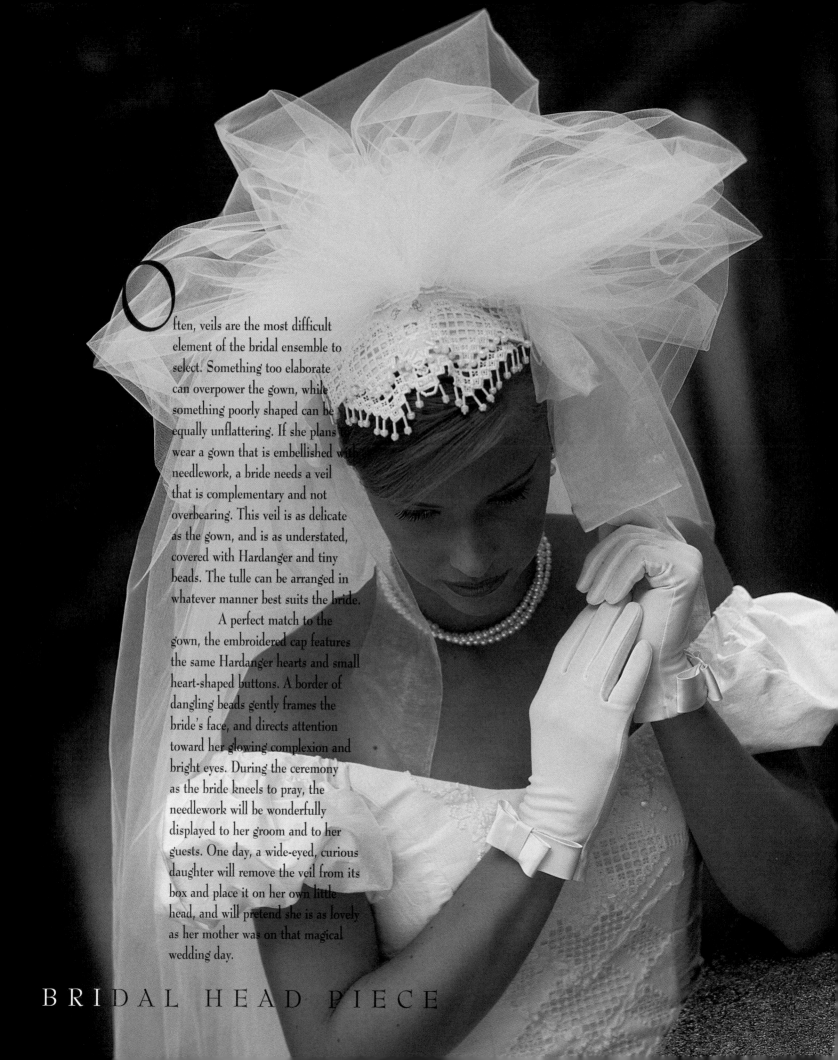

Often, veils are the most difficult element of the bridal ensemble to select. Something too elaborate can overpower the gown, while something poorly shaped can be equally unflattering. If she plans to wear a gown that is embellished with needlework, a bride needs a veil that is complementary and not overbearing. This veil is as delicate as the gown, and is as understated, covered with Hardanger and tiny beads. The tulle can be arranged in whatever manner best suits the bride.

A perfect match to the gown, the embroidered cap features the same Hardanger hearts and small heart-shaped buttons. A border of dangling beads gently frames the bride's face, and directs attention toward her glowing complexion and bright eyes. During the ceremony as the bride kneels to pray, the needlework will be wonderfully displayed to her groom and to her guests. One day, a wide-eyed, curious daughter will remove the veil from its box and place it on her own little head, and will pretend she is as lovely as her mother was on that magical wedding day.

BRIDAL HEAD PIECE

BRIDAL HEAD PIECE

DESIGN
Top: 106W X 42H
28 count 7.57 X 3, cut fabric 14 X 9
32 count 6.63 X 2.63, cut fabric 12 X 9
Bottom: 106W X 58H
28 count 7.57 X 4.14, cut fabric 13.5 X 10
32 count 6.63 X 3.63, cut fabric 12 X 9
The model was stitched on 32 count White Irish Linen from Charles Craft.

ADDITIONAL MATERIALS
DMC White Pearl Cotton, sizes #8 and #12.
Mill Hill Beads: White Seed Beads #00479, White Small Bugle Beads #70479, White Medium Bugle Beads #80479,
Oriental Pearl Pebble Beads #05147 .
White covered wire, 30 gauge.
4 yards of 3" white ribbon.
Two 4" x 8" pieces of white taffeta.
2 3/4 yards of 72" wide tulle.
No. 8 Kreinik Fine Braid #191 Pale Yellow, Kreinik #1 Japan Gold #002J.

DESIGN NOTES
1. Each square on chart represents two fabric threads. All stitch illustrations show the stitch worked over a single fabric thread.
2. Beads are represented on chart by these symbols: ● #00479, #70479 and #80479 bold oblong dashes, ○ #05147.

INSTRUCTIONS
Top
1. Complete all Kloster Blocks using #8 DMC White Pearl Cotton.
2. Complete the Buttonhole edge using #8 DMC White Pearl Cotton.
3. Complete the Satin Stitch heart using one strand of No. 8 Kreinik Fine Braid #191 Pale Yellow. The ribbons at the side of the hearts are stitched using one strand of Kreinik #1 Japan Gold #002J.
4. Attach the Mill Hill Small Bugle Beads #70479 and Seed Beads #00479 where indicated except where they are placed at the intersection of the Woven Bars.
5. Complete the Algerian Eye stitches surrounding the Hardanger Hearts using #12 DMC White Pearl Cotton.
6. Complete the Woven and Buttonhole Bar found in the center using #12 DMC White Pearl Cotton.
7. Complete the center of each Hardanger Heart using #12 DMC White Pearl Cotton in a pattern of Woven Bars and Dove's Eyes.
8. Complete the two side sections using #12 DMC White Pearl Cotton in a pattern of Woven Bars and Dove's Eyes. Attach Mill Hill Seed Beads #00479 at each intersection of the Woven Bars. Optional: Reinforce the Buttonhole with Fray Check®.
9. Carefully cut away the excess fabric on the outside of the Buttonhole edge.
10. Attach Mill Hill Pebble Bead #05147 and Seed Beads #00479 at each point of the Buttonhole edge.
11. Attach a string of 10-15 Seed Beads #00479 at point A.

Bottom
1. Complete the Buttonhole edge and all Kloster Blocks using #8 DMC White Pearl Cotton.
2. Complete the Algerian Eye stitches using #12 DMC White Pearl Cotton.
3. Complete the center Woven and Bottonhole Bar, and the Woven Bar and Dove's Eye edge using #12 DMC White Pearl Cotton.
4. Carefully cut away the extra fabric on the outside of the Buttonhole edge.
5. Attach a string of 10-15 Mill Hill Beads #00479 at point A. Attach Medium Bugle Beads #80479, Pebble Beads #05147 and Seed Beads #00479 to each point of the Buttonhole edge.

FINISHING INSTRUCTIONS
1. Using the pattern provided, cut two pieces of taffeta for the lining of the head piece. With right sides together, and using a 1/2" seam, stitch around from point B to point B. Leave the long side open for turning and to attach the veil. Clip. Turn to right side.
2. The veil as shown consists of an 8" pouf with a waltz length veil. It is not necessary to hem the tulle. Open the tulle so that you are working with the entire 72" width. Fold 18" back along the full width. Then bring the cut edge back to the folded edge. Using a length of #8 Pearl Cotton, run a long basting stitch through these three layers. Gather. Attach to the open edge of the lining of the head piece. Turn other edge in and hem closed. 30 gauge covered wire may be attached to the lining to help shape the head piece.
3. Place the lining with its attached pouf and veil between the top and bottom stitched pieces. The bottom piece should have the right side of the stitching showing. Stitch closed between points B and C along the Buttonhole edge. Attach the Buttonhole edge from point B to point B along the straight edge to the tulle on the top and on the bottom pieces.
4. You may also wish to tack the top piece to the bottom piece at each point D.
5. Attach 8" and 12" loops of 3" wide ribbon at point B. Attach 4" and 6" loops of Small (#70479) or Medium (#80479) beads at point B.

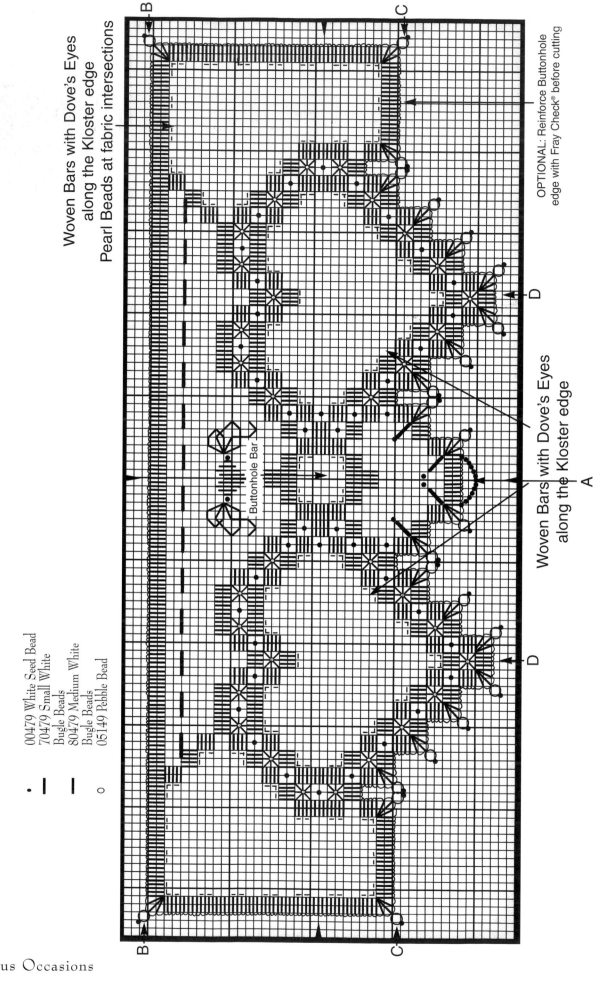

Woven Bars with Dove's Eyes
along the Kloster edge
Pearl Beads at fabric intersections

Woven Bars with Dove's Eyes
along the Kloster edge

Buttonhole Bar

OPTIONAL: Reinforce Buttonhole
edge with Fray Check® before cutting

00479 White Seed Bead
70479 Small White
Bugle Beads
80479 Medium White
Bugle Beads
05149 Pebble Bead

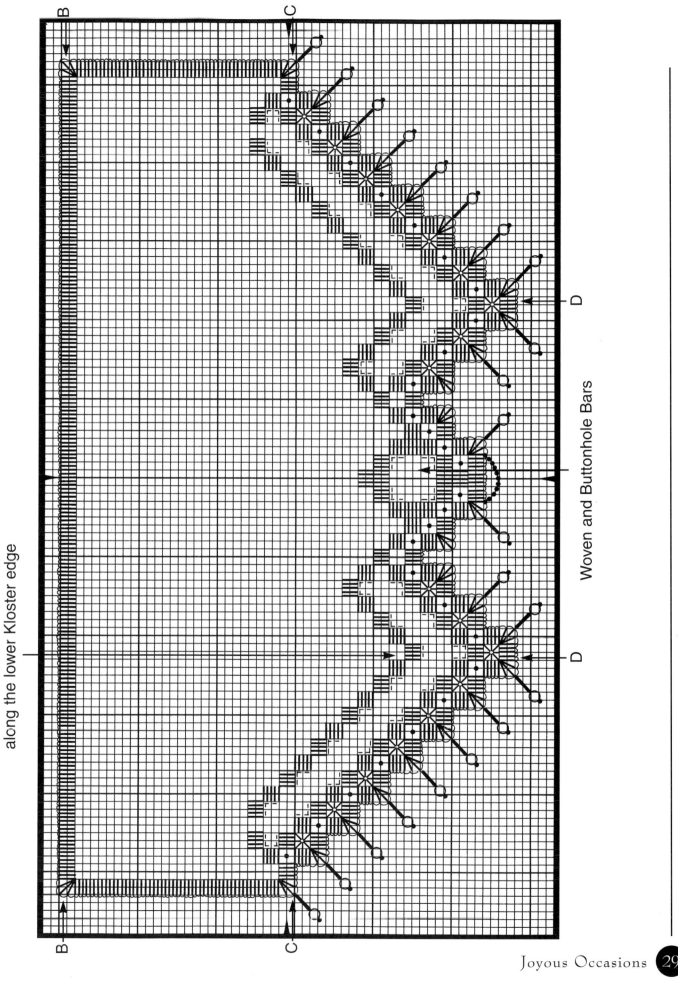

Woven Bars with Dove's Eyes
along the lower Kloster edge

Woven and Buttonhole Bars

Headpiece Pattern

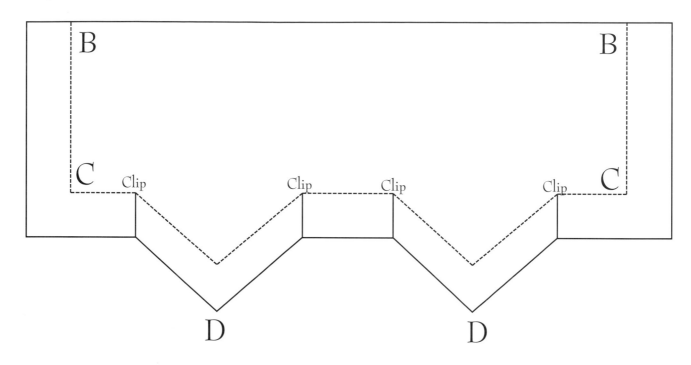

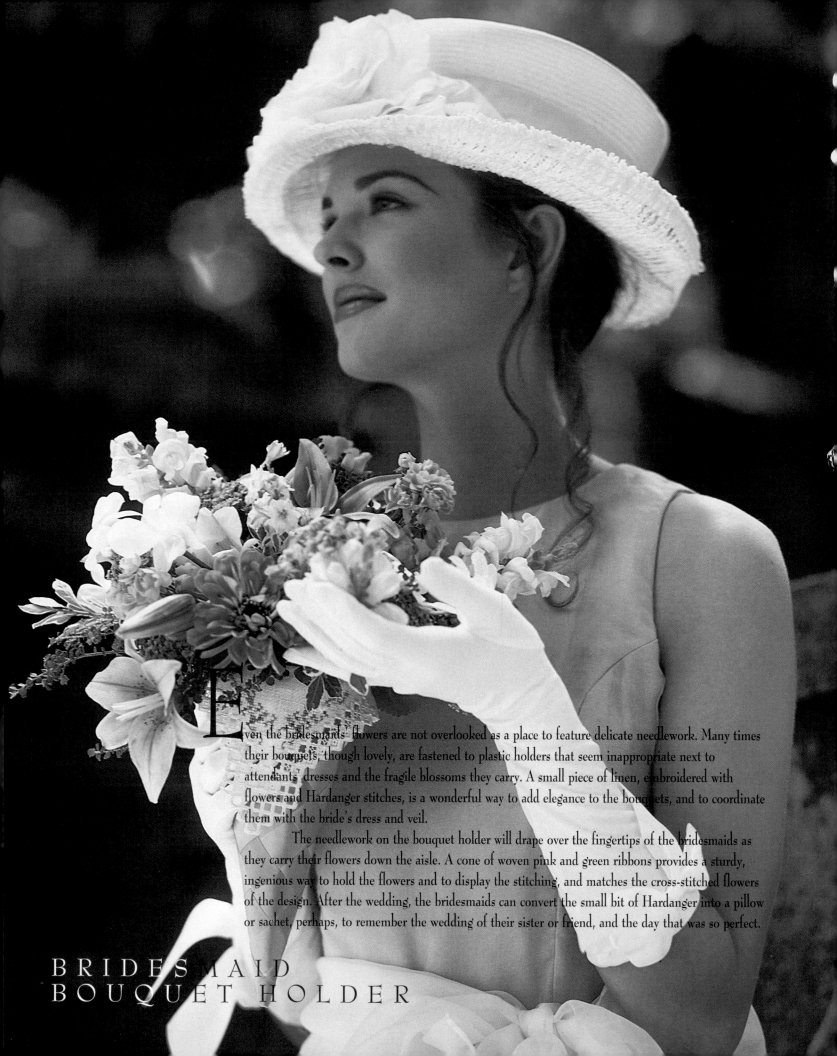

Even the bridesmaids' flowers are not overlooked as a place to feature delicate needlework. Many times their bouquets, though lovely, are fastened to plastic holders that seem inappropriate next to attendants' dresses and the fragile blossoms they carry. A small piece of linen, embroidered with flowers and Hardanger stitches, is a wonderful way to add elegance to the bouquets, and to coordinate them with the bride's dress and veil.

The needlework on the bouquet holder will drape over the fingertips of the bridesmaids as they carry their flowers down the aisle. A cone of woven pink and green ribbons provides a sturdy, ingenious way to hold the flowers and to display the stitching, and matches the cross-stitched flowers of the design. After the wedding, the bridesmaids can convert the small bit of Hardanger into a pillow or sachet, perhaps, to remember the wedding of their sister or friend, and the day that was so perfect.

BRIDESMAID
BOUQUET HOLDER

BRIDESMAID
BOUQUET HOLDER

DESIGN 70H X 86W
28 count 5 X 6.14, cut fabric 10 X 12
32 count 4.37 X 5.37, cut fabric 9 X 11
The model was stitched on 32 count Cream Belfast Linen from Zweigart®.

ADDITIONAL MATERIALS:
DMC Ecru Pearl Cotton, sizes #8 and #12
#00123 Cream Mill Hill Beads (represented by the ● symbol on chart)
DMC floss

∷	225 Pale Pink
o	224 Lt. Pink
♥	223 Md. Pink
■	3051 Dk. Green
V	3052 Md. Green

DESIGN NOTES
1. Each square on the chart represents two fabric threads.
2. This design uses a variety of needlework techniques including Cross Stitch, Backstitch, Buttonhole Edge, Kloster, Algerian Eye, Dove's Eye, Woven Bar, Picot, Satin, Buttonhole Corner, and Lacy Edge.

INSTRUCTIONS
1. Complete all Cross Stitches using two strands of floss over two fabric threads. Use two strands of 3052 Md. Green to Backstitch the vines.
2. Use #8 DMC Ecru Pearl Cotton for the Satin Stitch heart, the Klosters and the Buttonhole edge.
3. Using #12 DMC Ecru Pearl Cotton, complete the Algerian Eye Stitches.
4. Attach beads.
5. Cut and remove the marked fabric threads between Klosters. Using #12 DMC Ecru Pearl Cotton, work the center Hardanger pattern of Woven Bars, Dove's Eyes and Picots.
6. Complete the Lacy Edge. You will be cutting and removing both vertical and horizontal fabric threads beyond the Buttonhole edge area.
 a. Cut and remove the vertical fabric thread on the outside edge of the Buttonhole edge. (See arrow on the left. It is the vertical thread that is at the inside corner of the Buttonhole edge). Cut and remove every 8th thread to the point of the design. Repeat this procedure for the right side.
 b. Cut every 5th, 6th and 7th vertical fabric thread on both sides of the point. Remove them to five threads below the bottom of the Lacy Edge. See cutting line. Leaving these threads in place below this point will provide stability to the fabric as you complete the Woven Bars of the Lacy Edge.
 c. Cut and remove the horizontal fabric thread on the outside edge of the Buttonhole edge. (See arrow on the left). Cut and remove every 8th thread to the point of the design. Repeat this procedure for the right side.
 d. Counting down from the arrow (the first horizontal fabric thread), cut and remove the 2nd, 3rd and 4th horizontal fabric threads on both sides of the point. Remove them to five threads beyond the side of the Lacy Edge. (See cutting line.)
 e. Using #12 DMC Ecru Pearl Cotton, extend a reinforcing thread from under the Klosters and the Buttonhole edge, out to the Lacy Edge and back, following the direction indicated by the arrows. This reinforcing thread will provide stability and strength to the Lacy Edge. It will be woven with the other fabric threads.
 f. Using #12 DMC Ecru Pearl Cotton, complete the Woven Bars and the Buttonhole Corners of the first Lacy Edge row. Continue the Woven Bars next to the Buttonhole edge, traveling in a stair-step fashion. Add a new length of Pearl Cotton for the second and third rows of Woven Bars and Buttonhole corners.
 g. Cut the fabric away from the rest of the Buttonhole edge and from the Lacy Edge.

FINISHING INSTRUCTIONS
Finishing Instructions found on page 35.

Woven Bars with Picots and Dove's Eyes
along the lower Kloster edge.

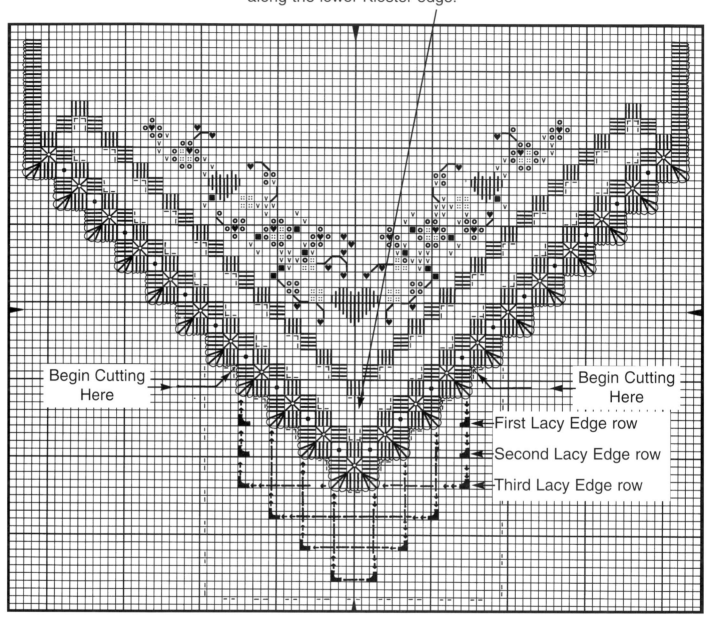

Begin Cutting
Here

Begin Cutting
Here

First Lacy Edge row

Second Lacy Edge row

Third Lacy Edge row

::	225 Pale Pink
o	224 Lt. Pink
♥	223 Md. Pink
■	3051 Dk. Green
V	3052 Md. Green

FINISHING INSTRUCTIONS

1" wide satin ribbon: 2 1/2 yds. each of pink and green (for Bridesmaid Bouquet Holder), 5 yds. white (for white Bridal Bouquet Holder)
1/3 yd. fusible interfacing
Straight pins
Matching sewing thread

1. Cut ten 10" long pieces of one color 1" wide ribbon; place face down and side by side onto surface you can pin into, such as ironing board or fabric covered wooden board. Pin ribbon lengths at both ends. (Illustration 1)
2. Cut ten 10" long pieces of second color 1" wide ribbon. Weave over and under pinned lengths, making sure ribbon is face down. Pin at ends. (Illustration 2)
3. Cut 10" square from fusible interfacing; fuse to ribbon. (Illustration 3)
4. Trace cone pattern (found on page 40) and place on interfacing. Trace top curve; cut out pattern.
5. Serge all edges or finish with a narrow 1/8"-1/4" hem.
6. Roll pattern into cone shape; fold in bottom point and seam edge. Hand stitch closed.
7. Fold unstitched edge of Hardanger embroidery over cone; whipstitch to inside edge of ribbon to secure.

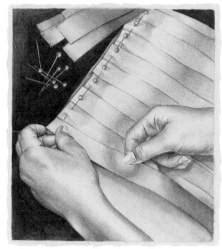
Illustration 1

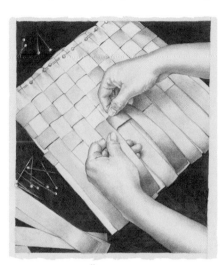
Illustration 2

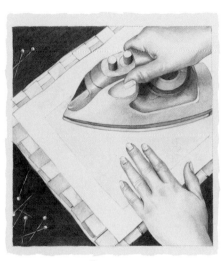
Illustration 3

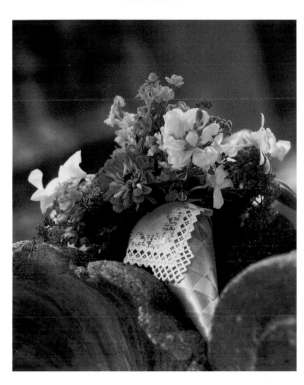

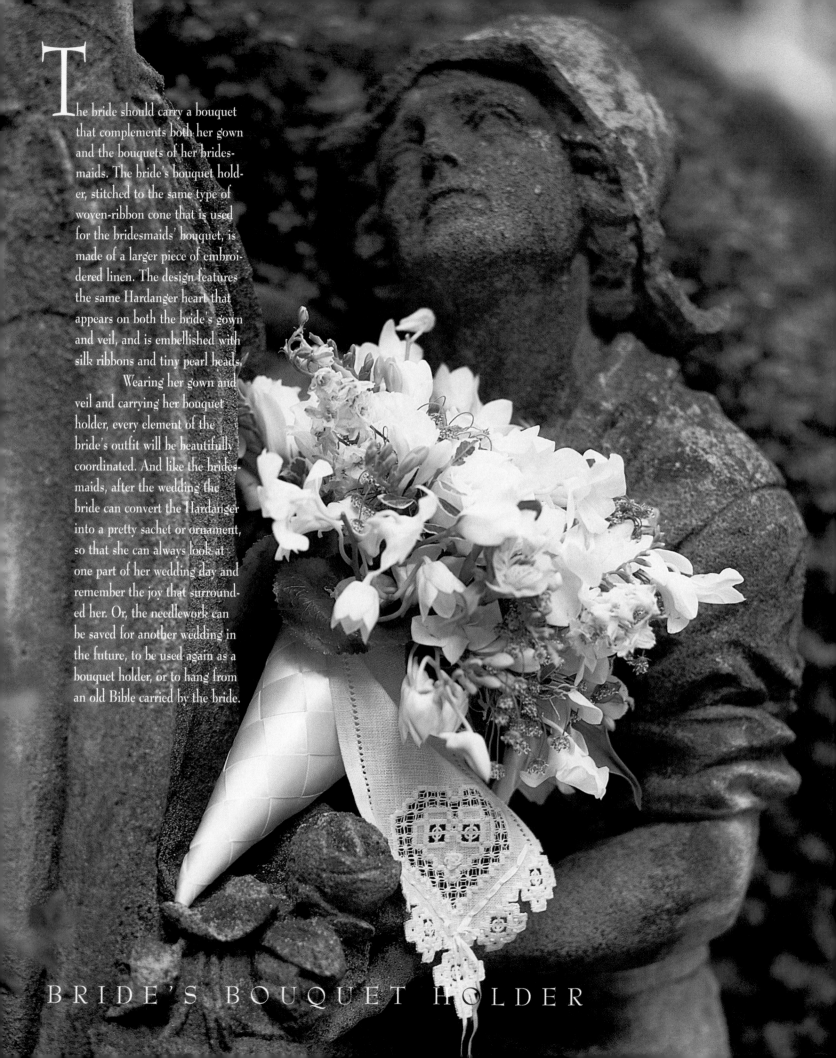

T he bride should carry a bouquet that complements both her gown and the bouquets of her bridesmaids. The bride's bouquet holder, stitched to the same type of woven-ribbon cone that is used for the bridesmaids' bouquet, is made of a larger piece of embroidered linen. The design features the same Hardanger heart that appears on both the bride's gown and veil, and is embellished with silk ribbons and tiny pearl beads.

Wearing her gown and veil and carrying her bouquet holder, every element of the bride's outfit will be beautifully coordinated. And like the bridesmaids, after the wedding the bride can convert the Hardanger into a pretty sachet or ornament, so that she can always look at one part of her wedding day and remember the joy that surrounded her. Or, the needlework can be saved for another wedding in the future, to be used again as a bouquet holder, or to hang from an old Bible carried by the bride.

BRIDE'S BOUQUET HOLDER

BRIDAL BOUQUET HOLDER

DESIGN 102H X 86W
28 count 7.57 X 6.14 (stitched area only), cut fabric 13" X 20"
32 count 6.62 X 5.38 (stitched area only), cut fabric 12" X 20"
The main portion of the design is worked on one end of the length. Cut the material to allow fabric to hang below the flowers.
The model was stitched on 32 count Antique White Belfast Linen from Zweigart®.

ADDITIONAL MATERIALS
DMC White Pearl Cotton, sizes #8 and #12
YLI 4mm. silk ribbon #1 White
#00479 White Mill Hill Seed Beads

DESIGN NOTES
1. Each square on the chart represents two fabric threads.
2. This design uses a variety of needlework techniques including Algerian Eye, Hemstitching Over Four, Kloster, Wrapped Bars, Buttonhole, Corner Dove's Eye, Woven Bars, Buttonhole Bars, French Knot and Stem Stitch Rose.
3. The chart for this design shows the bottom area that is to be stitched. The design should be stitched on the end of the fabric. Continue the Hemstitching along the entire length of the fabric.

INSTRUCTIONS
1. Complete all Klosters and the Buttonhole edge using #8 DMC White Pearl Cotton.
2. Use #12 DMC White Pearl Cotton to work Algerian Eye stitches.
3. Attach beads where ● symbols appear.
4. Cut and withdraw the marked fabric threads. Using #12 DMC White Pearl Cotton, complete the Woven Bars and Buttonhole Bars. Use the same Pearl Cotton for the Wrapped Bars and Corner Dove's Eyes of the heart border.
5. Cut and remove the four vertical threads for each Hemstitch side. Turn excess fabric to the back (This is 12 threads from the withdrawn vertical threads). Count 12 threads from this turn and fold again. Trim excess fabric. Using #12 DMC White Pearl Cotton, work the Hemstitch Over Four catching a thread or two of the turned back hem as you work along the length of the fabric.
6. Add YLI #1 White Ribbon and a bow at the center. Begin the Stem Stitch Rose with a French Knot at the center then continue with Stem Stitches as you work toward the outside of the flower. Attach beads on top of the ribbon after it is in place.

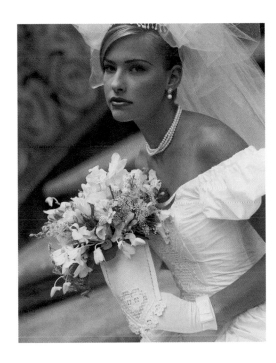

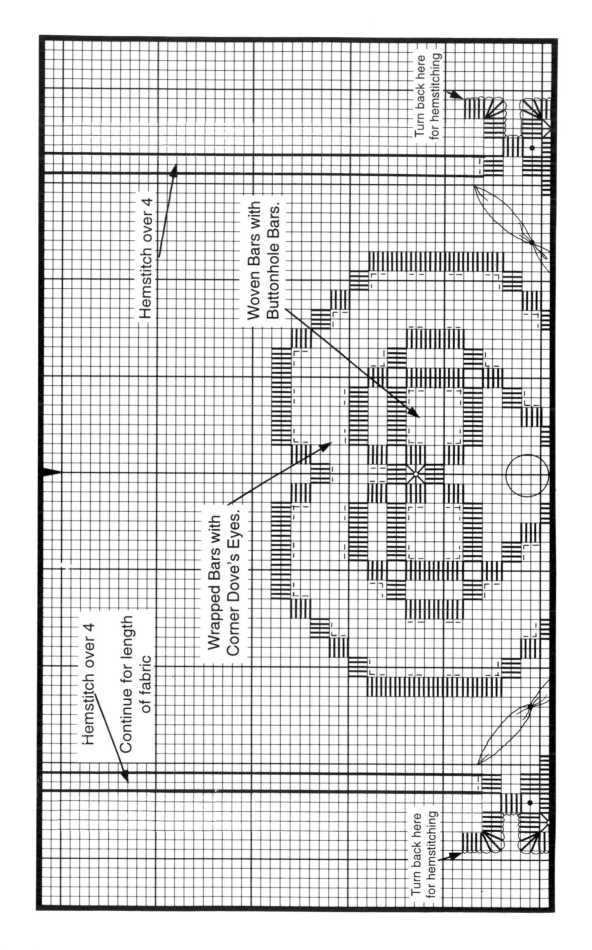

Turn back here for hemstitching

Hemstitch over 4

Woven Bars with Buttonhole Bars.

Wrapped Bars with Corner Dove's Eyes.

Hemstitch over 4

Continue for length of fabric

Turn back here for hemstitching

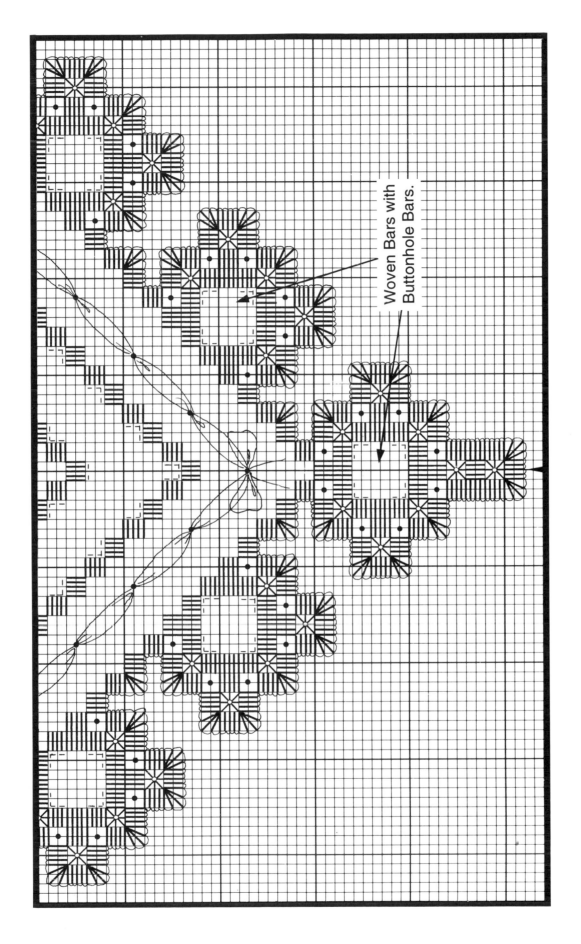

Woven Bars with Buttonhole Bars.

See page 35 for ribbon weaving and finishing instructions.

Cone Pattern

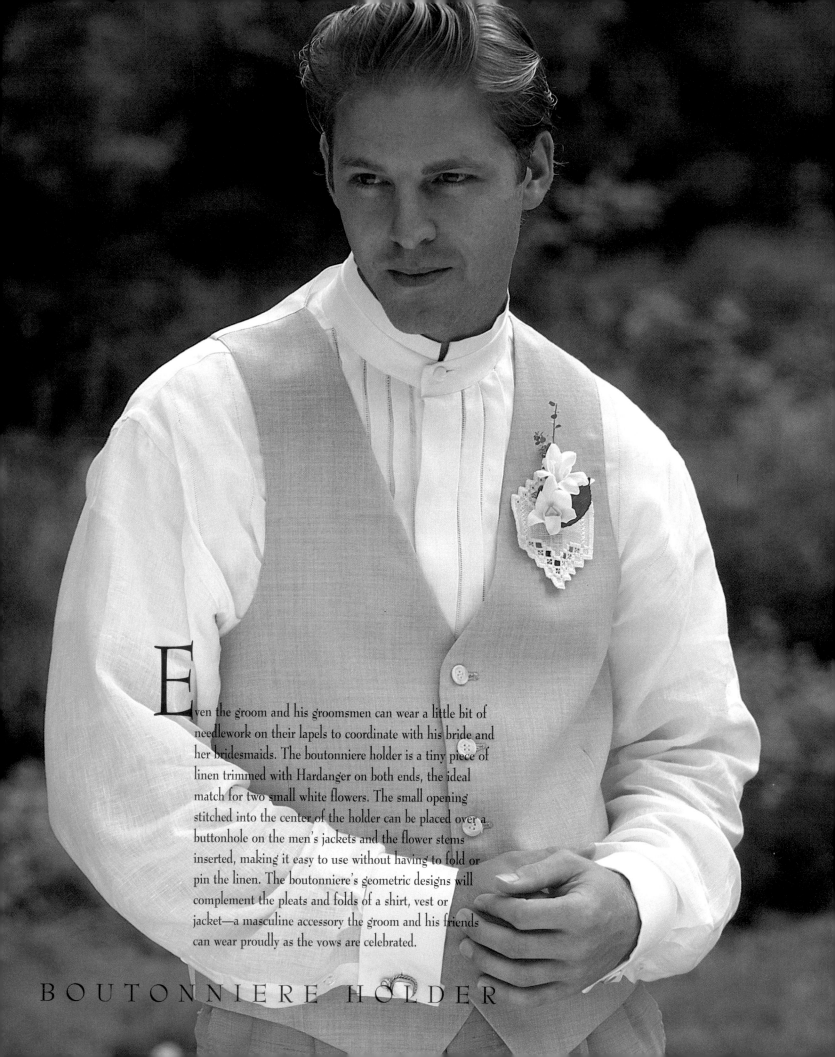

Even the groom and his groomsmen can wear a little bit of needlework on their lapels to coordinate with his bride and her bridesmaids. The boutonniere holder is a tiny piece of linen trimmed with Hardanger on both ends, the ideal match for two small white flowers. The small opening stitched into the center of the holder can be placed over a buttonhole on the men's jackets and the flower stems inserted, making it easy to use without having to fold or pin the linen. The boutonniere's geometric designs will complement the pleats and folds of a shirt, vest or jacket—a masculine accessory the groom and his friends can wear proudly as the vows are celebrated.

BOUTONNIERE HOLDER

BOUTONNIERE HOLDER

DESIGN 38W X 58H
28 count 2.7 X 4.36, cut fabric 9 X 10.5
32 count 2.31 X 3.62, cut fabric 8.5 X 9.5
The model was stitched on 28 count White Linen from Wichelt Imports, Inc.

ADDITIONAL MATERIALS
DMC White Pearl Cotton, sizes #8 and #12

DESIGN NOTES
1. Each square on the chart represents two fabric threads.
2. The design contains a variety of needlework techniques including: Algerian Eye, Four-sided, Buttonhole, Kloster, Woven Bar and Dove's Eye.

INSTRUCTIONS
1. Use #8 DMC White Pearl Cotton to work Klosters, Buttonhole edge and the Four-sided stitch.
2. Use #12 DMC White Pearl Cotton for the Algerian Eye stitches.
3. Cut the marked fabric threads.
4. Using #12 DMC White Pearl Cotton complete the pattern of Woven Bars and Dove's Eyes.
5. Trim fabric away from the Buttonhole edge. Also trim the fabric threads from the hole in the center.

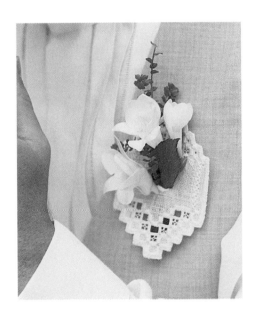

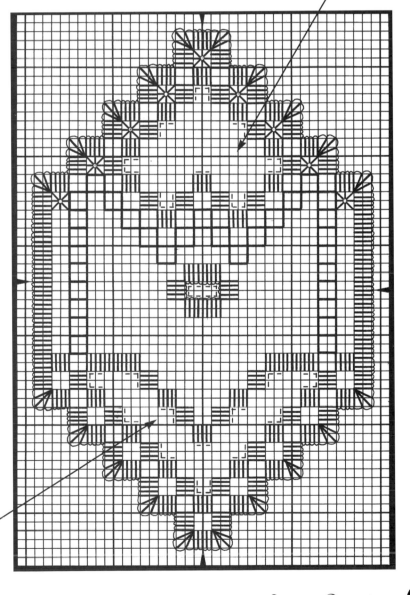

Woven Bars
with Dove's Eyes

Woven Bars
with Dove's Eyes
along the upper
Kloster edge

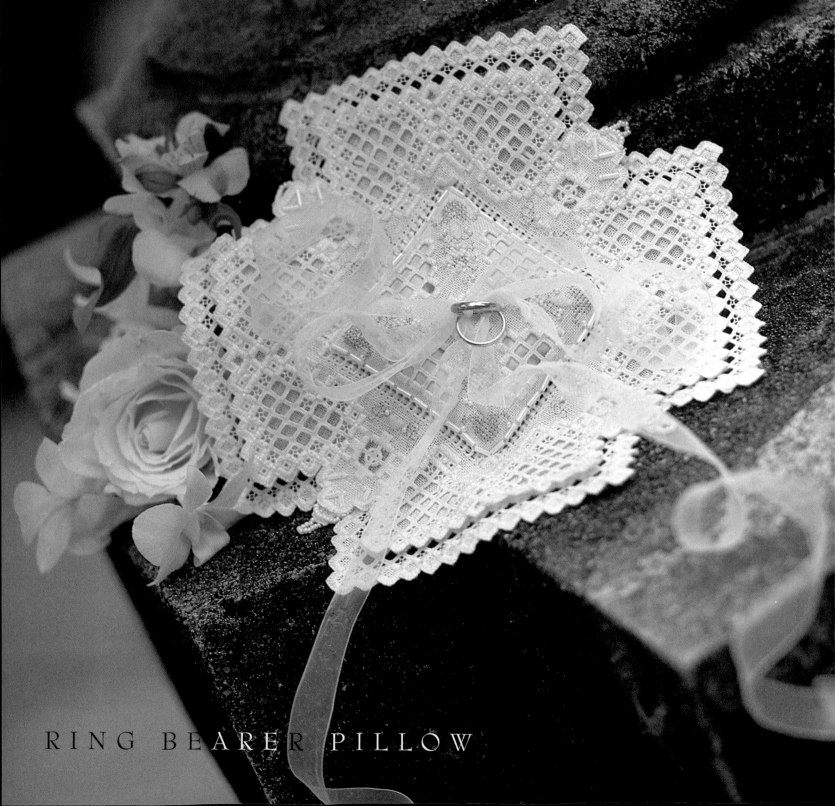

Complete your Hardanger wedding collection with this exquisite ring bearer's pillow. Needleworkers have long found this small pillow rest the perfect place to decorate with stitchery. This version, made of two layers of linen almost completely covered with Hardanger stitches, is one of the most marvelous you could make.

The Hardanger is so extensive that the pillow looks as if it were made of lace. Accented by a variety of beads and gold metallic threads, the area on which the rings are tied is actually quite small; the borders are wide and encrusted with shimmering threads and beads. Such a dazzling example of your needlework skill will be admired by everyone who sees it, and the pillow will become an heirloom destined to be treasured for generations. Just as the rings are symbols of the couple's love and commitment to each other, so will this pillow be a symbol of your love for them.

RING BEARER PILLOW

RING BEARER PILLOW

DESIGN
Top: 130W X 130H
32 count 8.13 X 8.13, cut fabric 12 X 12
Bottom: 154W X 154H
32 count 9.63 X 9.63, cut fabric 14 X 14
The model was stitched on 32 count White Irish Linen from Charles Craft.

ADDITIONAL MATERIALS
White DMC Pearl Cotton, sizes #8 and #12
Mill Hill Beads: White Seed Beads #00479, White Small Bugle Beads #70479
Kreinik #1 Japan Gold #002J, No. 8 Kreinik Fine Braid #191 Pale Yellow
2 yards of white 1/8" ribbon
1 yard of 1/2" white ribbon
Two 4" pieces of white taffeta
Polyester fiberfill
DMC White floss

DESIGN NOTES
Each square represents two fabric threads. All stitch illustrations also show the stitch worked over a single fabric thread.

INSTRUCTIONS
Top
1. Complete all Kloster Blocks using #8 DMC White Pearl Cotton.
2. Complete the Buttonhole edge using #8 DMC White Pearl Cotton.
3. Complete all Cross Stitches using two strands of DMC White floss (where □ symbols appear). Use one strand of Kreinik #1 Japan Gold #002J where X symbols appear.
4. Use one strand of Kreinik #1 Japan Gold #002J for all Backstitch.
5. Attach Mill Hill White Seed Beads #00479 (represented by ● on chart) and White Small Bugle Beads #70479 (represented by bold dash on chart.)
6. Satin Stitch the center of flowers and all hearts using Kreinik Fine Braid #191 No. 8.
7. Cut and remove the four fabric threads for each Hemstitch area. Using DMC White #12 Pearl Cotton, complete the Ladder Hemstitch, and the Algerian Eye Stitch.
8. Work the inside of each Hardanger heart in a pattern of Woven Bars and Dove's Eyes using #12 DMC White Pearl Cotton.
9. Work the inside of the triangles in Woven Bars using #12 DMC White Pearl Cotton.
10. Complete the Woven and Buttonhole bars using #12 DMC White Pearl Cotton.
11. Cut away excess fabric on the outside edge of the Buttonhole edge. Cut out the center of each of the three Kloster Blocks where the hearts meet at each corner of the design.
12. String 12-15 White Seed Beads #00479 and attach to points A, forming a loop.

Bottom
1. Complete all Kloster Blocks and the Buttonhole edge using #8 DMC White Pearl Cotton.
2. Complete the inner Hardanger section in a pattern of Woven Bars and Dove's Eyes using #12 DMC White Pearl Cotton.
3. Complete the Ladder Hemstitch using #12 DMC White Pearl Cotton.

FINISHING INSTRUCTIONS
1. Cut two 4" pieces of taffeta. With right sides together, sew around three sides using a 1/4" seam. Turn to right side. Stuff lightly. Stitch closed.
2. Place the mini stuffed pillow between the back of the top piece and the right side of the bottom piece. Using the 1/8" ribbon, lace together by going up and down through the Ladder Hemstitching.
3. Attach two 18" lengths of 1/2" ribbon for the rings at point B.

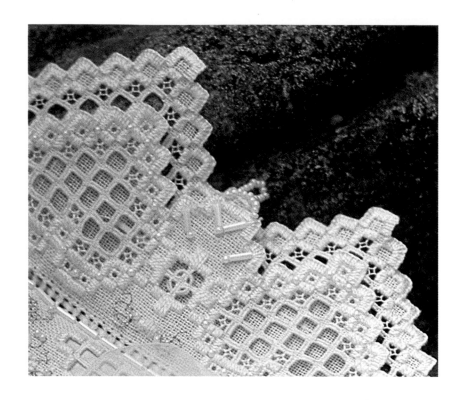

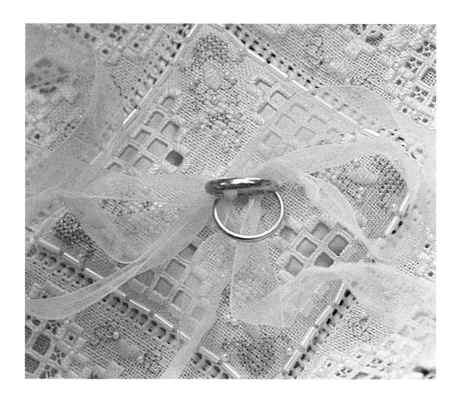

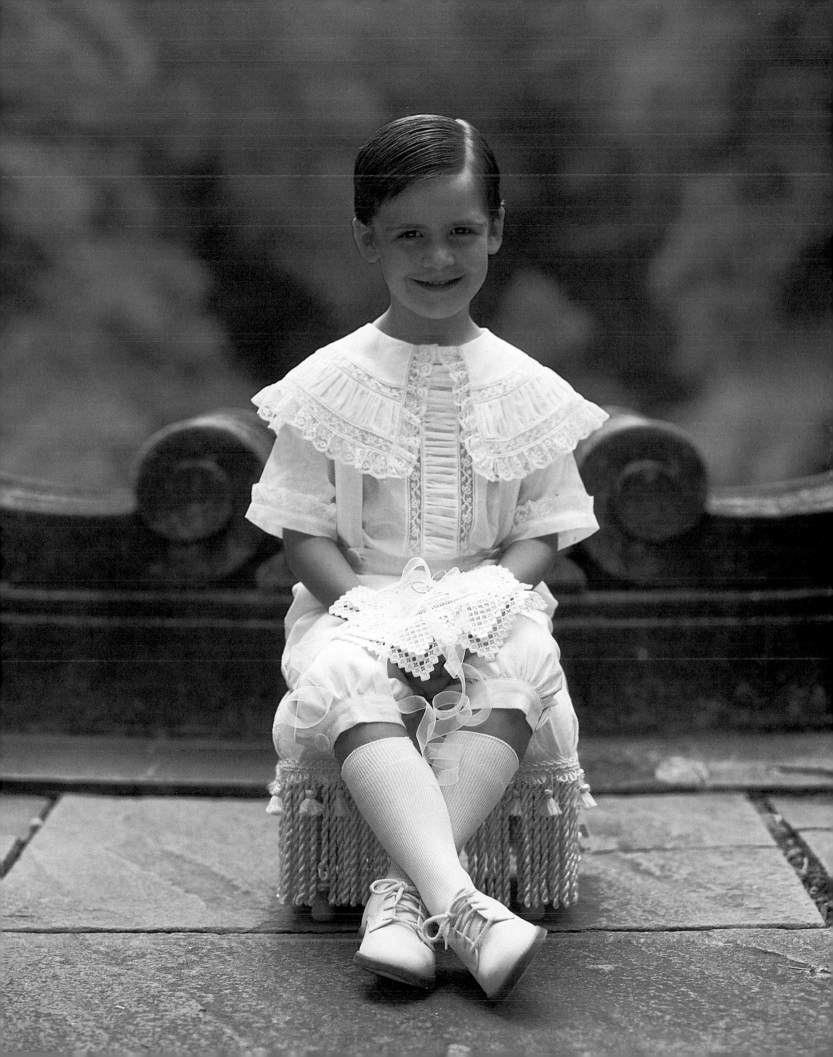

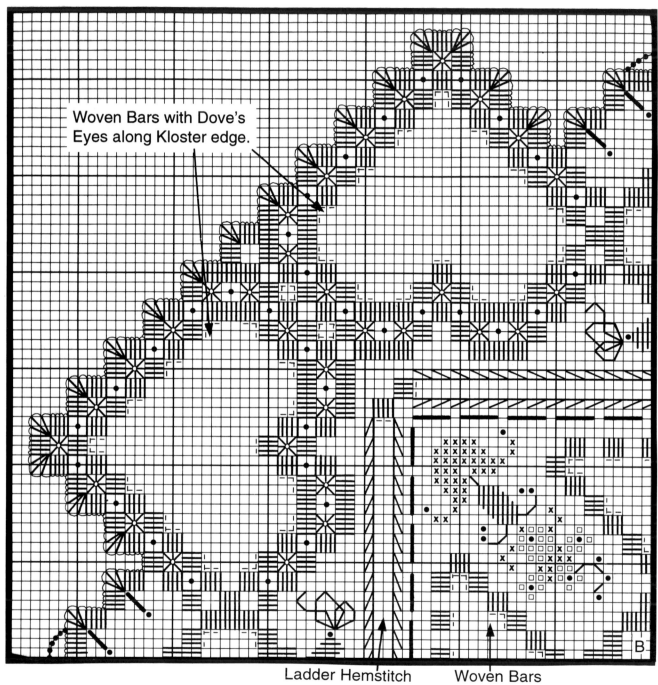

Woven Bars with Dove's Eyes along Kloster edge.

Ladder Hemstitch Woven Bars

□ DMC White floss
X Kreinik #1 Japan Gold #002J
● Mill Hill White Seed Beads #00479

Pillow Top

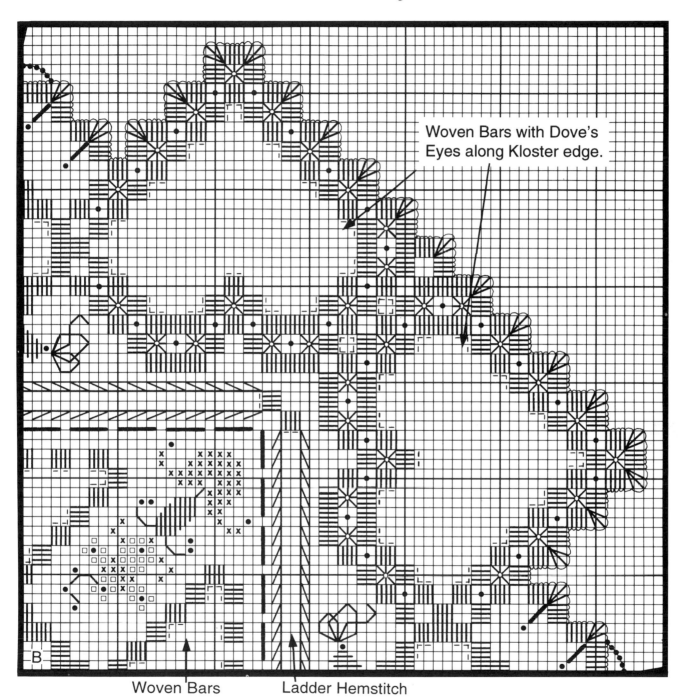

Woven Bars with Dove's
Eyes along Kloster edge.

Woven Bars Ladder Hemstitch

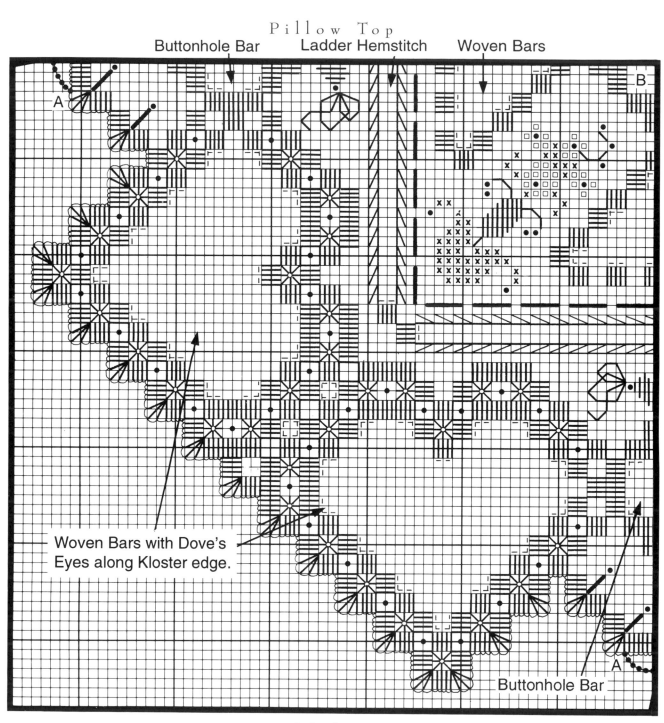

Pillow Top

Buttonhole Bar **Ladder Hemstitch** **Woven Bars**

A

B

Woven Bars with Dove's
Eyes along Kloster edge.

Buttonhole Bar

A

□ DMC White floss
X Kreinik #1 Japan Gold #002J
● Mill Hill White Seed Beads #00479

Pillow Top

Woven Bars Ladder Hemstitch Buttonhole Bar

B

A

Woven Bars with Dove's
Eyes along Kloster edge.

A

Buttonhole Bar

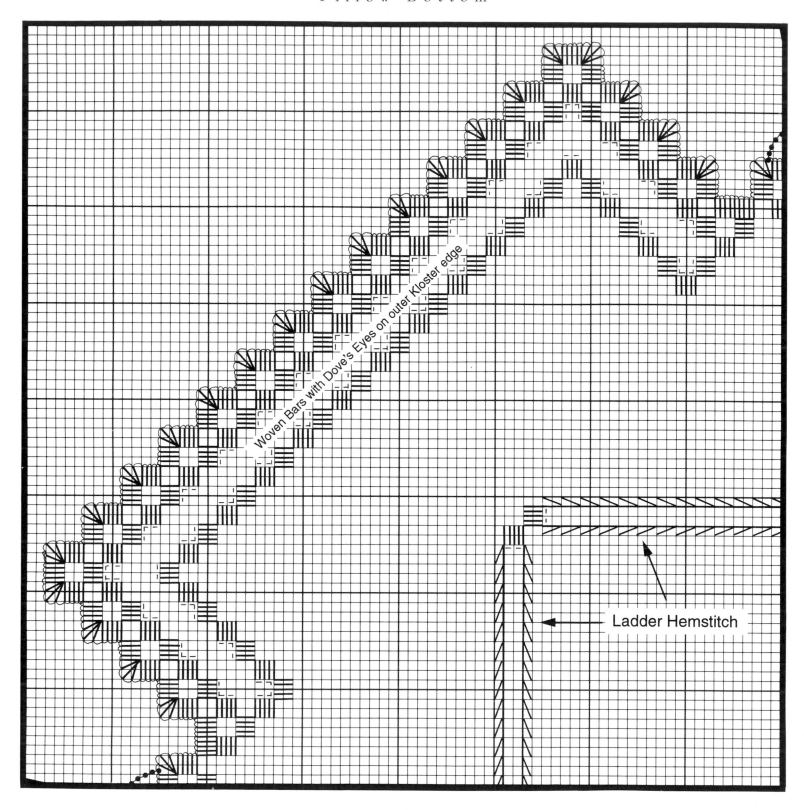

Woven Bars with Dove's Eyes on outer Kloster edge

Ladder Hemstitch

□ DMC White floss
X Kreinik #1 Japan Gold #002J
● Mill Hill White Seed Beads #00479

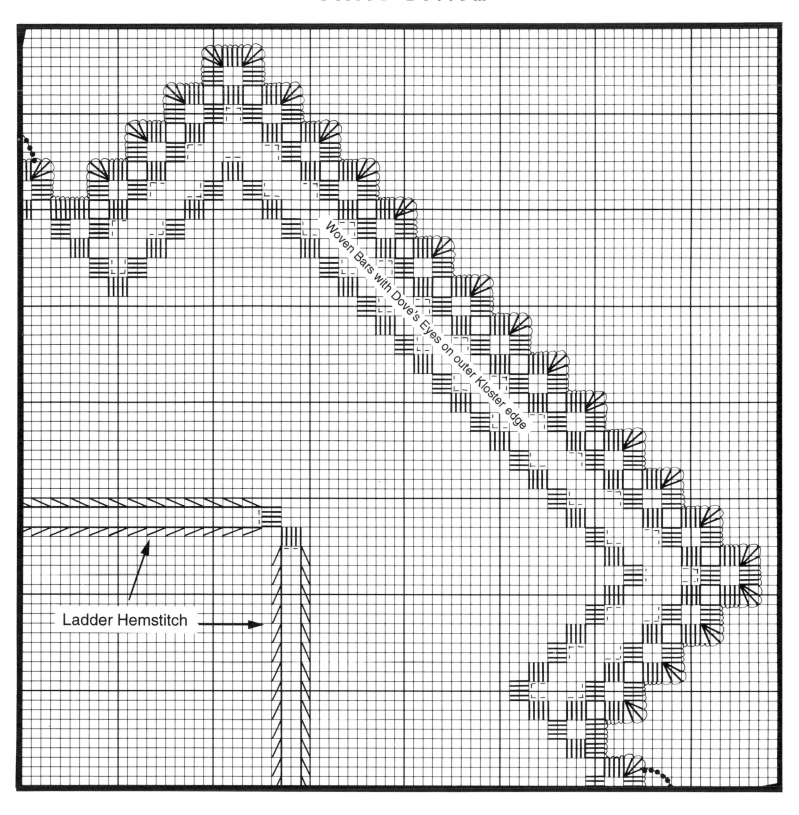

Woven Bars with Dove's Eyes on outer Kloster edge

Ladder Hemstitch →

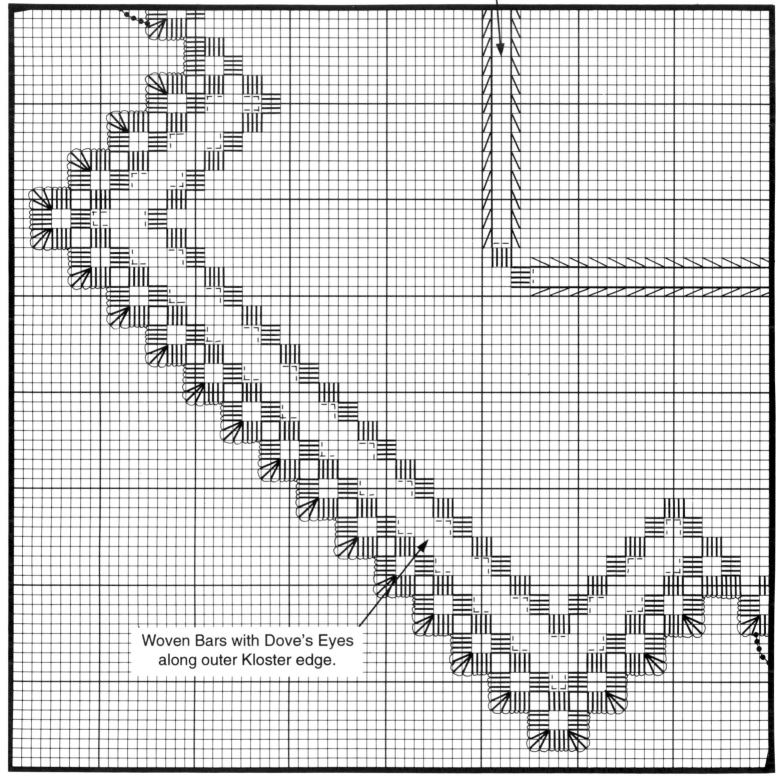

Ladder Hemstitch

Woven Bars with Dove's Eyes
along outer Kloster edge.

□ DMC White floss
X Kreinik #1 Japan Gold #002J
● Mill Hill White Seed Beads #00479

Ladder Hemstitch

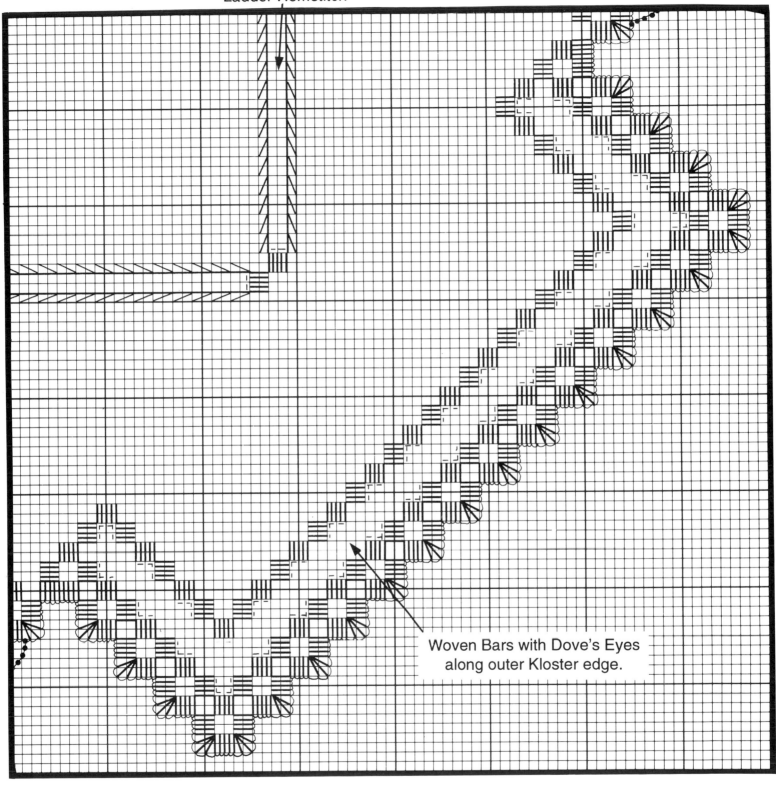

Woven Bars with Dove's Eyes
along outer Kloster edge.

Bridal Passages

by Laura Franck

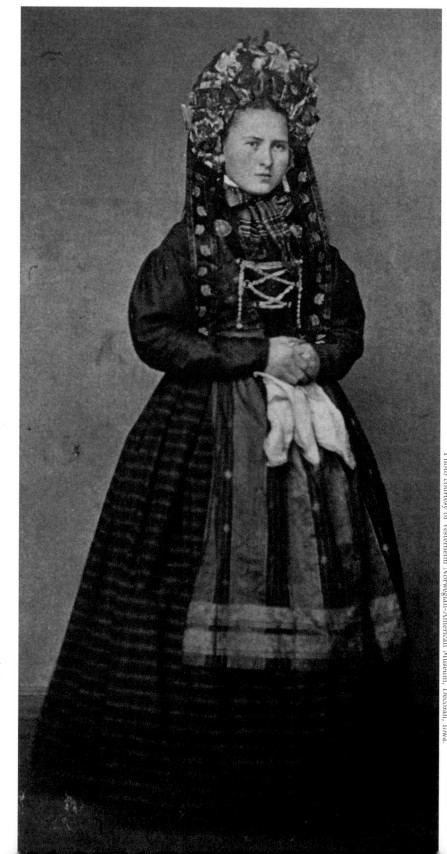

"It took us two or three days to bake enough cakes for this affair...Oh, all the cakes at this wedding! I guess they expected seventy or eighty people.

"

In this partially hand-painted photograph, a bride from Lardal in Vestfold, Norway (1860s) is wearing a print plaid skirt which was probably a practical choice as much as a decorative one. Her intricate crown of silk fabric and ribbons is a traditional element of early Norwegian weddings.

"It was a very big wedding. The couple was married in the church in the afternoon, and after that came to her home for the wedding dinner and celebration. It took us two or three days to bake enough cakes for this affair...Oh, all the cakes at this wedding! I guess they expected seventy or eighty people. We made white cakes, dark cakes, silver and gold cakes, chocolate and coconut cakes, maybe a couple of each kind. Layers and loaf cakes, too. The wedding cake was a three-tiered fruit cake, filled with all kinds of raisins and currants and maybe citron. The bottom was made in a good-sized, round milkpan, the next a smaller pan, and the top the smallest of all. It was a pretty, white-frosted cake, and good tasting. There was lovely bread and those good sweet raised biscuits with currants, shortening, and sugar in them. Halvor had butchered a calf for meat, and they had mashed potatoes, pickles of all kinds, and jelly; mince and apple pies, and coffee made in the washboiler. There was not another inch to spare on the tables for all the food. Everybody for miles around was invited, of course...In those days the wedding would be at the church at 2 p.m..."

This description of Lena Johnson's wedding from the 1880s is one of the many stories of Norwegian immigrant life in central Wisconsin, as told by Thurine Oleson to her daughter Erna Oleson Xan. And like the scrumptous fare described above, wedding

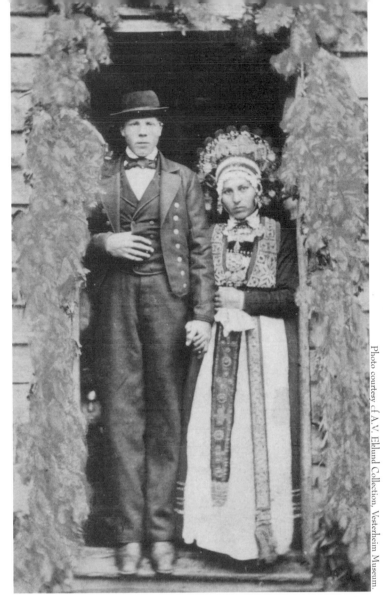

In traditional Norwegian wedding style, the bride, pictured here with her groom in Graven in Hardanger, Norway (1860s), is dressed in a festive *bunader* (costume). The elaborate *kranse* (crown) symbolized virginity, while the streamers attached to her belt indicated her new marital status.

Photo courtesy of A.V. Eklund Collection, Vesterheim Museum.

celebrations in rural Norway leaned toward elaborate display, and it was not uncommon to include feasting, music, dancing and the use of intricately embroidered *bunader* (costumes) in festivities that stretched out several days long. But when immigrants made the transition from their Norwegian valleys to the American frontier, many of the pioneers inevitably sensed a cultural barrier, and in efforts to close the chasm between themselves and the Americans, began modifying their wedding traditions and dress.

Accessories for the bride in traditional Norwegian celebrations included an elaborate *kranse*, or crown, symbolizing virginity, a belt with streamers indicating her new marital status and many silver brooches covered with spoon-like dangles. As a rule, the bride had finer jewelry than anyone in the land and in certain areas of Norway, the jewelry and the dress would only be worn on her wedding day. The bridal costume generally consisted of a red skirt, a white linen or cotton apron with white embroidery, a black jacket (in the Hardanger region, there was beadwork on the front), and a white shirt with either white or colored embroidery, depending on locality. The original design of a woman's *bunader* allowed for necessary alterations which would enable the dress to be worn throughout a

lifetime. First worn by a young girl for her church confirmation, the sturdy costume could be let out or taken in and used thereafter for special occasions such as baptisms, confirmations, Christmas and weddings. Many of the costumes featured Hardanger, the cutwork

confused by reflective objects. In the early 1800s, silver was considered magical and it symbolized family and ancestors. Superstitions held that silver pieces which were handed down carried family spirits and became spiritually more valuable.

would wear as a married woman. At the appropriate time, the bride changed from her red skirt dress into what became her best clothes. The matron in honor dressed like the bride with the exception that she wore the headdress of a married woman and the bride's maid donned her finest church-going clothes. The wedding ceremony and the celebration constituted their own strict rules and a group of specially appointed officials ensured that everything happened correctly and at the right time.

Traditionally festive Norwegian costumes were the clothes of choice at this 1935 wedding of Gabriel and Margaret Bjornes at the Mendekirken church in Minneapolis, Minnesota. The bride's costume, a copy of a wedding dress from Hardanger, Norway features the cutwork embroidery of the same name.

embroidery technique that prospered in Norway and was originally worked by white linen thread on white linen fabric. Handcovering, a tradition dating back to the Roman Catholic period, delegated that the bride cover her hands during the wedding ceremony using a white piece of linen having white or black stitches.

Metal played a significant role in the bridal dress. Not only did the pendants and brooches serve decorative purposes, they also provided protection from evil spirits who were believed to be easily

The bridal jewelry included a pendant which might be a medal with an ornamental motif from the Bible such as God's lamb, or Norwegian coins, perhaps even a locket with a filigree rose. Also worn was a belt with decorative square metal plates, either brass or silver, attached to a belt of red fabric.

Only on the actual wedding day were the bridal headdress and costume worn. One of the most meaningful parts of the celebration was the bride's change from the bridal headdress to the one she

After setting the wedding date, the prospective groom, or a specially appointed *bedemann* (inviting man) went out to extend an invitation to all relatives of both bride and groom. Included among the invited guests were those who lived in a clearly defined area called the *bearlage* (inviting circle). And everyone invited contributed to the food for the wedding celebration. June, October and November were popular months for weddings, since during these times farming required less effort. Good traveling conditions and favorable weather meant that many guests could be conveniently transported and housed for the celebration.

On the day of the wedding, friends and family were greeted at the farm by the master of ceremonies and served food before setting out for the church. The wedding procession traditionally included the bridal couple preceded by outriders, fiddlers and a person with a brandy keg ready to quench the thirst of any person. After the bride and groom came the groom's parents, the bride's parents, close

relatives, distant relatives, friends, then neighbors. Since the journey to the church could cross land and water, decorated boats and carriages insured passage across both. Once the bridal procession entered the church, bride and groom seated themselves for the ceremony in wedding chairs at the front.

Back at the farm for the first of the festivities, the guests were greeted at the door by the official hostess, the *mor i buret*. Both she and the *kjogemester* (master of ceremonies) worked together in placing people at the appropriate seats by the table, keeping the crowd entertained, fed and under control.

The organized church, which was taken for granted in the Old Country, did not exist in America. Faced with the planning and organization required to build their own congregations, the immigrants set out to find the right pastors and teachers to instruct their children in religion. The Norwegians brought with them a compelling need for ordained ministers to perform religious services, but until the establishment of a new clergy was possible, marriage, for example, was performed by a lay preacher or justice of the peace.

When Norwegians, after practicing their wedding traditions for hundreds of years, migrated to America in search of fertile farmland and better lives, they witnessed the evolution of their own new and unique Norwegian-American culture. The festive costumes so much a part of their heritage had been left behind for

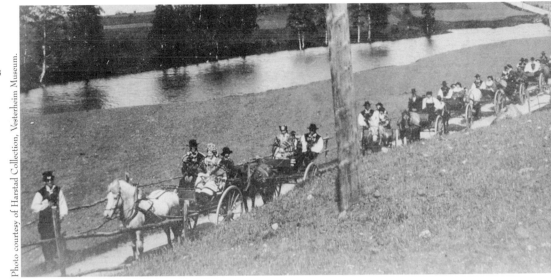

Pictured in this photograph from about 1900 are the 18 carriages of the Olav M. Harstad wedding procession in Setesdal, Norway. Seated in the first carriage are the bride and groom.

the journey and if brought, were sold or simply not worn. A written passage from the journal of a traveler in the 1860s explained that many heirlooms were sold to secure passage money for America.

The majority of wedding photographs from the early immigrants demonstrates the move towards exclusively wearing American fashions. While black and white pictures show no evidence as to what colors were worn, green appears frequently in written references to wedding attire and in many surviving examples of fashions worn by the Norwegian-Americans. Before 1900, only the wealthy could afford an impractical white dress which would be used only once. So uncommon were white wedding gowns that when the first one was worn in Stevens Point, Wisconsin in 1883, the entire town came out to see the bride. A local newspaper reported in detail the event, including a list of gifts received. The bride was the

daughter of Norwegian immigrants and she married an immigrant from Norway who had become a successful businessman.

Beginning in the 1870s, photos began to show bodice details and belt streamers reminiscient of Norwegian folk weddings. Floral wreaths became popular (replacing the traditional crown or headdress) and were used with and without veils. Another look into the Oleson family memoirs presents a fine example of the mingling of New and Old World traditions. While no elaborate costumes were worn, the festivities described could have easily taken place on the fjords of Norway.

"A bride in those days (1880s) did not wear a veil. She would have a wreath of artificial flowers around her head, which matched the groom's buttonhole bouquet. His trousers would fit very tight, and the coat would probably have one button and be cut away in front. The bride's

dress would be of worsted (wool), since all weddings were in fall, winter or early spring. People were too busy in summer to fool around with celebrations. The presents were rather simple, like a pretty picture, a bedspread, a set of six water glasses and a pitcher to match. Some gave a little money, usually a dollar, and some a pretty dish.

The wedding supper was served some time after the couple came back from the church with all the guests. At the Johnson wedding, the table was set for fourteen to fifteen people. When it came time to eat, the bride and groom were seated first, then their attendants, then the minister and his wife, then the parents and closest relatives, until the first table was full. After they had eaten, it did not matter how many tables we had to set. Usually pretty young girls acted as waitresses.

After everyone was full and satisfied, the young folks would begin to look at each other, saying with their eyes, "Oh I wish that minister would hurry up and go home so we can dance!" As a rule, he did not stay very late, and no sooner had he gone than the fiddler would go out and get his fiddle from his buggy or cutter, and sit down in the room where they were to dance. We could hardly wait until he could tune up his violin and begin the square dance, which was the custom as the first dance at a wedding. The bridal couple, attendants, sister of the groom and brother of the bride would make the first set. The dance would last

until two or three o'clock in the morning, when the guests would begin to leave. There were no wedding trips in those days.

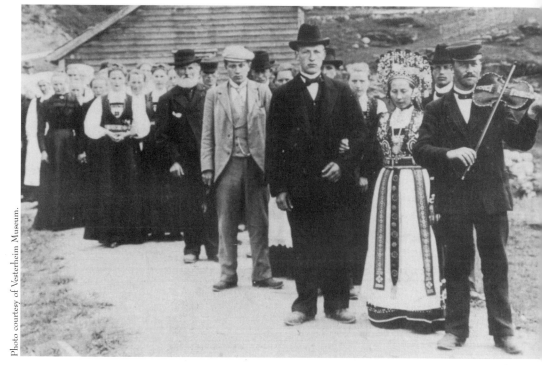

This wedding procession in Hardanger, Norway is dated about 1900. The bride dons a traditional wedding costume complete with crown, pendant, brooch and a belt with streamers attached.

The bride and groom would stay in her mother's house the first night and move to their new home the next day, or as soon as their new place was ready to start housekeeping. Those that had to move far off with their new husbands would stay at home a few days after the wedding before they said the sad farewell."

After the turn of the century, fashion simplified and sewing became an easier and less expensive way of dressing for one's wedding. Wearing a white dress also became much more plausible for middle and working class brides. The immigrant women brought to

America their skills in decorating festive costumes and the making of everyday clothing and household linens. Combining these skills brought new colors, fabrics, ideas and techniques to the textiles of the New World. A needleworker often was forced to make due with available materials. This improvisation, combined with influences from other embroidery techniques, helped turn the Old World style into the New World adaptations on present display at many American Nordic museums like the Vesterheim Norwegian-American Museum in Decorah, Iowa.

Each new decade brought with it a change in styles. Dresses rose from the ankle length skirts of the early 1920s to an uneven hemline (short in front, long in back) in the

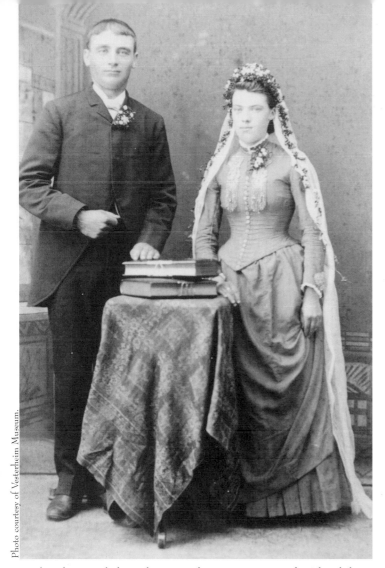

Photo courtesy of Vesterheim Museum.

This photograph from the 1880s features Jorgen Menfostad with his wife in Spring Grove, Minnesota. By this time, floral wreaths had become popular (replacing the traditional crown) and were sometimes used with veils like the one the bride wears here.

late 1920s. The Great Depression in the 1930s did not allow for many formal weddings, so practicality came into play once again. Wartime, 1940s, also saw the use of more practical wedding garments, but by the 1950s, brides had made their way back into formal gowns. The 1960s and 1970s served as years of economic and societal changes and many young people rejected the traditional wedding wear and instead chose to wear the unusual. Individuality had become more acceptable and after many years of conformity, Norwegian-Americans turned to celebrating their heritage once again. In 1980, a wedding in Larson, Wisconsin featured a bride commemorating her Norwegian ancestry by donning an authentic, embroidered West Telemark *bunader* while the groom wore a jacket and kilt similar to those of his own Scottish forebears.

In a theme common to many immigrant experiences, the Norwegian-Americans learned about making difficult selections, having to abandon much and bring little. Some traditions were maintained and others changed. The wedding customs and traditions of long ago have gained a new appreciation and the grandchildren and great-grandchildren of the pioneers are helping to revive the ties to their original homeland, Norway. And it is through the illuminating collections of needlework, clothing, photographs and words that the Norwegian experience can be better defined and shared by us all.

References
Dardis, Joan Pavel. "Vesterheim—The Norwegian-American Museum." Treasures in Needlework (Summer 1993)
Gesme, Ann Urness. Between Rocks and Hard Places. Cedar Rapids: Gesme Enterprises, 1993.
Lenthe, Sue. "Vesterheim Norwegian-American Museum." Piecework (May/June 1995)
Neilsen, Rebecca. "Baubles, Bangles and Bunads: An Interview with Norwegian Silversmith Hilde Nodtvedt." Sons of Norway Viking (September 1989)
Noss, Aagot. Lad og Krone: Fra Jente til Brur. Oslo: Universitesforlage, 1991.
Williams, Patricia. "New World Brides." Sons of Norway Viking (June 1993)
Xan, Erna Oleson. Wisconsin My Home. Madison: University of Wisconsin, 1952.

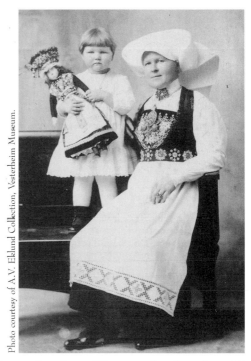

Photo courtesy of A.V. Eklund Collection, Vesterheim Museum.

Taken in Stoughton, Wisconsin, this photo from 1915 features Marie Maurseth Egge in a traditional Hardanger costume with her daughter Helen (aged 2). Helen holds a doll dressed as a bride from Hardanger, Norway.

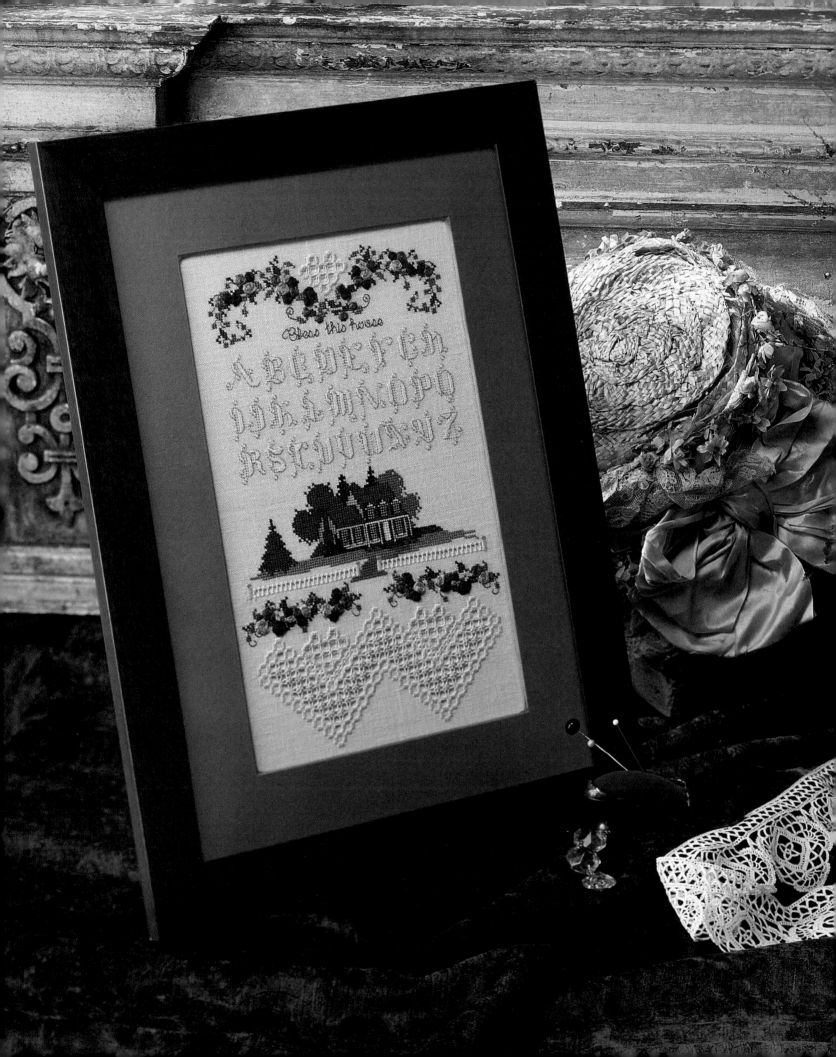

YOUR
HOME

BLESS
THIS HOUSE

DESIGN 116W X 191H
28 count 8.28 X 13.64, cut fabric 14" X 20"
32 count 7.25 X 11.93, cut fabric 13" X 18"
The model was stitched on 32 count Antique White Belfast Linen from Zweigart®.

ADDITIONAL MATERIALS
DMC Ecru Pearl Cotton, sizes #8 and #12
YLI 4mm. silk ribbon in colors 157 Lt. Mauve, 158 Md. Mauve and 159 Dk. Mauve. The color of ribbon used for flowers is indicated within the circle symbol on the chart.
DMC floss

♦	632	Brick Red
s	407	Md. Brick Red
o	928	Pale Blue
–	3047	Pale Yellow
II	3046	Lt. Yellow
·		White
8	223	Lt. Pink
♥	3802	Burgundy
/	3053	Lt. Green
V	3052	Md. Green
x	3051	Dk. Green
■	935	Very Dk. Green
●	645	Md. Gray
✱	844	Dk. Gray
ss	822	Lt. Tan
bs	644	Md. Tan

DESIGN NOTES
1. Each square on the chart represents two fabric threads.
2. This design employs a variety of needlework techniques including Cross Stitch, Backstitch, Satin, Queen, Four-sided, Ladder Hemstitch, Kloster, Corner Dove's Eye, Connected Wrapped Bars with Bullion centers.
3. The alphabet may be used to personalize any of the other designs in this book.

INSTRUCTIONS
1. Complete all Cross Stitches using two strands of floss over two fabric threads.
2. All vines are Backstitched using two strands of 3052 Md. Green. "Bless This House" is Backstitched using a single strand of 3051 Dk. Green. Use one strand of 3046 Lt. Yellow for the Queen stitch lamp posts. Use a single strand of 844 Dk. Gray to Backstitch (bs) around the windows and house.
3. The Alphabet is worked as follows: Use two strands of 822 Lt. Tan to Satin Stitch (ss) the center of each letter. Use a single strand of #644 Md. Tan to Backstitch (bs) each letter.
4. Complete the lamp posts and the Klosters using #8 DMC Ecru Pearl Cotton. Cut and remove the four horizontal fabric threads between each set of lamp posts. Using #12 DMC Ecru Pearl Cotton, work the vertical fabric threads in a Ladder Hemstitch.
5. Using #12 DMC Ecru Pearl Cotton, complete the Four-sided stitch between the hearts and the Hardanger border.
6. Cut and withdraw the marked fabric threads in each of the three hearts. Use #12 DMC Ecru Pearl Cotton to work the inner Hardanger area in Wrapped Bars and Corner Dove's Eyes.
7. Cut and withdraw the marked fabric threads in the bottom Hardanger area. Use #12 DMC Ecru Pearl Cotton to work the inner Hardanger area in Connected Wrapped Bars with Bullion centers.
8. After all stitching is complete, clean and press the fabric. Complete the Ribbon Embroidery flowers in Stem Stitch roses. Begin each flower with a French Knot center then work a Stem Stitch as you work toward the outside of the flower. Allow the ribbon to twist and turn.

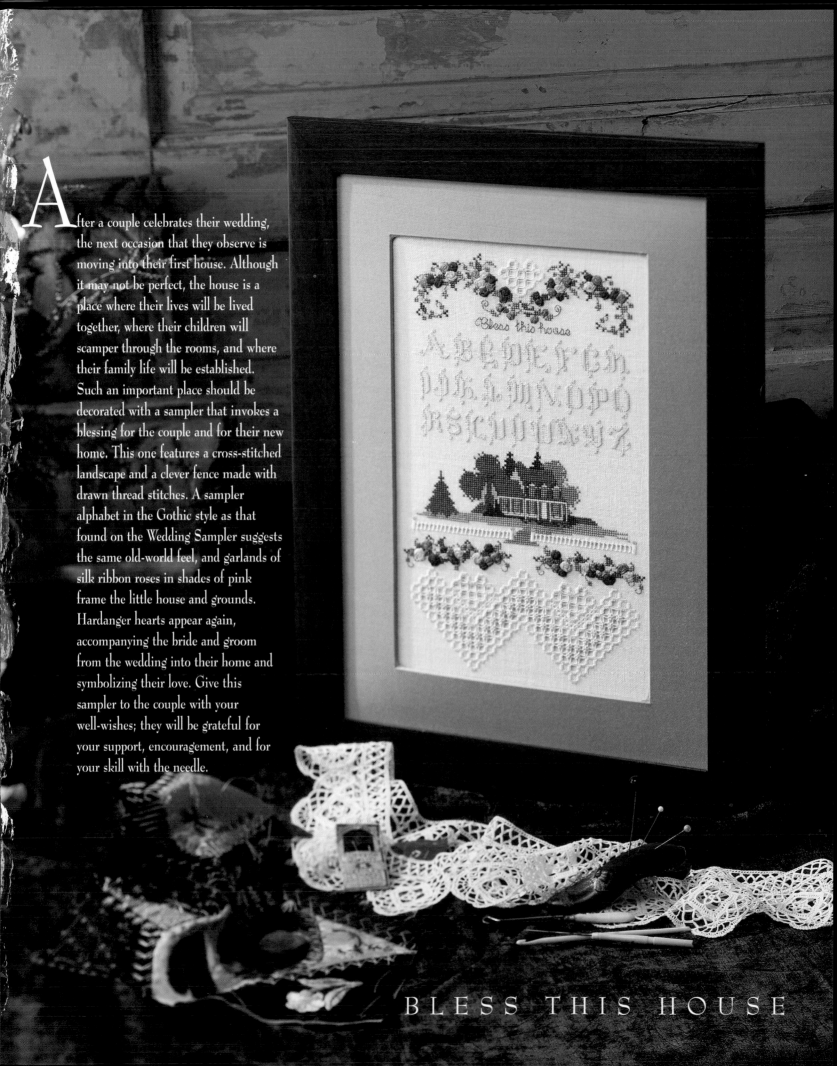

After a couple celebrates their wedding, the next occasion that they observe is moving into their first house. Although it may not be perfect, the house is a place where their lives will be lived together, where their children will scamper through the rooms, and where their family life will be established. Such an important place should be decorated with a sampler that invokes a blessing for the couple and for their new home. This one features a cross-stitched landscape and a clever fence made with drawn thread stitches. A sampler alphabet in the Gothic style as that found on the Wedding Sampler suggests the same old-world feel, and garlands of silk ribbon roses in shades of pink frame the little house and grounds. Hardanger hearts appear again, accompanying the bride and groom from the wedding into their home and symbolizing their love. Give this sampler to the couple with your well-wishes; they will be grateful for your support, encouragement, and for your skill with the needle.

BLESS THIS HOUSE

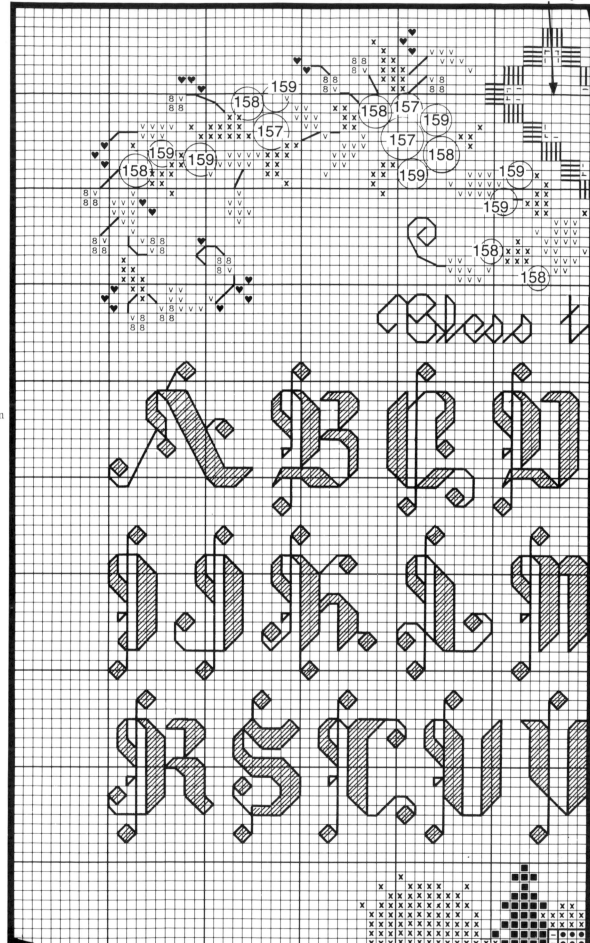

♦	632 Brick Red
s	407 Md. Brick Red
o	928 Pale Blue
−	3047 Pale Yellow
‖	3046 Lt. Yellow
•	White
8	223 Lt. Pink
♥	3802 Burgundy
/	3053 Lt. Green
V	3052 Md. Green
x	3051 Dk. Green
■	935 Very Dk. Green
●	645 Md. Gray
✦	844 Dk. Gray
ss	822 Lt. Tan
bs	644 Md. Tan

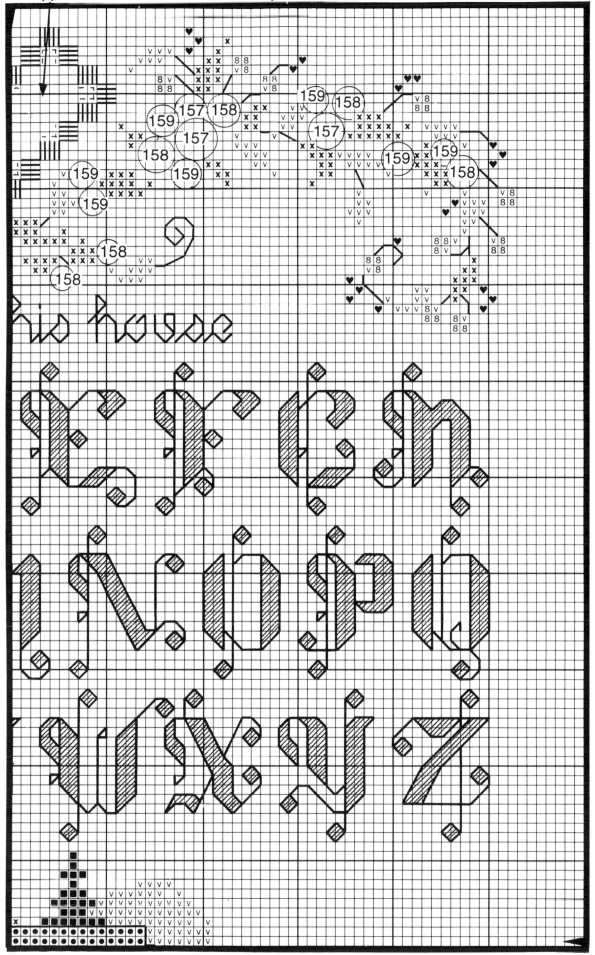

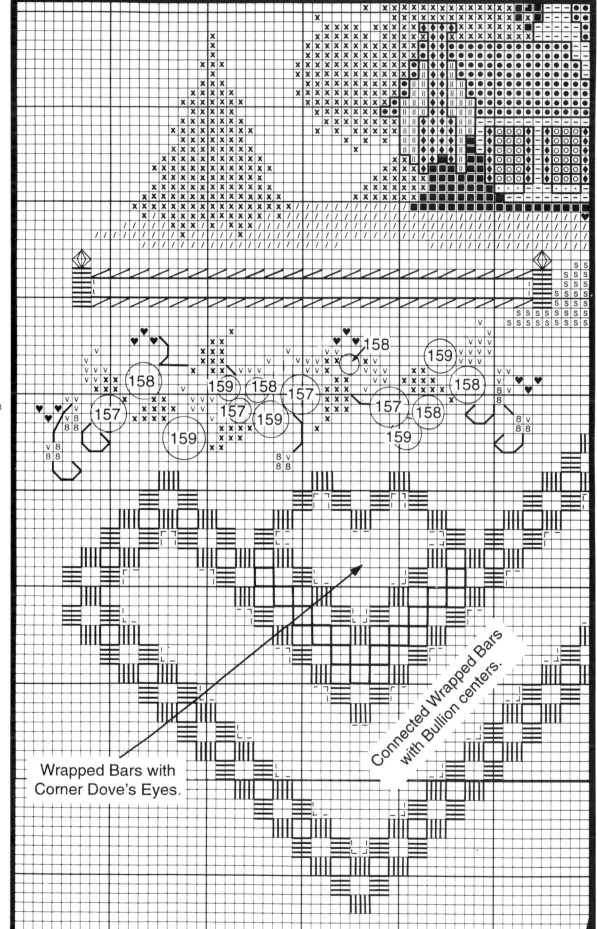

◆ 632 Brick Red
ѕ 407 Md. Brick Red
○ 928 Pale Blue
— 3047 Pale Yellow
‖ 3046 Lt. Yellow
• White
8 223 Lt. Pink
♥ 3802 Burgundy
/ 3053 Lt. Green
V 3052 Md. Green
x 3051 Dk. Green
■ 935 Very Dk. Green
● 645 Md. Gray
✳ 844 Dk. Gray
ss 822 Lt. Tan
bs 644 Md. Tan

Wrapped Bars with
Corner Dove's Eyes.

Connected Wrapped Bars
with Bullion centers.

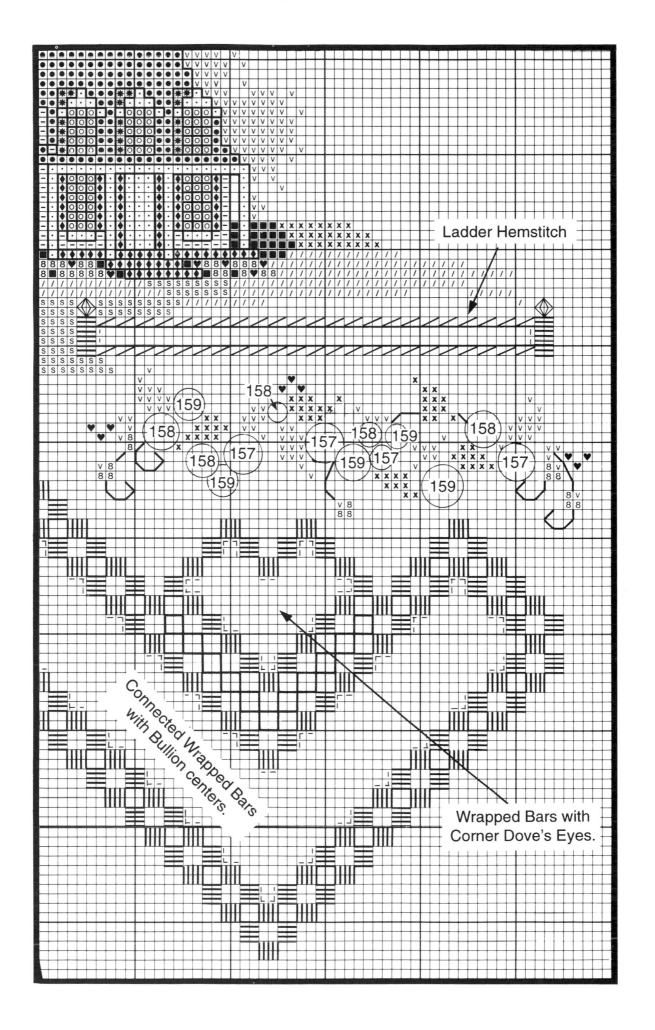

Ladder Hemstitch

Connected Wrapped Bars with Bullion centers.

Wrapped Bars with Corner Dove's Eyes.

BELLPULL

DESIGN 46W X 140H
28 count 3.29 X 10, cut fabric 9 X 19
32 count 2.88 X 8.75, cut fabric 8 X 16
The model was stitched on 32 count Vintage Linen from Wichelt Imports, Inc.

ADDITIONAL MATERIALS
DMC Ecru Pearl Cotton, sizes #8 and #12
Caron Collection Wildflowers™, Rose Quartz
4 Mother of Pearl Hearts (BDS2222) from Access Commodities (indicated on chart by the symbol ✳)
Nordic Needle brass heart
Wood'N Accents 4" opening bellpull.
DMC floss

o	223	Md. Mauve
/	224	Lt. Mauve
x	644	Tan
•	3051	Dk. Green
»	3052	Md. Green
–	3053	Lt. Green
♥	3721	Md. Dk. Mauve

DESIGN NOTES
1. Each square on the chart represents two fabric threads.
2. This design uses a variety of needlework techniques including Cross Stitch, Satin, Four-sided, Mosaic, Kloster, Woven Bar, Dove's Eye, Withdrawing and Re-weaving, Old-Fashioned Hemstitch and Interlace.
3. The chart for this design shows the area that is to be stitched. The suggested fabric length allows for extra fabric above the stitched area for the placement of the brass heart.

INSTRUCTIONS
1. Complete all Cross Stitches using two strands of floss.
2. Complete all Klosters and the Mosaic stitch using one strand of Caron Collection Wildflowers™, Rose Quartz.
3. Use #8 DMC Ecru Pearl Cotton for the Four-sided stitches and for the Satin Stitch tulips at the top of the design.
4. Complete the Interlace stitch areas (above and below) "Welcome" as follows:
 a. Cut and withdraw the 1st and 3rd horizontal fabric threads at the center of the design.
 b. Cut the 2nd and 4th horizontal fabric threads at the center also. Withdraw each cut thread to the edge of the design. Re-weave the 2nd thread into the place formerly occupied by the 1st thread. Re-weave the 4th thread into the place formerly occupied by the 3rd thread.
 c. Weave #12 DMC Ecru Pearl Cotton into the side of the fabric where the threads have been re-woven. Work an Interlace stitch along the remaining vertical fabric threads.
5. Cut and remove the marked fabric threads of the Hardanger areas. Using #12 DMC Ecru Pearl Cotton, complete the Hardanger pattern of Woven Bars with a Dove's Eye in the center square.
6. Finish both sides as follows:
 a. Completely remove the two marked vertical fabric threads.
 b. Count 20 threads out from the withdrawn vertical fabric threads. Crease to the back. Count 20 threads from the first crease and again crease the fabric to the back. Cut the excess fabric away 4 fabric threads from the second crease.
 c. Using #12 DMC Ecru Pearl Cotton and working from the front, complete the Old-Fashioned Hemstitch. Gather two fabric threads together and stitch two fabric threads deep, catching a thread of the turned back hem.
7. Attach brass heart where indicated near top of chart.
8. Make a pocket for the bellpull rods by creasing the fabric back 1" above the heart and also 3/4" below the lower Hardanger area. Crease 1/2" back from the first creases. Allow a 1/4" hem and trim away the excess fabric. Slip stitch in place.

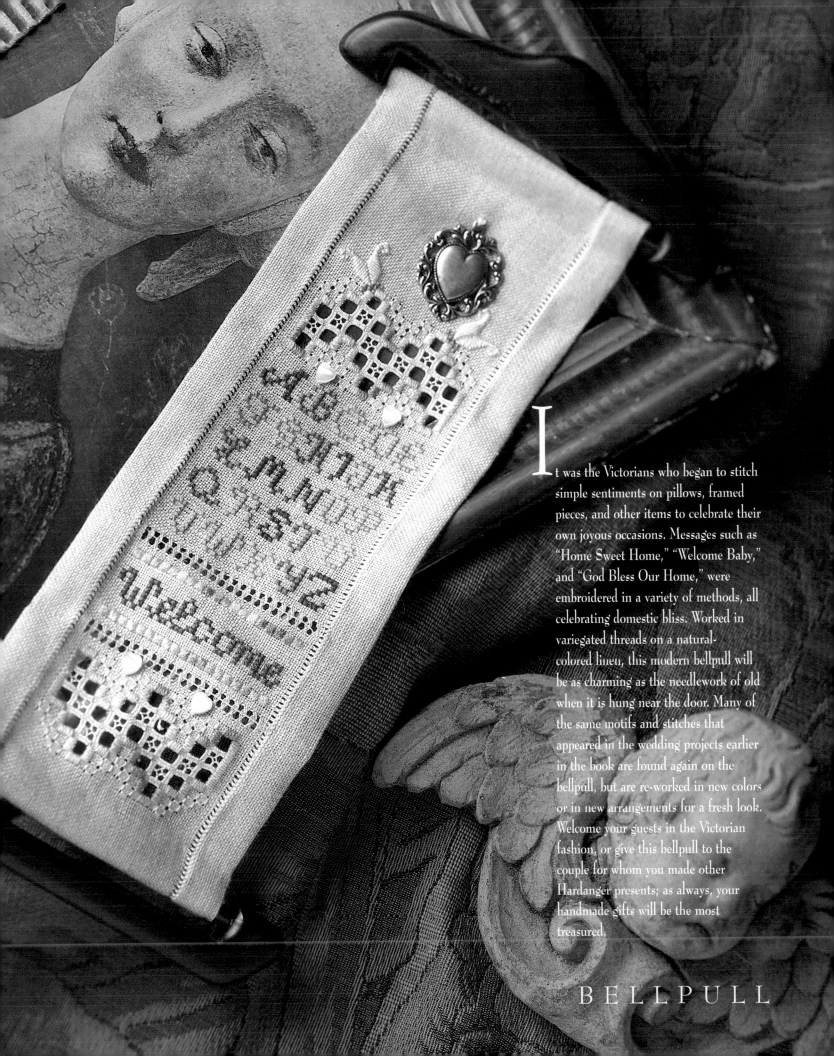

It was the Victorians who began to stitch simple sentiments on pillows, framed pieces, and other items to celebrate their own joyous occasions. Messages such as "Home Sweet Home," "Welcome Baby," and "God Bless Our Home," were embroidered in a variety of methods, all celebrating domestic bliss. Worked in variegated threads on a natural-colored linen, this modern bellpull will be as charming as the needlework of old when it is hung near the door. Many of the same motifs and stitches that appeared in the wedding projects earlier in the book are found again on the bellpull, but are re-worked in new colors or in new arrangements for a fresh look. Welcome your guests in the Victorian fashion, or give this bellpull to the couple for whom you made other Hardanger presents; as always, your handmade gifts will be the most treasured.

BELLPULL

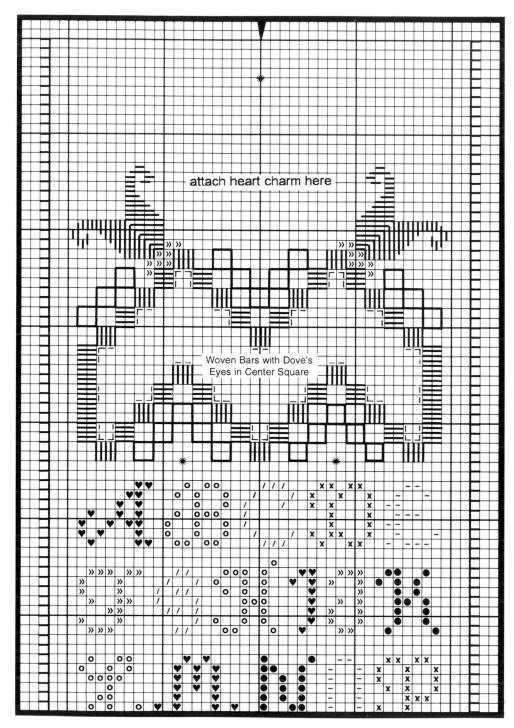

attach heart charm here

Woven Bars with Dove's
Eyes in Center Square

o	223	Md. Mauve
/	224	Lt. Mauve
x	644	Tan
●	3051	Dk. Green
»	3052	Md. Green
–	3053	Lt. Green
♥	3721	Md. Dk. Mauve

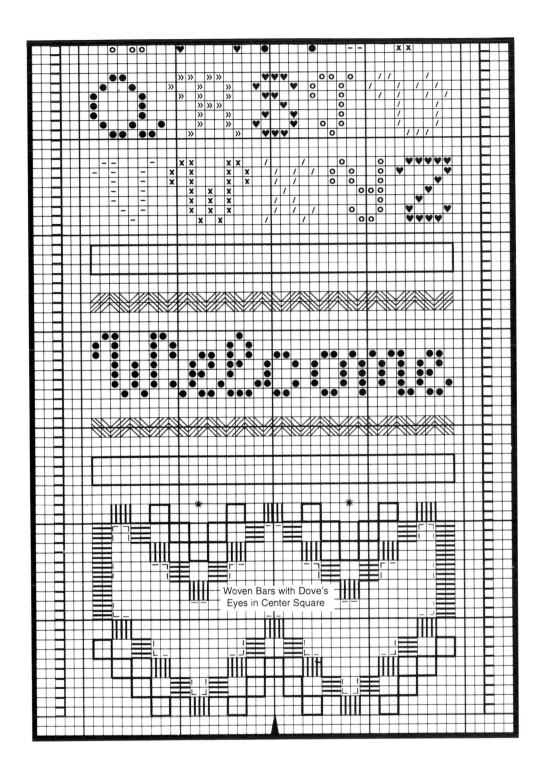

Woven Bars with Dove's
Eyes in Center Square

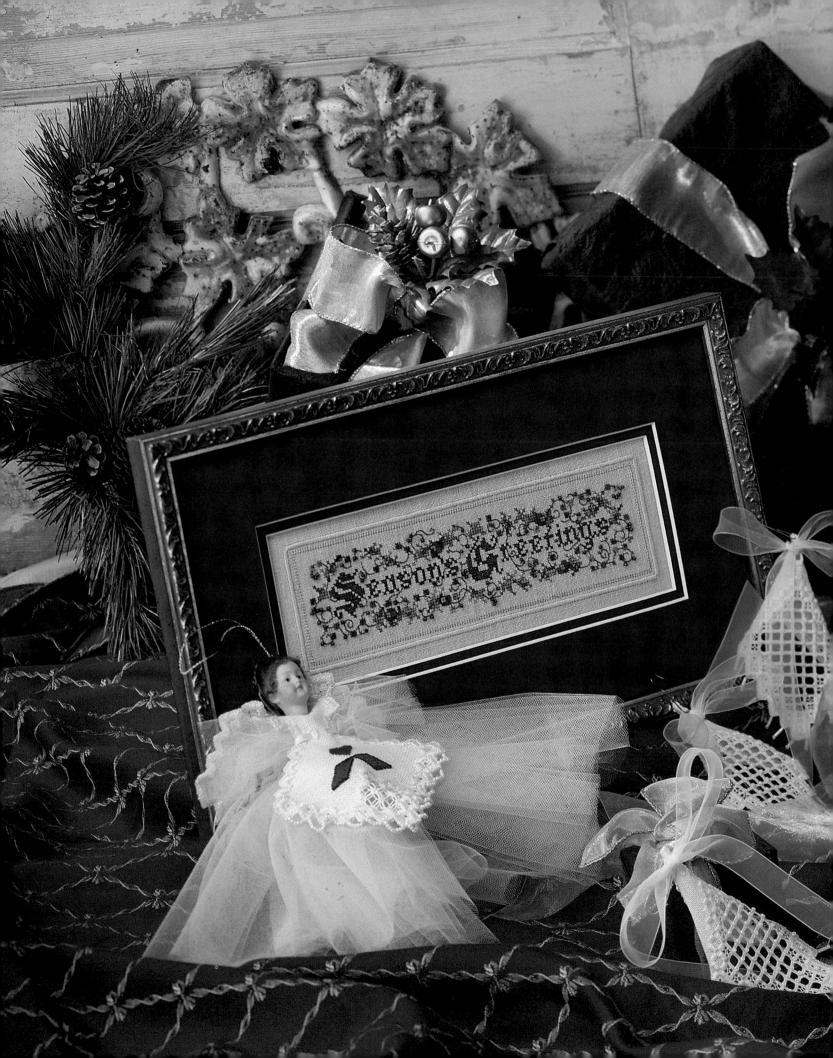

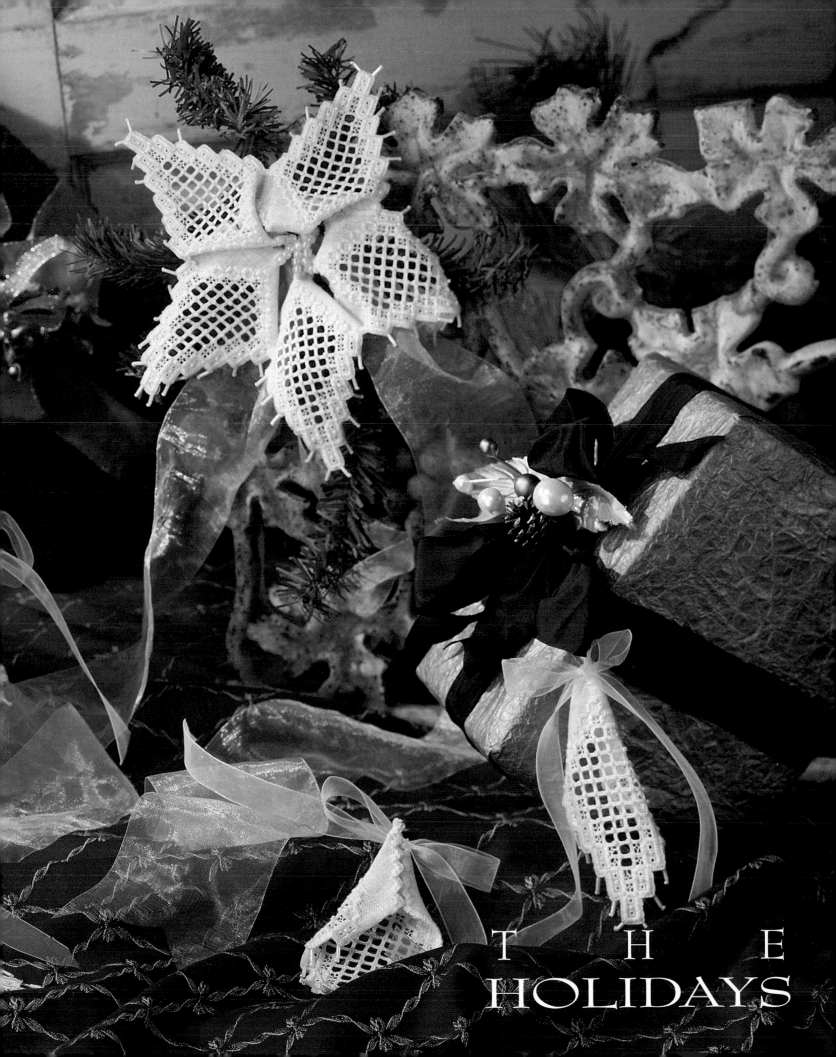

THE
HOLIDAYS

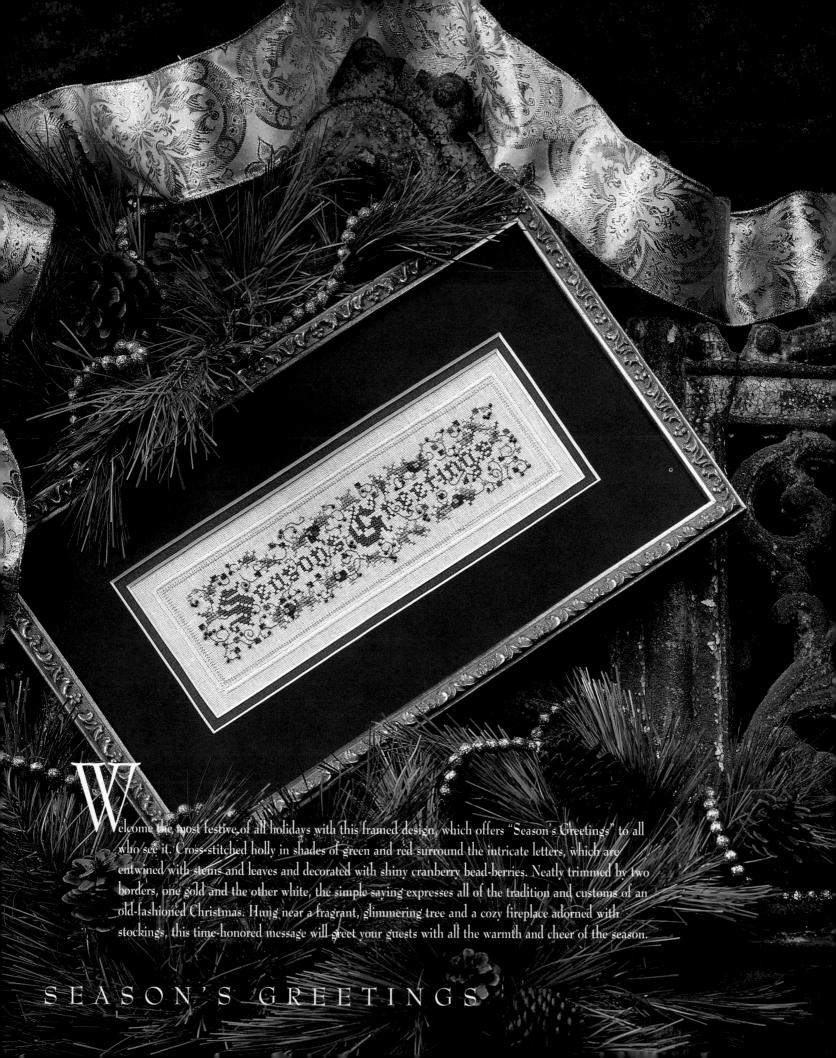

elcome the most festive of all holidays with this framed design, which offers "Season's Greetings" to all who see it. Cross-stitched holly in shades of green and red surround the intricate letters, which are entwined with stems and leaves and decorated with shiny cranberry bead-berries. Neatly trimmed by two borders, one gold and the other white, the simple saying expresses all of the tradition and customs of an old-fashioned Christmas. Hung near a fragrant, glimmering tree and a cozy fireplace adorned with stockings, this time-honored message will greet your guests with all the warmth and cheer of the season.

SEASON'S GREETINGS

SEASON'S GREETINGS

DESIGN 45H X 144W
28 count 10.28 X 3.21, cut fabric 16 X 9
32 count 9 X 2.81, cut fabric 15 X 8
The model was stitched on 32 count Cream Belfast Linen from Zweigart®.

ADDITIONAL MATERIALS
#8 DMC Ecru Pearl Cotton
Kreinik #1 Japan Gold #002J
DMC floss

■	895	Dk. Green
x	3346	Md. Green
∧	3347	Lt. Green
u	498	Red
▼	815	Dk. Red
s	891	Lt. Red
o	894	Pink
●	#03003	Antique Cranberry Mill Hill Beads

DESIGN NOTES
1. Each square on the chart represents two fabric threads.
2. This design employs a variety of needlework techniques including Backstitch, Cross Stitch, Satin, and Long Arm Cross.

INSTRUCTIONS
1. Complete all Cross Stitches using two strands of floss.
2. Backstitch all vines using two strands of 3346 Md. Green. Use a single strand of 815 to Backstitch around the berries.
3. Attach beads.
4. Using #8 DMC Ecru Pearl Cotton, complete the Satin Stitch border.
5. Using Kreinik #1 Japan Gold #002J, complete the inner Long Arm Cross border.

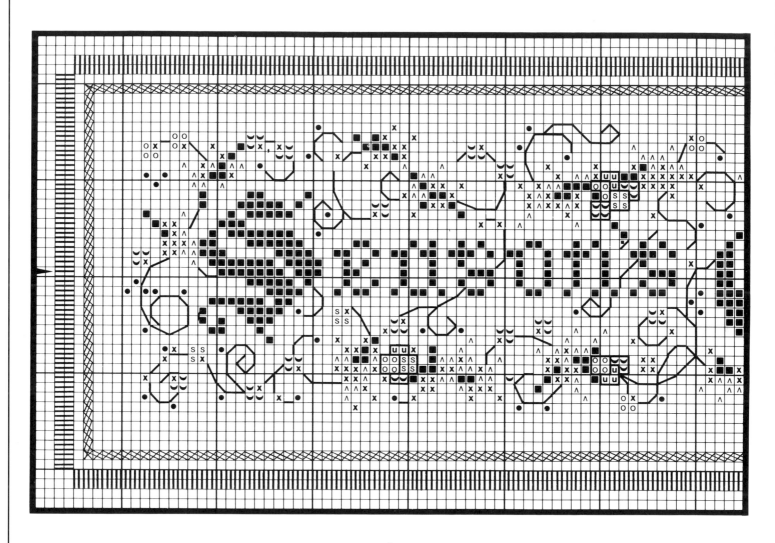

■	895 Dk. Green
x	3346 Md. Green
∧	3347 Lt. Green
u	498 Red
▼	815 Dk. Red
ѕ	891 Lt. Red
o	894 Pink
•	3003 Ant. Cranberry bead

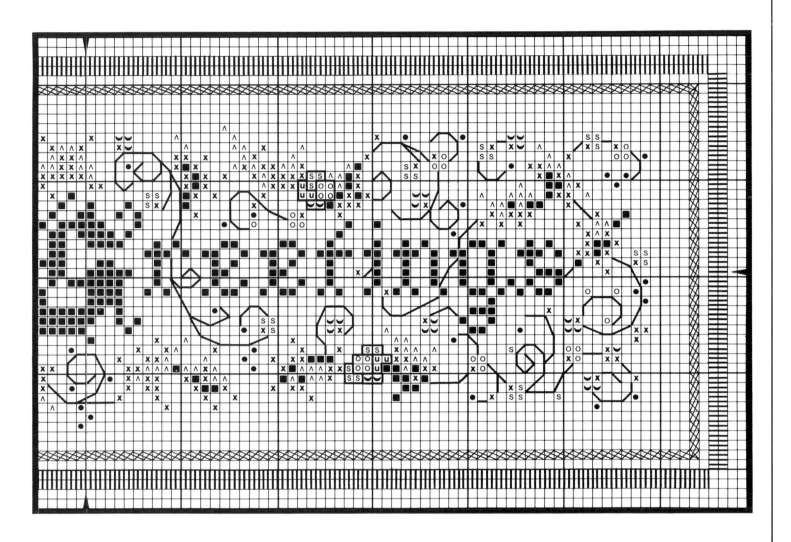

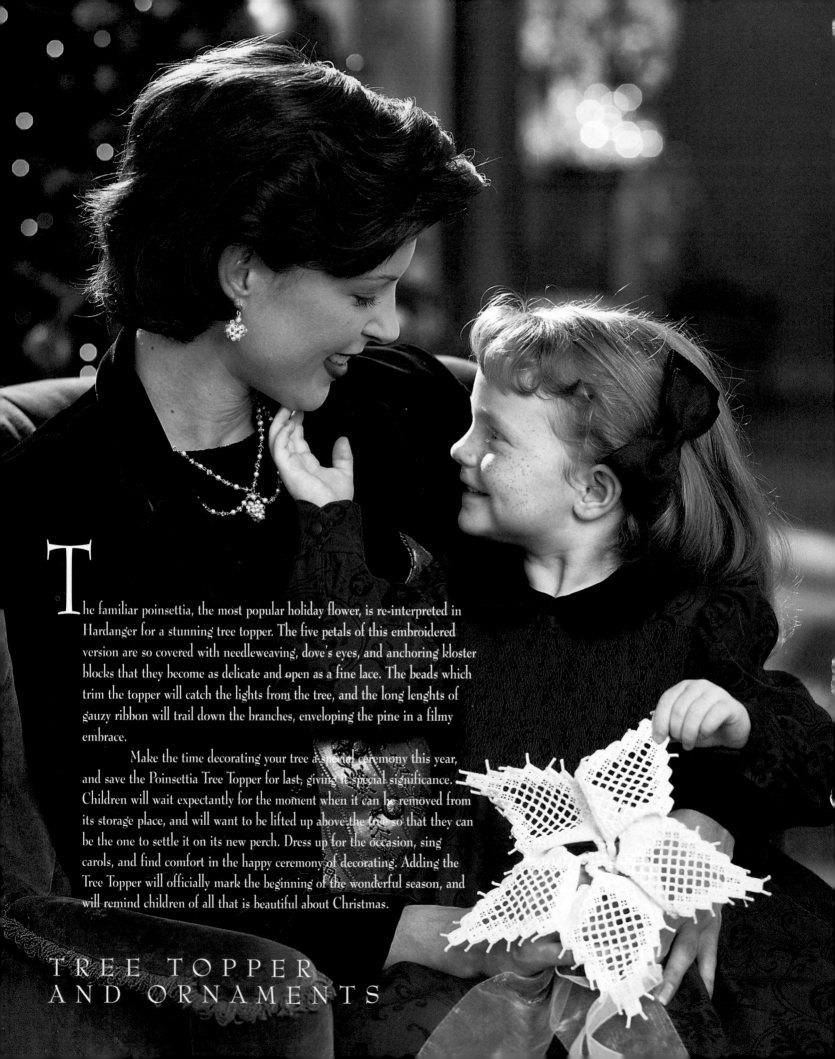

The familiar poinsettia, the most popular holiday flower, is re-interpreted in Hardanger for a stunning tree topper. The five petals of this embroidered version are so covered with needleweaving, dove's eyes, and anchoring kloster blocks that they become as delicate and open as a fine lace. The beads which trim the topper will catch the lights from the tree, and the long lenghts of gauzy ribbon will trail down the branches, enveloping the pine in a filmy embrace.

Make the time decorating your tree a special ceremony this year, and save the Poinsettia Tree Topper for last, giving it special significance. Children will wait expectantly for the moment when it can be removed from its storage place, and will want to be lifted up above the tree so that they can be the one to settle it on its new perch. Dress up for the occasion, sing carols, and find comfort in the happy ceremony of decorating. Adding the Tree Topper will officially mark the beginning of the wonderful season, and will remind children of all that is beautiful about Christmas.

TREE TOPPER
AND ORNAMENTS

TREE TOPPER
AND ORNAMENTS

DESIGN
Tree Topper: 86H X 244W
32 count 5.37 X 15.25, cut fabric 11 X 21
Single Ornament: 86H X 54W
32 count 5.37 X 3.37, cut fabric 11 X 9
The models were stitched on 32 count White Irish Linen from Charles Craft.

ADDITIONAL MATERIALS
For both projects:
White DMC Pearl Cotton, sizes #8 and #12.
Mill Hill Beads: White Seed Beads #00479 (● on chart), White Small Bugle Beads #70479 (bold dashes on chart)
In addition to these materials, the following items are necessary, depending on the project.
Tree Topper only:
One 11" X 21" piece of 32 count White Irish Linen from Charles Craft
Mill Hill Oriental Pearl Pebble Beads #05147 (represented by the ○ symbol on chart)
White covered wire, 30 gauge
2 yards White ribbon
Single Ornament only:
11" X 9" piece of 32 count White Irish Linen from Charles Craft
18" length of 1/2" white ribbon

DESIGN NOTES
The main chart shows the placement of each stitch and its relationship to the total design. Each square represents two fabric threads. Each tree top ornament has five sections. The chart shows two. All stitch illustrations also show the stitch worked over a single fabric thread.

INSTRUCTIONS
1. Complete all Kloster Blocks using DMC #8 White Pearl Cotton.
2. Complete the Buttonhole edge using DMC #8 White Pearl Cotton.
3. Use DMC #12 White Pearl Cotton to complete the Algerian Eye Stitch found between the Kloster Blocks and the Buttonhole edge.
4. Carefully cut and remove the marked fabric threads in the inner section of each point.
5. Complete the inner Hardanger pattern of Woven Bars and Dove's Eyes using DMC #12 White Pearl Cotton. Add Seed Beads #00479 at each intersection as you work the Hardanger pattern.
6. Carefully cut away the fabric on the outside of the Buttonhole edge.
7. Attach Mill Hill Seed Beads #00479 to the area near the Algerian Eye Stitches. Add Small Bugle Beads #70479 and Seed Beads #00479 to each point along the Buttonhole edge.
8. For Tree Topper only: Using an overcast stitch, attach the covered wire to the back of the Kloster Block/Buttonhole edge.

FINISHING INSTRUCTIONS:
Tree Topper
1. Join edge A to edge B.
2. Thread each point C onto a length of size #8 DMC White Pearl Cotton. Gather tightly and stitch firmly together.
3. Gather together the center of the 2 yard length of ribbon and attach to the back of the ornament. Use this ribbon to tie the Tree Topper to the top of the tree.
4. Add five large Pebble Beads #05147 to the center front of each point.
5. With the right side facing you, shape the ornament by straightening and pulling the wire on each point away from the center.
6. STAR OPTION: The Tree Topper may be shaped into a star. Follow steps one and two. From the back side join side D to side D.

Single Ornament:
Bring points A to G together. Tack. Thread the 18" length of ribbon through the hole between Kloster Blocks at top of ornament.

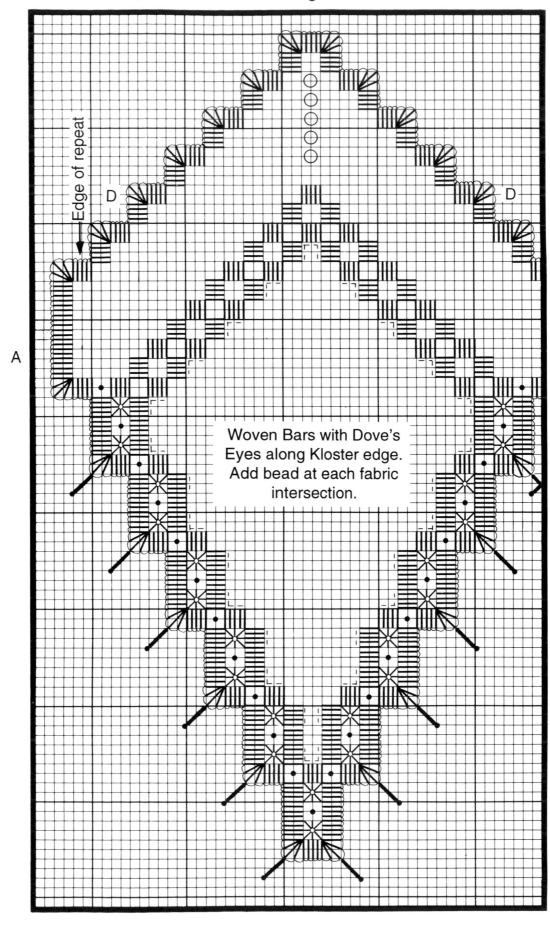

Woven Bars with Dove's Eyes along Kloster edge. Add bead at each fabric intersection.

C

D D

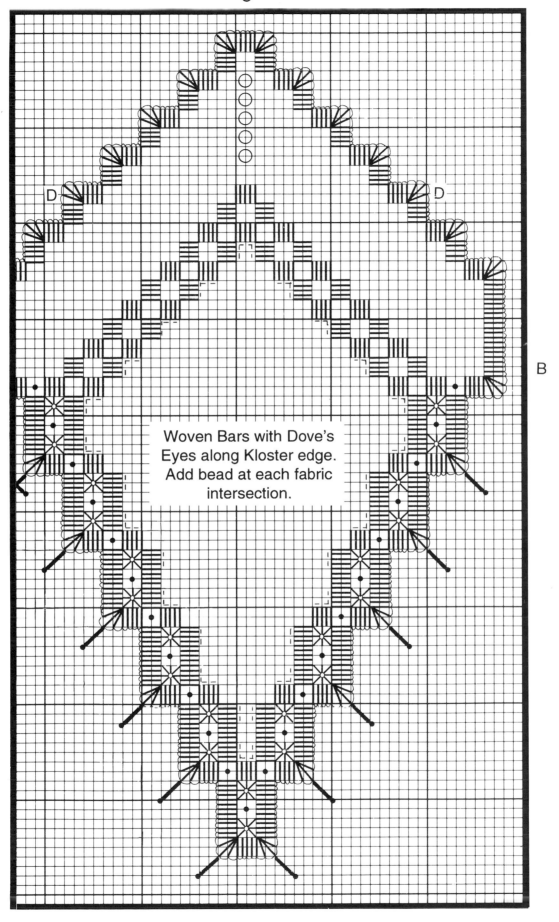

Woven Bars with Dove's
Eyes along Kloster edge.
Add bead at each fabric
intersection.

B

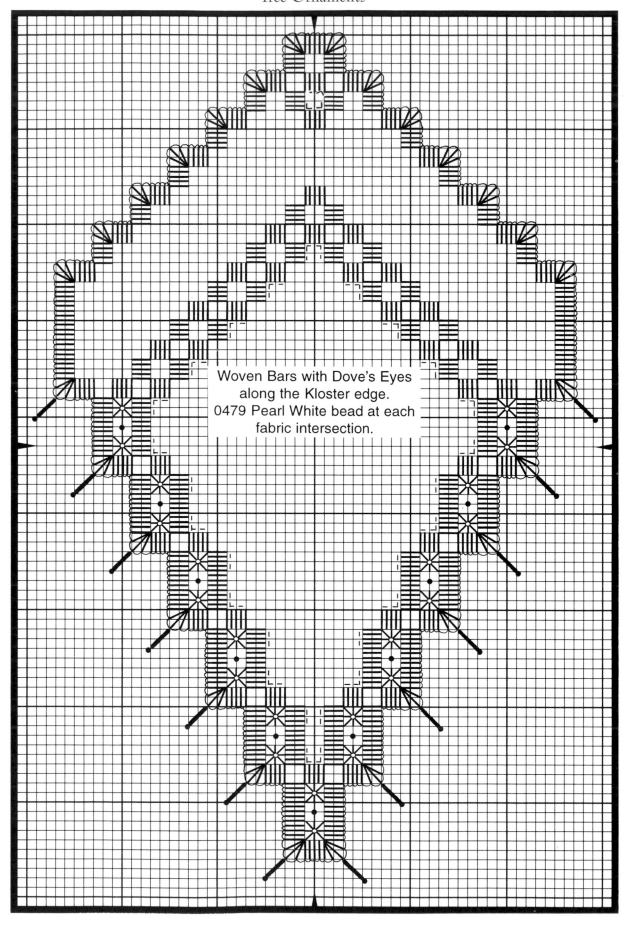

A

G

Woven Bars with Dove's Eyes
along the Kloster edge.
0479 Pearl White bead at each
fabric intersection.

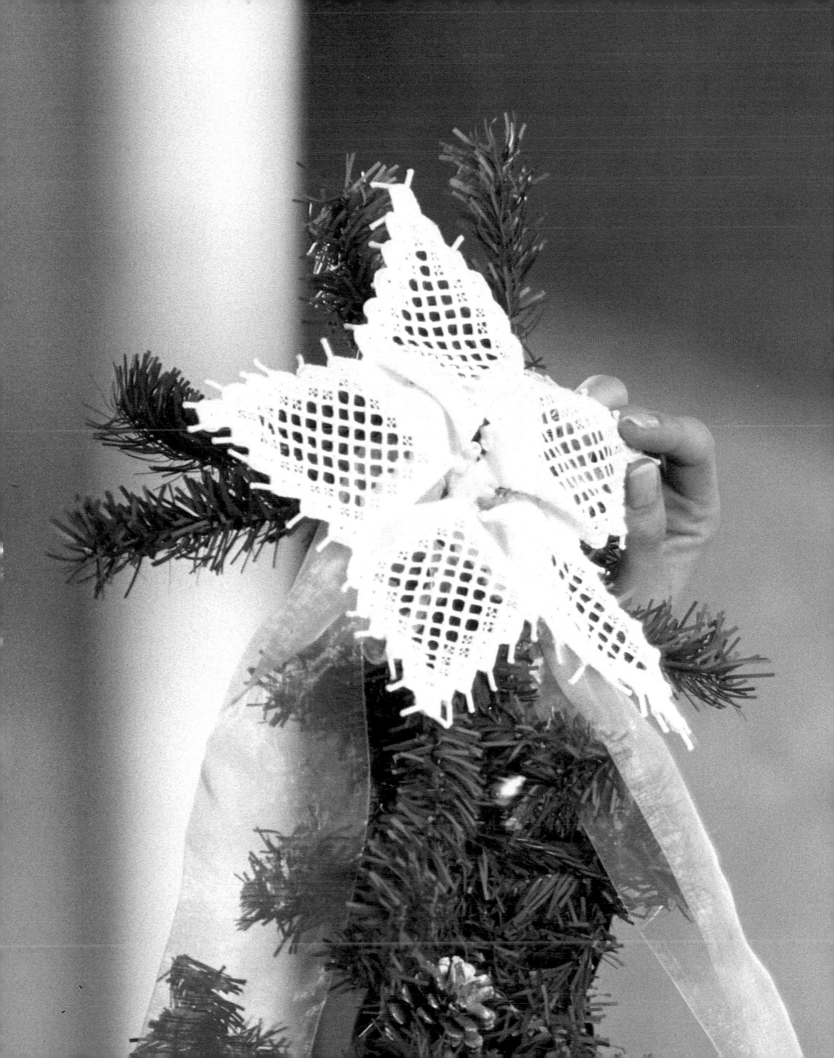

Angels are important beings to many people, who believe that they offer protection and guidance. They also play a special role in the Christmas story, announcing Christ's imminent arrival to Joseph and to Mary, and His birth to the shepherds. Because they are so essential to the Christian tradition, they often decorate Christmas trees alongside other religious ornaments. This ethereal angel features a tulle skirt and embroidered pinafore and wings. A bold cross-stitched motif in red and green accents the pale colors of the angel's gown and complexion, as she gazes intently from the decorated boughs. There is no doubt that the little ones in your house will make this ornament their favorite. Like a magical doll, the angel will be one they will want to play with as they help decorate the tree. Make one for each child in your household, and give them a guardian angel they can hang all by themselves.

CHRISTMAS ANGEL

CHRISTMAS ANGEL

DESIGN
Angel Dress: 54W X 126H
25 count 4.32 X 10.08, cut fabric 10 X 16
28 count 3.85 X 9, cut fabric 9 X 15
Angel Wings: 62W X 54H
25 count 4.96 X 4.32, cut fabric 11 X 10
28 count 4.42 X 3.85, cut fabric 10 X 9
The model was stitched on 25 count Cream Dublin Linen from Zweigart®.

ADDITIONAL MATERIALS
DMC Ecru Pearl Cotton, sizes #5 and #8
DMC Pearl Cotton, size #5: 498 Red and 890 Green
Medium porcelain angel head from Village Dolls and Miniatures
12" X 60" piece of cream tulle
1 1/2 yards double face cream satin ribbon
#00123 Cream Mill Hill Beads
Optional: 30 gauge covered wire

DESIGN NOTES
1. Each square on the chart represents two fabric threads.
2. This design uses a variety of needlework stitches including Satin, Algerian Eye, Buttonhole, Kloster, Wrapped Bar and Corner Dove's Eye.

INSTRUCTIONS
Angel Wings and Dress
1. Complete all Klosters and the Buttonhole edge using #5 DMC Ecru Pearl Cotton.
2. Use #8 DMC Ecru Pearl Cotton for the Algerian Eye stitches.
3. Use #5 DMC 498 Red Pearl Cotton for the Satin Stitch heart. Use #5 DMC 890 Green Pearl Cotton for the Satin Stitch leaves.
4. Cut and remove the marked fabric threads.
5. Use #8 DMC Ecru Pearl Cotton for the pattern of Wrapped Bars with Corner Dove's Eyes on the front of the skirt, Wrapped Bars on the back of the skirt, and Wrapped Bars on the wings.
6. Cut the fabric away from the Buttonhole Edge.
7. Attach a string of nine #00123 Cream Mill Hill Beads from the Buttonhole corner to corner along the front and back of the skirt.

FINISHING INSTRUCTIONS:
1. Sleeves: Cut a piece measuring 6" X 12" from the end of the 12" X 60" length of tulle. Using a long running stitch, gather tightly in the middle of the 12" length.
2. Skirt: Fold tulle in half along the length. Stitch a long running stitch along the fold. Gather tightly.
3. Optional: Stitch covered wire to the back of the Klosters and Buttonhole edge of the skirt.
4. Clip the 4 X 4 fabric threads of the neck opening. Clip the 2 X 4 fabric threads of the front and back waist openings.
5. Slip the ribbon (provided) attached to the angel head through the neck opening. Secure the head by running a straight pin through the metal loop (provided) and the back of the Klosters.
6. Fold dress in half. Slip the sleeves through the bodice. Tie the ribbon around the center of the sleeves.
7. Attach skirt to the ribbon that is tied around the center of the sleeves.
8. Fold the 1 1/2 yard length of ribbon in half. Lace through the waist openings of the front and the back. Slip the ends through the 4 X 4 fabric thread opening on the wing piece. Tie.

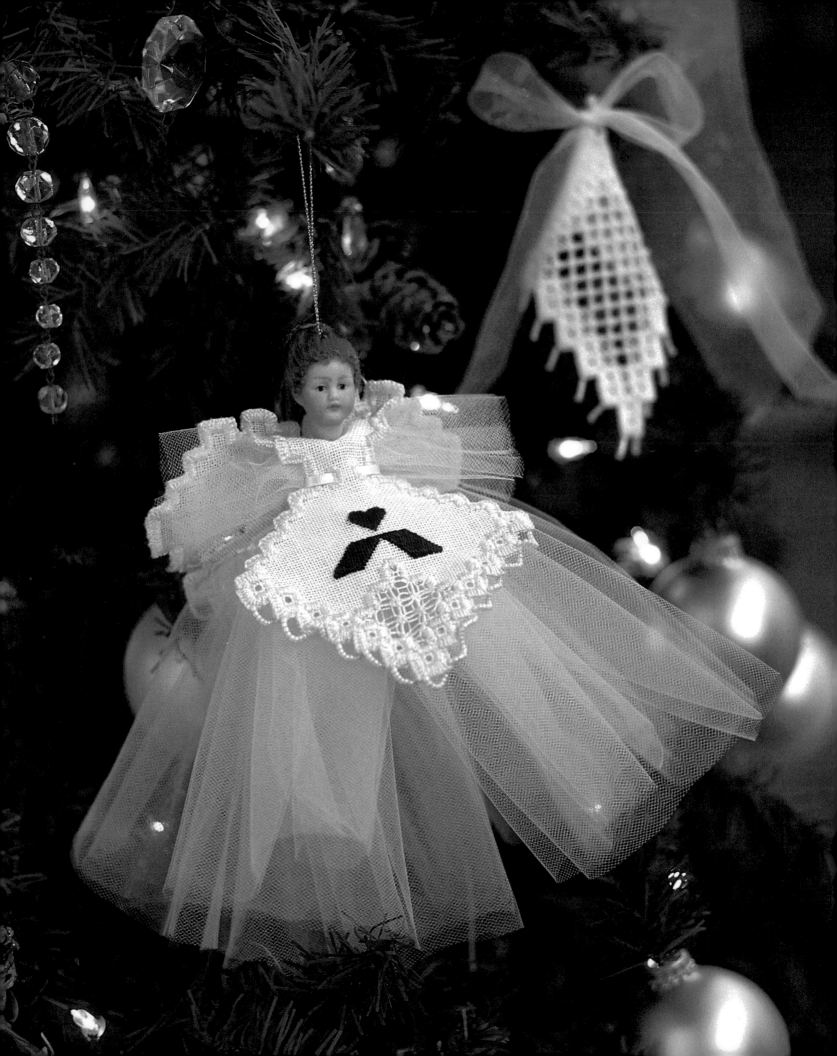

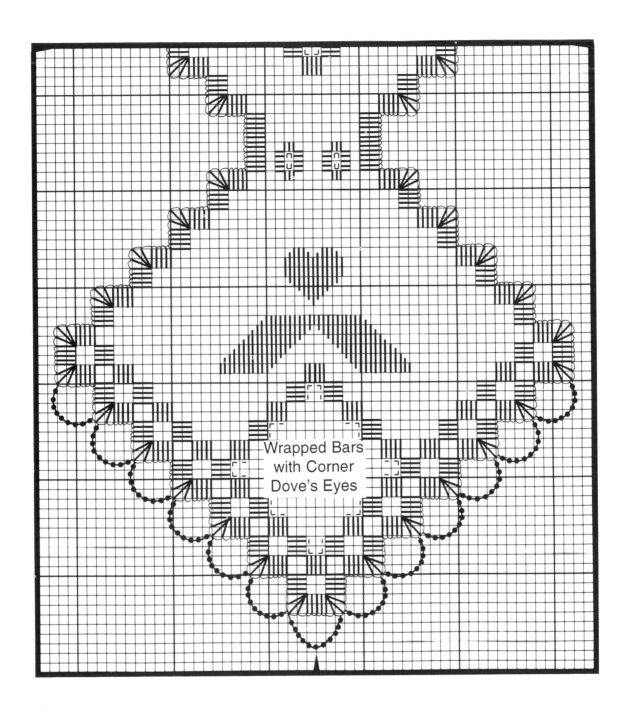

Wrapped Bars
with Corner
Dove's Eyes

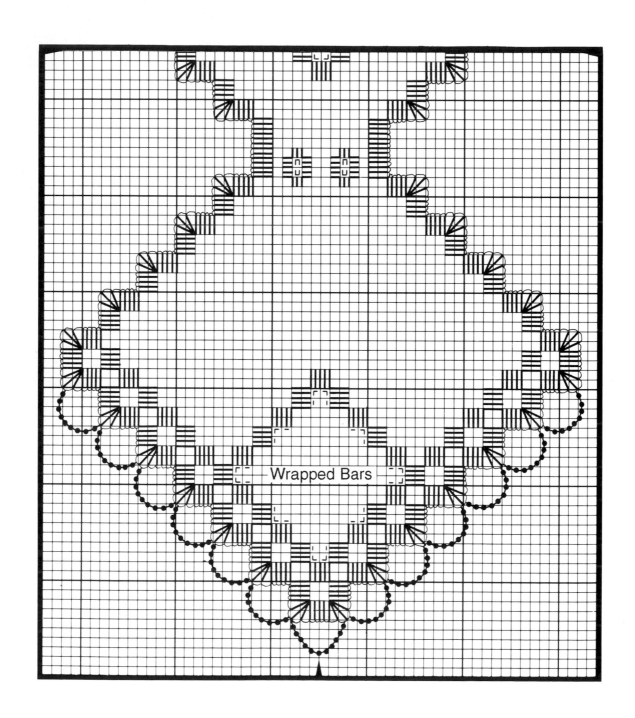

Wrapped Bars

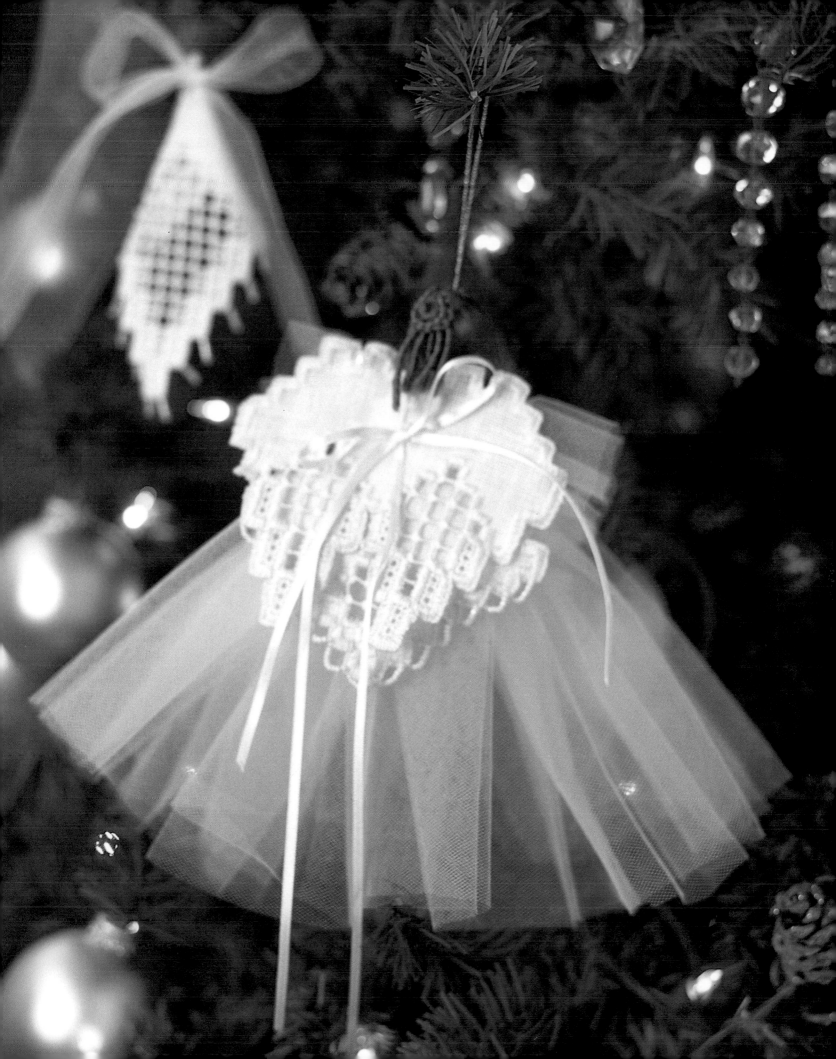

Angel Ornament (Wings)

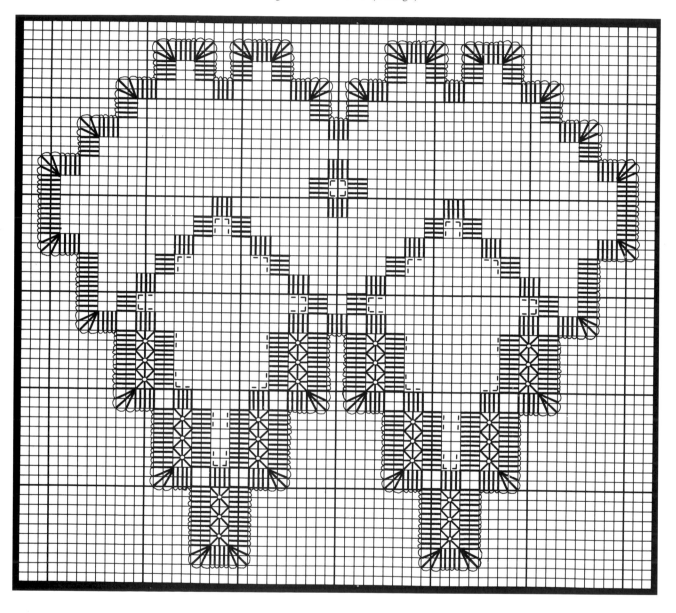

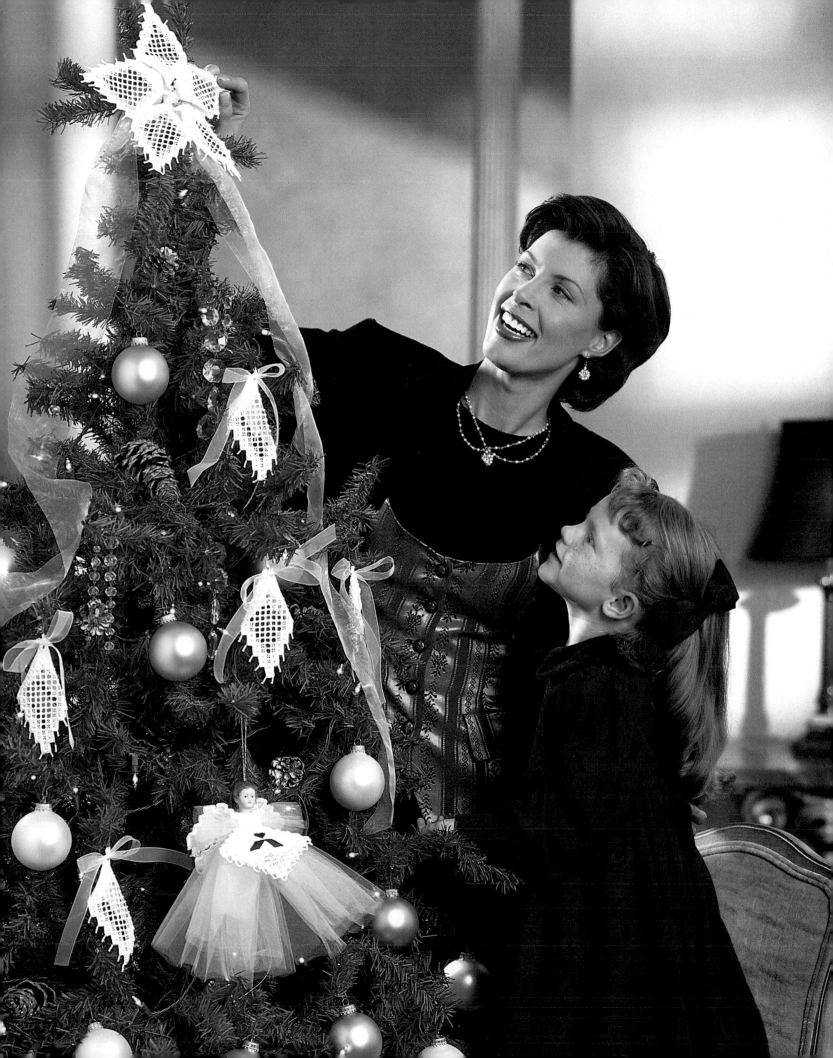

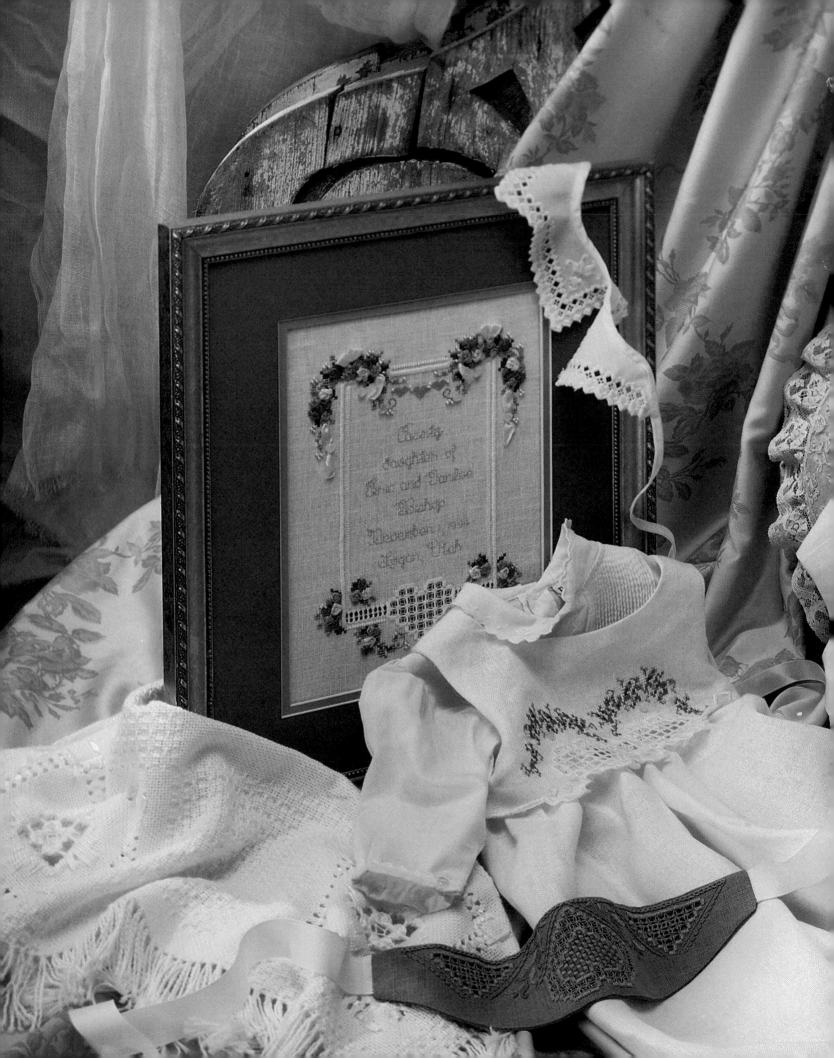

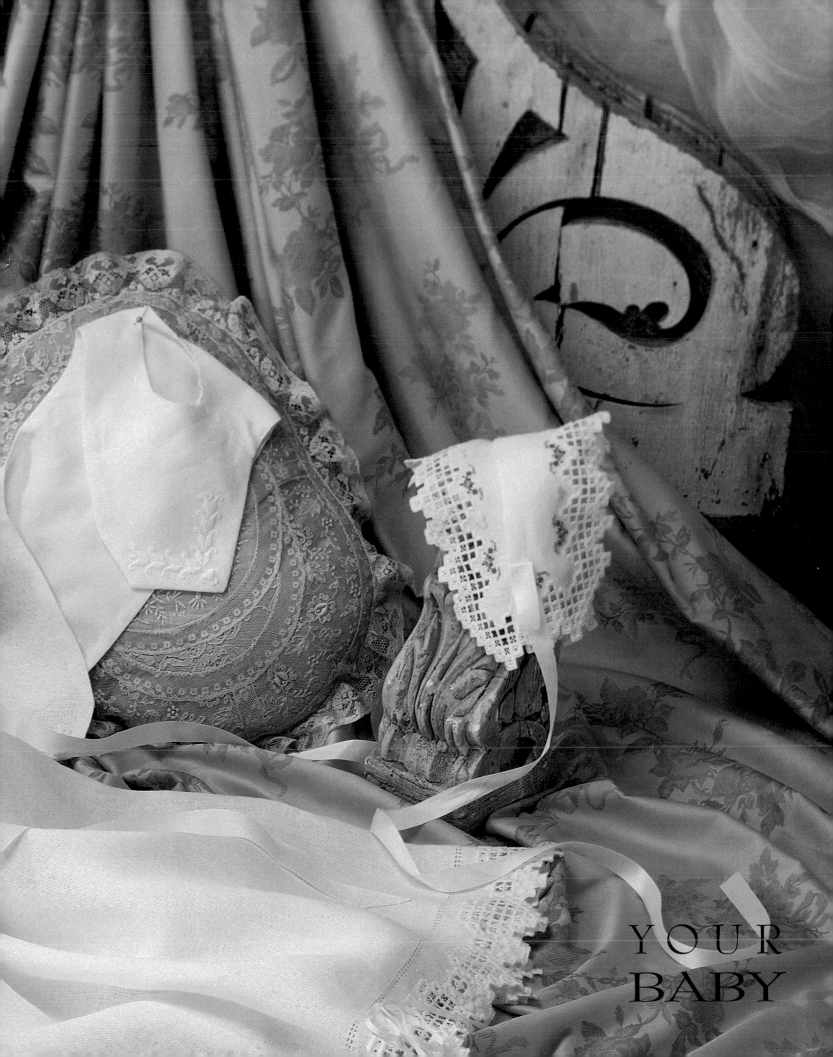

YOUR
BABY

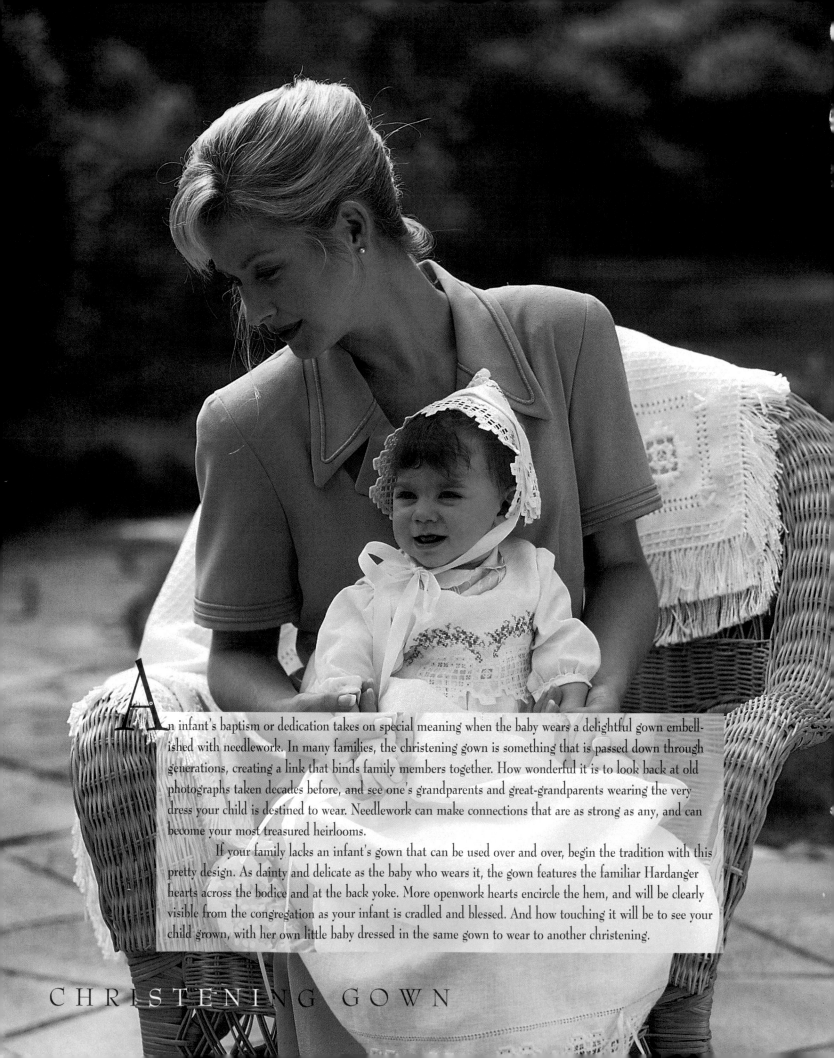

An infant's baptism or dedication takes on special meaning when the baby wears a delightful gown embell-ished with needlework. In many families, the christening gown is something that is passed down through generations, creating a link that binds family members together. How wonderful it is to look back at old photographs taken decades before, and see one's grandparents and great-grandparents wearing the very dress your child is destined to wear. Needlework can make connections that are as strong as any, and can become your most treasured heirlooms.

If your family lacks an infant's gown that can be used over and over, begin the tradition with this pretty design. As dainty and delicate as the baby who wears it, the gown features the familiar Hardanger hearts across the bodice and at the back yoke. More openwork hearts encircle the hem, and will be clearly visible from the congregation as your infant is cradled and blessed. And how touching it will be to see your child grown, with her own little baby dressed in the same gown to wear to another christening.

CHRISTENING GOWN

CHRISTENING GOWN

BODICE FRONT
DESIGN (stitched area only) 54 X 122 or more (see page 99 for Bodice Back)
28 count 3.86 X 8.71, cut fabric 12 X 17
32 count 3.38 X 7.63, cut fabric 11.50 X 15.50
The model was stitched on 28 count White Cashel Linen from Zweigart®.

ADDITIONAL MATERIALS (Bodice Back and Front)
Anchor #1 White Pearl Cotton, sizes 8 and 12
YLI 4mm. silk ribbon #1 White
4 Rose Quartz hearts from Access Commodities
3 pearl buttons
DMC floss

•	225	Pale Pink
/	224	Lt. Pink
o	223	Md. Pink
♥	221	Dk. Pink
x	3052	Md. Green
◆	3051	Dk. Green

DESIGN NOTES
1. Each square on the chart represents two fabric threads.
2. This design employs a variety of needlework techniques including Cross, Backstitch, Satin, Algerian Eye, Buttonhole, Kloster, Woven Bar, Dove's Eye, Picot and Buttonhole Bar.
3. The dimensions given are for the design area only. Refer to the bodice pattern pieces and photographs to determine the position for the stitching.

DIRECTIONS
1. Use care in determining the placement of the stitching. Refer to the bodice pattern pieces on the following pages.
2. Complete all Cross Stitches using two strands of floss worked over two fabric threads. Use two strands of 3052 Md. Green floss for the Backstitch vines.
3. Use two strands of 225 Pale Pink floss for the Satin Stitch hearts.
4. Attach the four Rose Quartz hearts, as indicated on chart by an open heart symbol.
5. Using Size 8 Anchor #1 White Pearl Cotton, complete the Klosters and the Buttonhole edge. Continue the Buttonhole edge to the sides of the bodice.
6. Using Size 12 Anchor #1 White Pearl Cotton, complete the Algerian Eye stitches.

Instructions continue on 3rd page following.

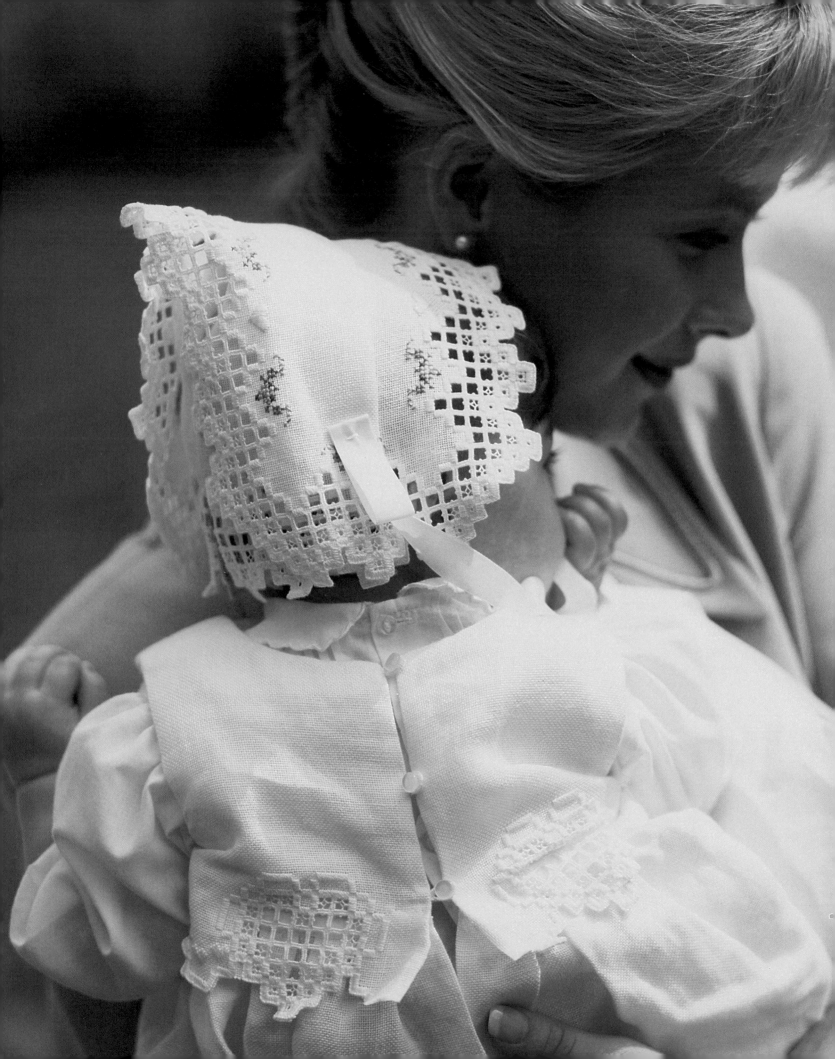

7. Cut and remove the marked fabric threads.
8. Using Size 12 Anchor #1 White Pearl Cotton, complete the inner Hardanger pattern of Woven Bars, Dove's Eyes, Picots and Buttonhole Bar.
9. Trim excess fabric from the Buttonhole edge.

BODICE BACK
DESIGN (stitched area only) 34 X 62 or more
28 count 2.42 X 4.42, cut fabric 12 X 18
32 count 2.12 X 3.87, cut fabric 11.50 X 17.50
The model was stitched on 28 count White Cashel Linen from Zweigart®.

DESIGN NOTES
1. Each square on the chart represents two fabric threads.
2. This design uses a variety of needlework techniques including Satin, Buttonhole, Kloster, Woven Bar, Picot, and Dove's Eye.
3. The dimensions given are for the design area only. Refer to the bodice front as well as the bodice back pattern piece to determine the position for the stitching.

INSTRUCTIONS
1. Using Size 8 Anchor #1 White Pearl Cotton, complete the Klosters and the Buttonhole edge. Continue the horizontal Buttonhole edges at the middle as well as at the sides until they are beyond the pattern edges. You may use the Size 8 Pearl Cotton for the Satin Stitch hearts or use two strands of #225 Pale Pink floss.
2. Using Size 12 Anchor #1 White Pearl Cotton, complete the Algerian Eye stitches.
3. Cut and remove the marked fabric threads. Using Size 12 Anchor #1 White Pearl Cotton, complete the inner Hardanger pattern of Woven Bars, Picots and Dove's Eyes.

SKIRT
DESIGN NOTES AND INSTRUCTIONS
The stitched model has a skirt length of 24". It is 50" wide.
1. Each square on the chart represents two fabric threads.
2. Follow the instructions given for working the Hardanger patterns of the bodice.
3. Work repeats of the pattern along the entire width of the fabric (54").
4. Withdraw six horizontal fabric threads one inch above the top row of Klosters. Using YLI 4mm. #1 White ribbon, work an Interlace stitch over the vertical fabric threads.
5. Trim fabric away from the Buttonhole edge.

CHRISTENING GOWN ASSEMBLY
ADDITIONAL MATERIALS
Paper for tracing
White thread
White cotton Batiste for lining the bodice
Three pearl buttons

BODICE ASSEMBLY
1. Trace the bodice pattern pieces given on pages 102 and 103 onto plain paper.
2. Cut one bodice front and two bodice back pieces from the cotton Batiste.
3. Cut the stitched bodice front and back pieces. The Buttonhole edge should correspond with (or to) the bottom edge of the Batiste lining.
4. With right sides together, stitch the shoulder seams of the stitched bodice front to the stitched bodice back. Press. Repeat this procedure for the lining.
5. With right sides together, stitch the neck of the stitched piece to the neck of the lining. Then stitch the lining to the stitched piece along both arm holes. Clip along the curved edges of the neck and the armholes.
6. Turn to right side by bringing the back bodice pieces toward the front through the shoulder seam. Press.
7. With right sides together, stitch the bodice to the lining from the neck seam to the bottom on both back pieces.
8. Matching the Buttonhole edge and the armhole seams, stitch front and back bodice pieces together. Press the seam open and finish the raw edges.

SKIRT ASSEMBLY
1. With right sides together, fold the skirt in half, matching the Buttonhole edges.
2. Seam to within 4" of the top of the skirt.
3. Determine the length of the skirt. The model shows a length of 24". Using a long basting stitch, gather the skirt. Gather until it fits the bottom edge of the bodice. Pin in place.
4. Stitch the right side of the skirt to the wrong side of the bodice lining. The raw seam will be on the inside of the gown. This will leave the buttonhole edge of the bodice piece free.
5. Stitch three small pearl buttons to the right side of back of the bodice.
6. Using Size 8 Anchor #1 White Pearl Cotton, make button loops for each button. Bring the Pearl Cotton to the front along the back bodice seam of the left bodice piece. Make three loops for each button by going back and forth three times. Buttonhole stitch the three loops together. Repeat this procedure for each button loop.

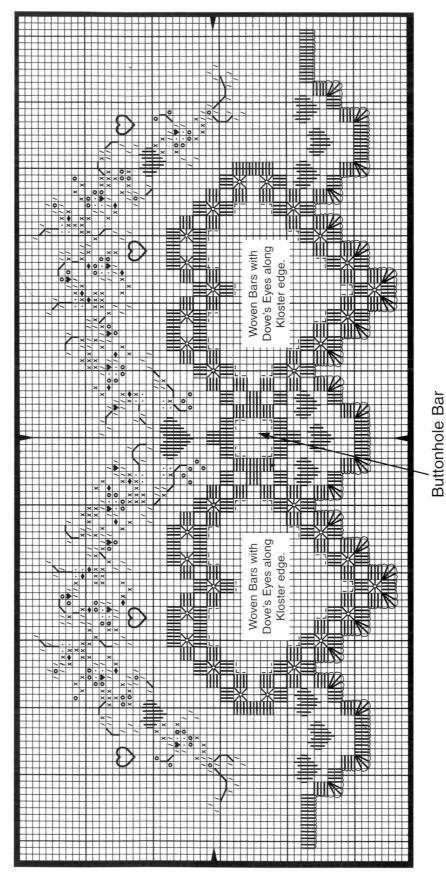

225 Pale Pink
224 Lt. Pink
223 Md. Pink
221 Dk. Pink
3052 Md. Green
3051 Dk. Green

Woven Bars with Dove's Eyes along Kloster edge.

Woven Bars with Dove's Eyes along Kloster edge.

Buttonhole Bar

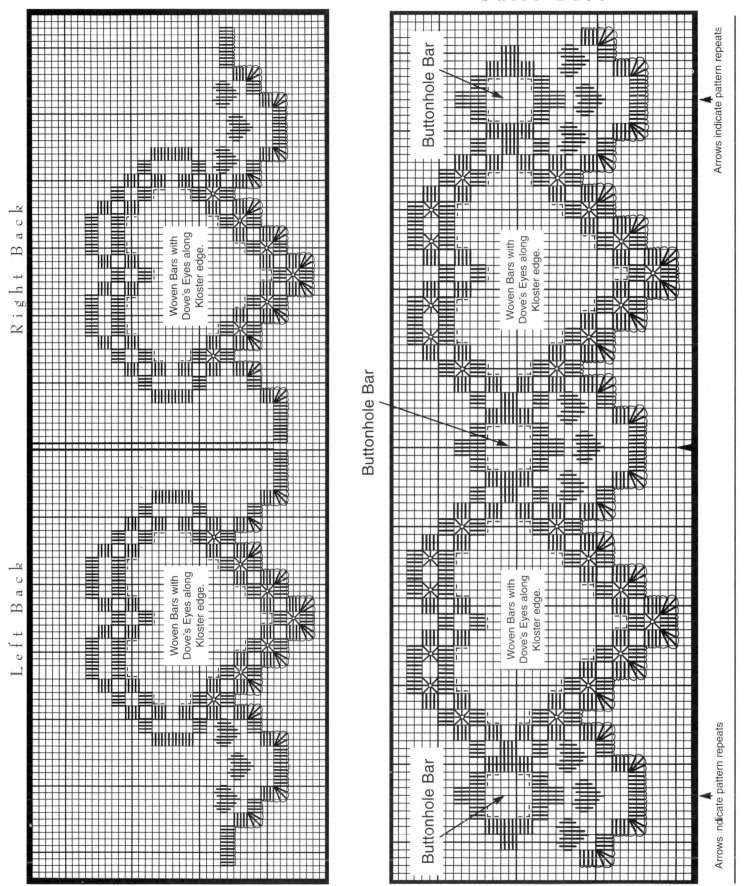

Bodice Back

Right Back

Left Back

Woven Bars with
Dove's Eyes along
Kloster edge.

Woven Bars with
Dove's Eyes along
Kloster edge.

Skirt Base

Buttonhole Bar

Buttonhole Bar

Buttonhole Bar

Buttonhole Bar

Woven Bars with
Dove's Eyes along
Kloster edge.

Woven Bars with
Dove's Eyes along
Kloster edge.

Arrows indicate pattern repeats

Arrows indicate pattern repeats

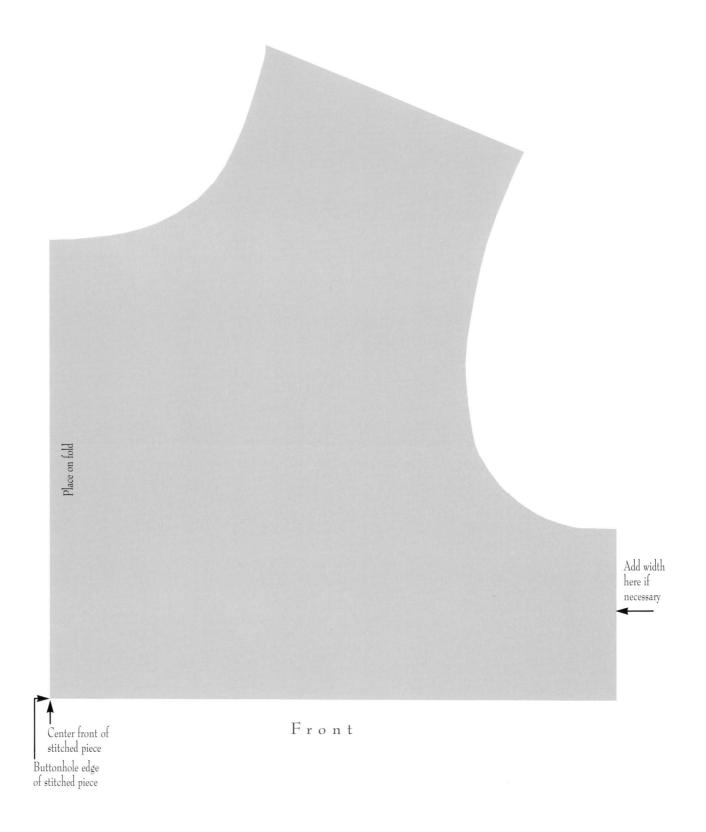

Place on fold

Add width
here if
necessary

Center front of
stitched piece

Buttonhole edge
of stitched piece

F r o n t

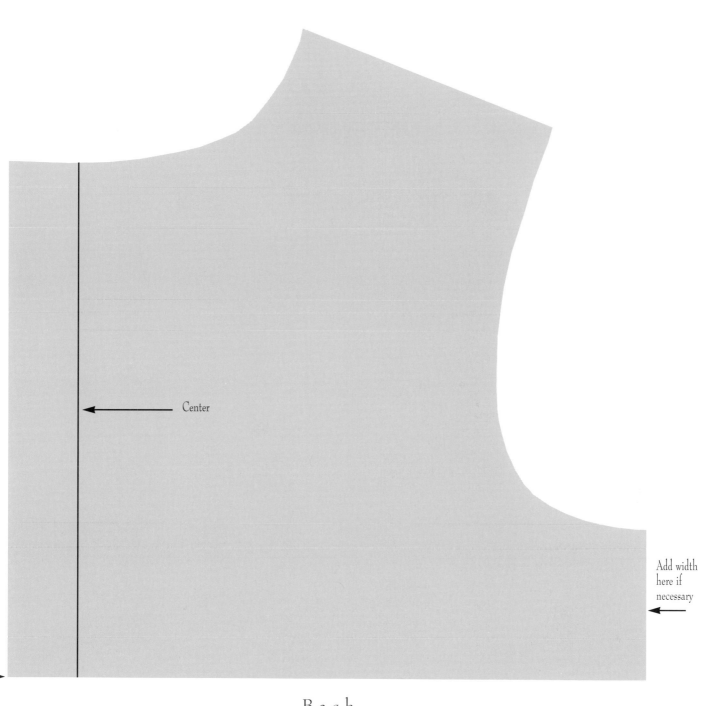

Center

Add width
here if
necessary

Back

Buttonhole edge
of stitched piece

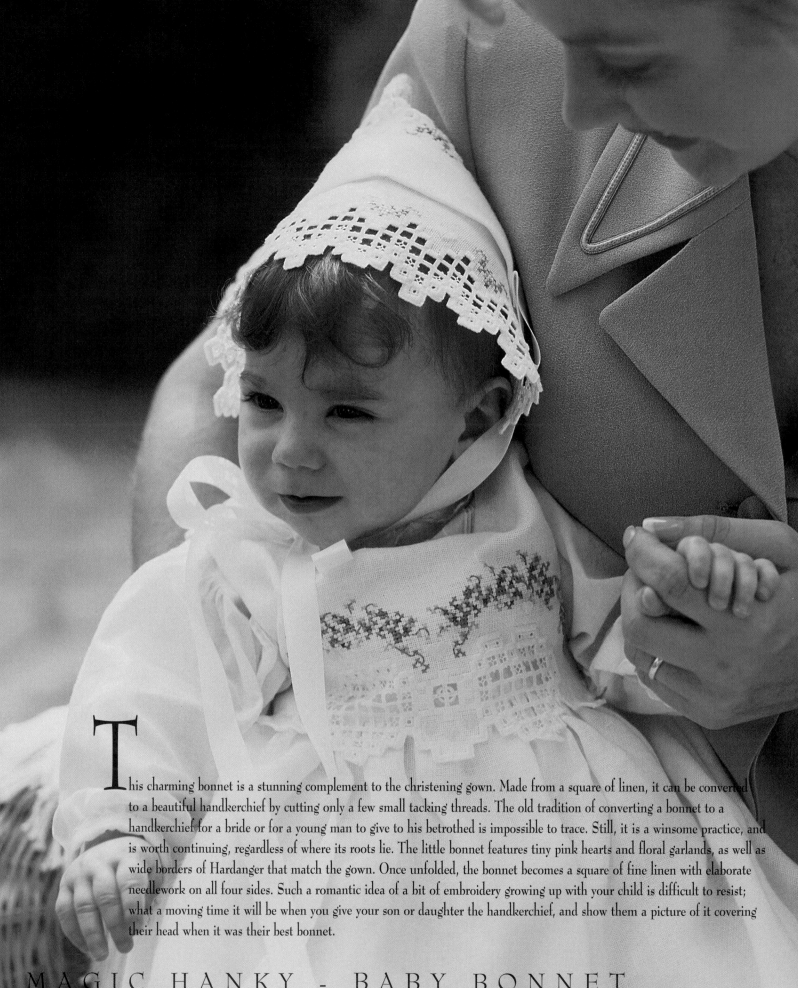

This charming bonnet is a stunning complement to the christening gown. Made from a square of linen, it can be converted to a beautiful handkerchief by cutting only a few small tacking threads. The old tradition of converting a bonnet to a handkerchief for a bride or for a young man to give to his betrothed is impossible to trace. Still, it is a winsome practice, and is worth continuing, regardless of where its roots lie. The little bonnet features tiny pink hearts and floral garlands, as well as wide borders of Hardanger that match the gown. Once unfolded, the bonnet becomes a square of fine linen with elaborate needlework on all four sides. Such a romantic idea of a bit of embroidery growing up with your child is difficult to resist; what a moving time it will be when you give your son or daughter the handkerchief, and show them a picture of it covering their head when it was their best bonnet.

MAGIC HANKY - BABY BONNET

MAGIC HANKY - BABY BONNET

DESIGN 182 X 182
28 count 13 X 13, cut fabric 18 X 18
32 count 11.50 X 11.50, cut fabric 17 X 17
The model was stitched on 28 count White Cashel Linen from Zweigart®.

ADDITIONAL MATERIALS
Anchor #1 White Pearl Cotton, sizes 8 and 12
1/2" wide double faced satin ribbon 36" long
DMC floss
- 225 Pale Pink
o 224 Lt. Pink
■ 223 Md. Pink
+ 3052 Md. Green
● 3051 Dk. Green

DESIGN NOTES
1. Each square on the chart represents two fabric threads.
2. This design uses a variety of needlework techniques including Cross Stitch, Backstitch, Buttonhole, Satin, Algerian Eye, Kloster, Woven Bar, Dove's Eye and Picot.

INSTRUCTIONS
1. Using Size 8 Anchor #1 White Pearl Cotton, complete the Klosters and the Buttonhole edge.
2. Complete all Cross Stitches and Backstitches using two strands of floss over two fabric threads. The hearts are Satin Stitched using two strands of DMC 225 Pale Pink. Backstitch the vines using two strands of DMC 3052 Md. Green.
3. Using Size 12 Anchor #1 White Pearl Cotton, complete the Algerian Eye stitches.
4. Cut and remove the marked fabric threads.
5. Using Size 12 Anchor #1 White Pearl Cotton, complete the inner Hardanger pattern of Woven Bars, Dove's Eyes and Picots.
6. Trim fabric away from the Buttonhole edge.

Finishing instructions for the baby bonnet can be found on page 108.

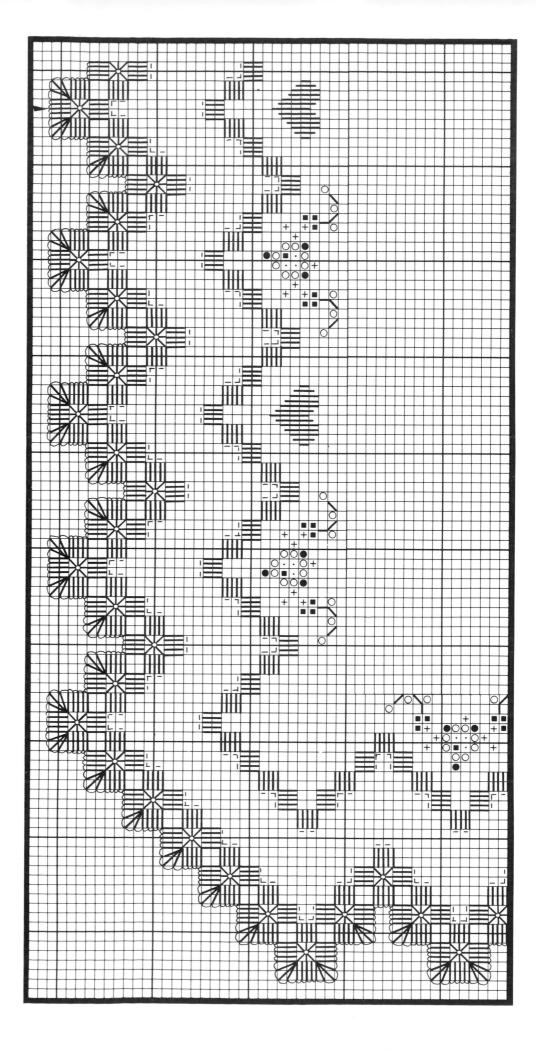

· 225 Pale Pink
○ 224 Lt. Pink
■ 223 Md. Pink
+ 3052 Md. Green
● 3051 Dk. Green

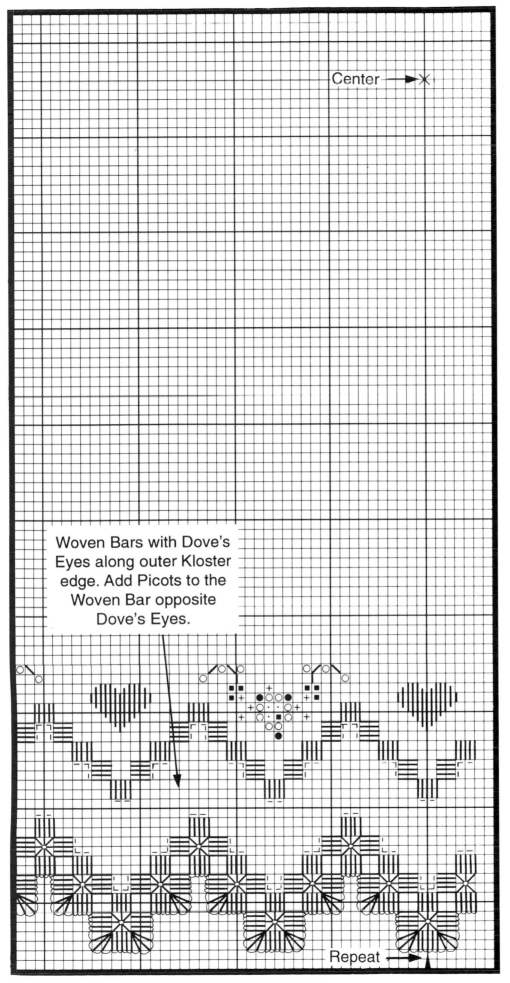

Center ——▶ ✕

These two sections represent 1/4 of the total stitched piece

Woven Bars with Dove's Eyes along outer Kloster edge. Add Picots to the Woven Bar opposite Dove's Eyes.

Repeat ——▶

FINISHING - BABY BONNET

1. Hand wash and press.
2. With right sides together, fold in half. (Illus. 1) Turn one edge back to show the right side of the Cross Stitches. (Illus. 2) Match the points of the Hardanger edge. Pin in place.
3. Fold in half again so that the first folded edge meets. (Illus. 3) Pin together.
4. Tack together. (Ilus. 4) Attach ribbon.

Illus. 1

Illus. 2

Front

Illus. 3

Back

Illus. 4

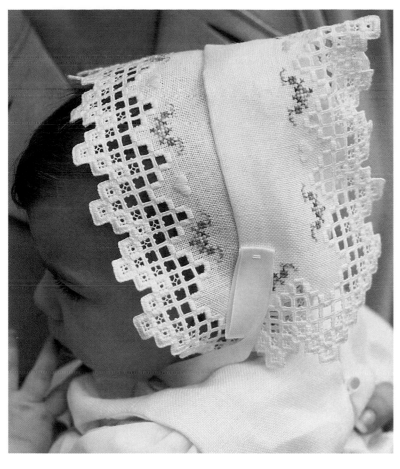

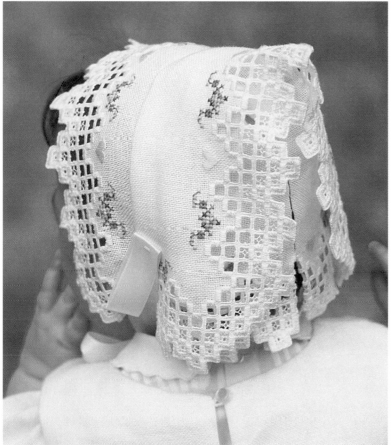

FOR BABY AND BRIDE

I'm just a hanky as square as can be,

But with a few stitches a bonnet I'll be.

Worn home from the hospital or on christening day,

I'll be carefully pressed and then put away.

For her wedding day as we all have been told,

Every beautiful bride must wear something old.

What would be better than to find little me?

A few stitches snipped and a hanky I'll be.

And if it's a boy, someday he might wed;

She'll carry the hanky he wore on his head.

Anonymous

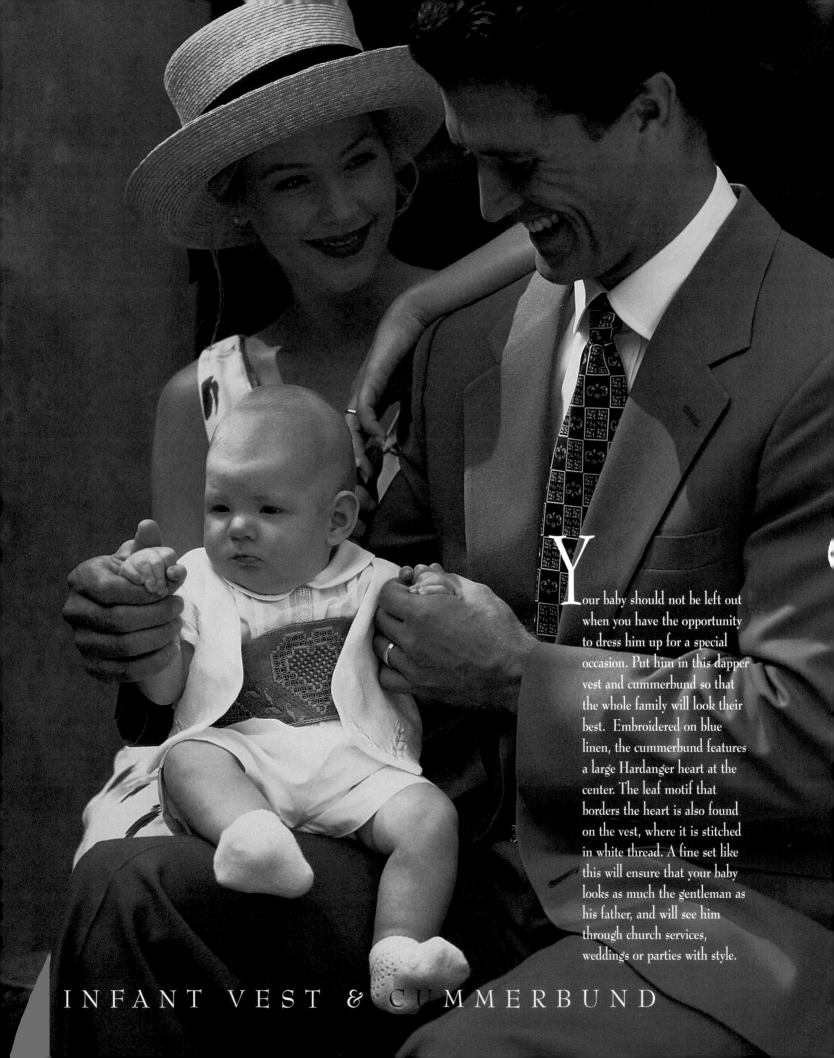

Your baby should not be left out when you have the opportunity to dress him up for a special occasion. Put him in this dapper vest and cummerbund so that the whole family will look their best. Embroidered on blue linen, the cummerbund features a large Hardanger heart at the center. The leaf motif that borders the heart is also found on the vest, where it is stitched in white thread. A fine set like this will ensure that your baby looks as much the gentleman as his father, and will see him through church services, weddings or parties with style.

INFANT VEST & CUMMERBUND

INFANT VEST

DESIGN 50W X 34H
28 count 3.57 X 2.43, cut fabric 12 X 12 (2 pieces)
32 count 3.12 X 2.12, cut fabric 11 X 11 (2 pieces)
The model was stitched on 28 count White Cashel Linen from Zweigart®.

ADDITIONAL MATERIALS
Two pieces of 12 X 14 white Batiste for the back, two pieces of 12 X 12 Batiste for lining the front.
Size 8 Anchor #1 White Pearl Cotton
Anchor floss: #1 White

DESIGN NOTES
1. Graph lines on the chart represent fabric threads.
2. This design uses a variety of needlework techniques including Bullion and Satin Stitch.
3. The same design is used for both sides of the vest front. They should be stitched in the lower corner of each front piece so that they
 face each other.
 The heart should be stitched 1" above the point of the vest.

INSTRUCTIONS
1. Using Size 8 Anchor #1 White Pearl Cotton, complete the Satin Stitch heart and the tulips.
2. Use two strands of Anchor White floss for the Bullion stitch.

FINISHING INSTRUCTIONS
1. Trace the vest pattern found on pages 113 and 114 onto paper.
2. Place the vest pattern so that the heart is centered 1" above the point of the vest. Cut the left and the right pieces.
3. Cut the front and back Batiste lining pieces. Cut a back piece from the Batiste to use as the vest back. It will be sewn to the two stitched
 front vest pieces.
4. With right sides together, sew the front and back pieces together at the shoulders. Use a 1/2" seam.
5. With right sides together, sew the lining 3" from the front side seam through the V and all the way around the neck and within 3" of the
 other front side seam. Then stitch the vest pieces to the lining pieces along the armholes. Clip along the curved edges of the neck and
 armholes.
6. Turn to right side. Press.
7. Sew the side seams. Make the bottom opening smaller by sewing the lining to the vest under the side seams. Leave a 3" opening. Slip stitch
 closed.

Cummerbund charts can be found on 116 and 117. Instructions for the cummerbund are found on page 118.

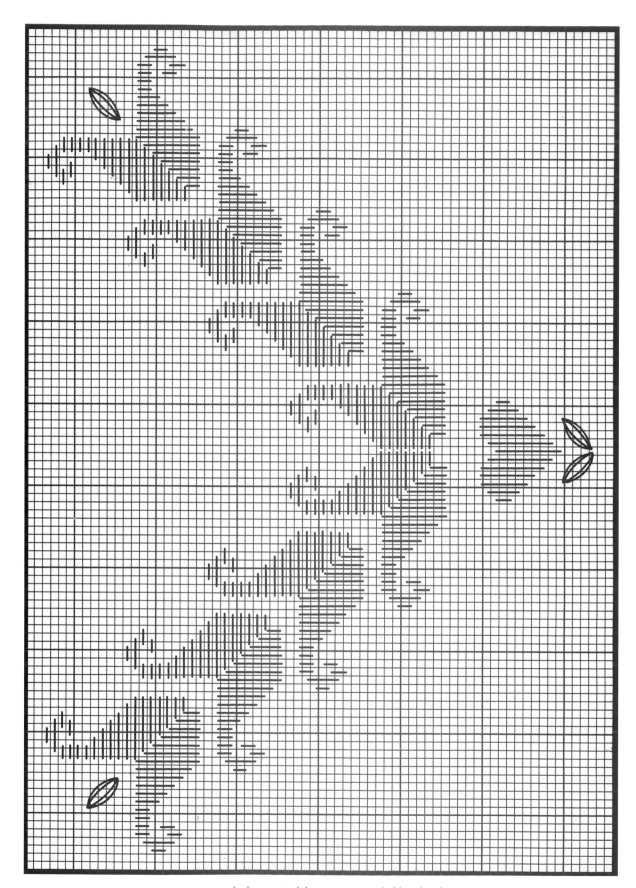

Note scale change: Graph lines represent single fabric threads

Clip

Cut 2 Batiste Lining pieces
Cut 2 Stitched pieces

1/2" Seam

1"

Center stitched heart 1" above point

Vest Back

Clip

Cut 2 Batiste pieces (1 for lining and 1 for back of vest)

Center back place on fold

1/2" Seam

Leave open for turning

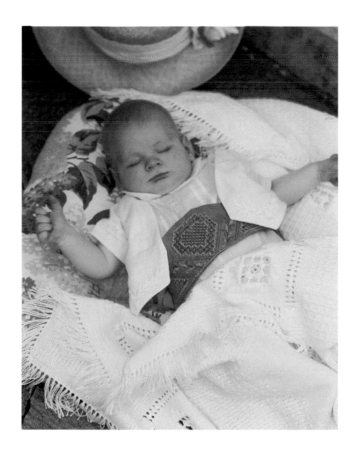

Cummerbund

Cut 1 lining piece
Cut 1 stitched fabric piece

1/2" Seam

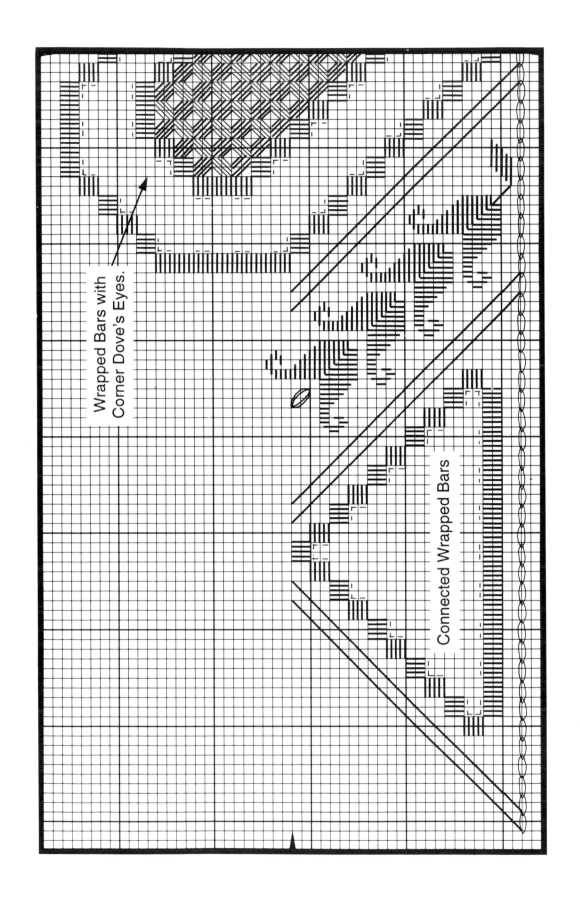

Wrapped Bars with Corner Dove's Eyes.

Connected Wrapped Bars

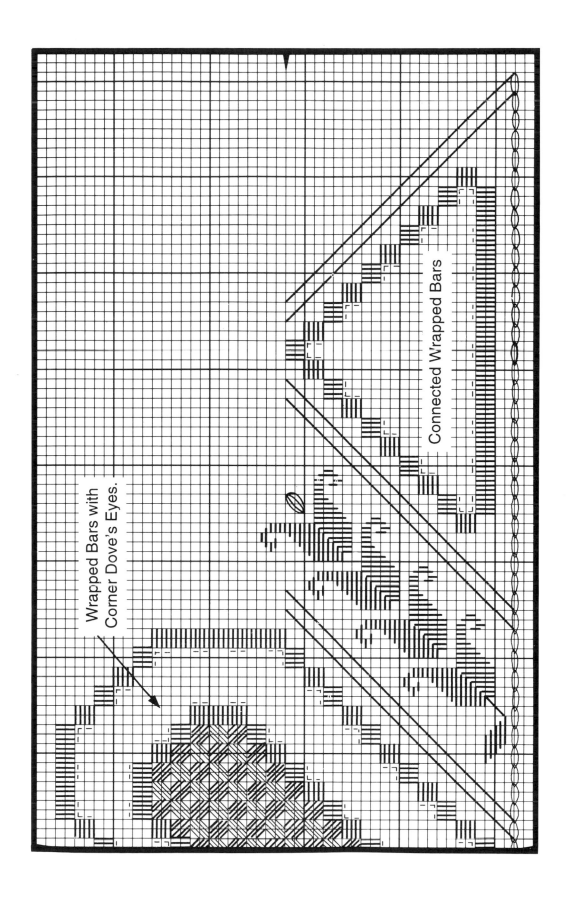

Wrapped Bars with
Corner Dove's Eyes.

Connected Wrapped Bars

CUMMERBUND

DESIGN 162W X 48H
28 count 11.57 X 3.42, cut fabric 17 X 9
32 count 10.12 X 3, cut fabric 16 X 9
The model was stitched on 32 count Antique Blue Linen from Wichelt Imports, Inc.

ADDITIONAL MATERIALS
#8 DMC Pearl Cotton: 932 Lt. Antique Blue and 931 Md. Antique. Blue
#12 DMC 932 Lt. Ant. Blue Pearl Cotton
9 X 18 fabric for lining
1" wide grosgrain ribbon
DMC floss
932 Lt. Ant. Blue
931 Md. Ant. Blue

DESIGN NOTES
1. Each square on the chart represents two fabric threads.
2. This design uses a variety of needlework techniques including Satin, Mosaic, Bullion, Cable, Chain, Klosters, Connected Wrapped Bars, Wrapped Bars and Corner Dove's Eyes.

INSTRUCTIONS
1. Complete all Klosters and the Chain Stitch border using #8 DMC 932 Lt. Antique Blue Pearl Cotton.
2. Use #8 DMC Pearl Cotton 931 Md. Antique Blue for the Cable Stitch.
3. Alternate #8 DMC 931 Md. Antique Blue Pearl Cotton and #8 DMC 932 Lt. Antique Blue Pearl Cotton for the Tulips at each side of the heart.
4. Use two strands of floss for the Mosaic stitch center of the heart. Alternate colors 931 Md. and 932 Lt. Ant. Blue. Use two strands of 931 Md. Ant. Blue floss for the Bullion stitch Tulip centers.
5. Cut and remove the marked fabric threads in the heart.
6. Using #12 DMC 932 Lt. Antique Blue Pearl Cotton, complete the pattern of Wrapped Bars and Corner Dove's Eyes.
7. Cut and remove the marked fabric threads of the two triangles.
8. Using #12 DMC 932 Lt. Antique Blue Pearl Cotton, complete the pattern of Connected Wrapped Bars.

FINISHING INSTRUCTIONS
1. Trace the Cummerbund pattern found on pages 114 and 115. Using the pattern, cut the lining and the stitched piece.
2. Pin a length of ribbon at each side of the Cummerbund.
3. With right sides together, stitch around the lining and stitched linen pieces.
4. Turn to right side. Slip stitch closed.

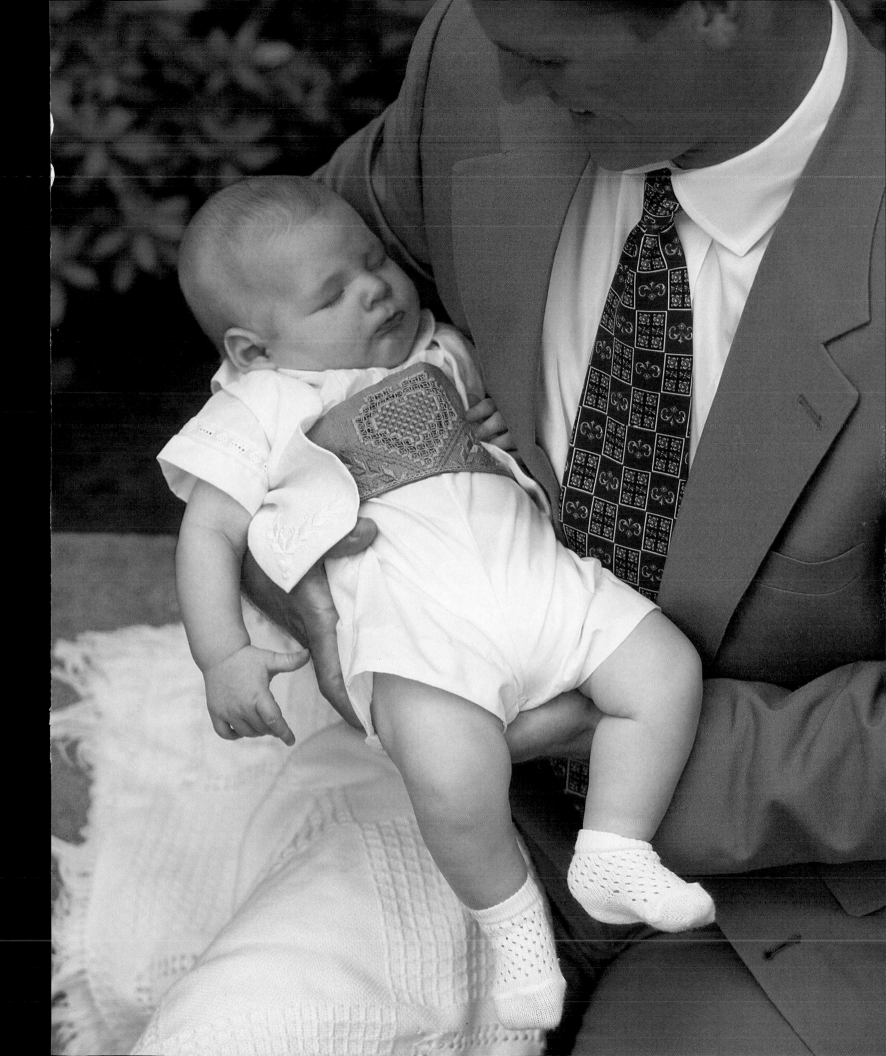

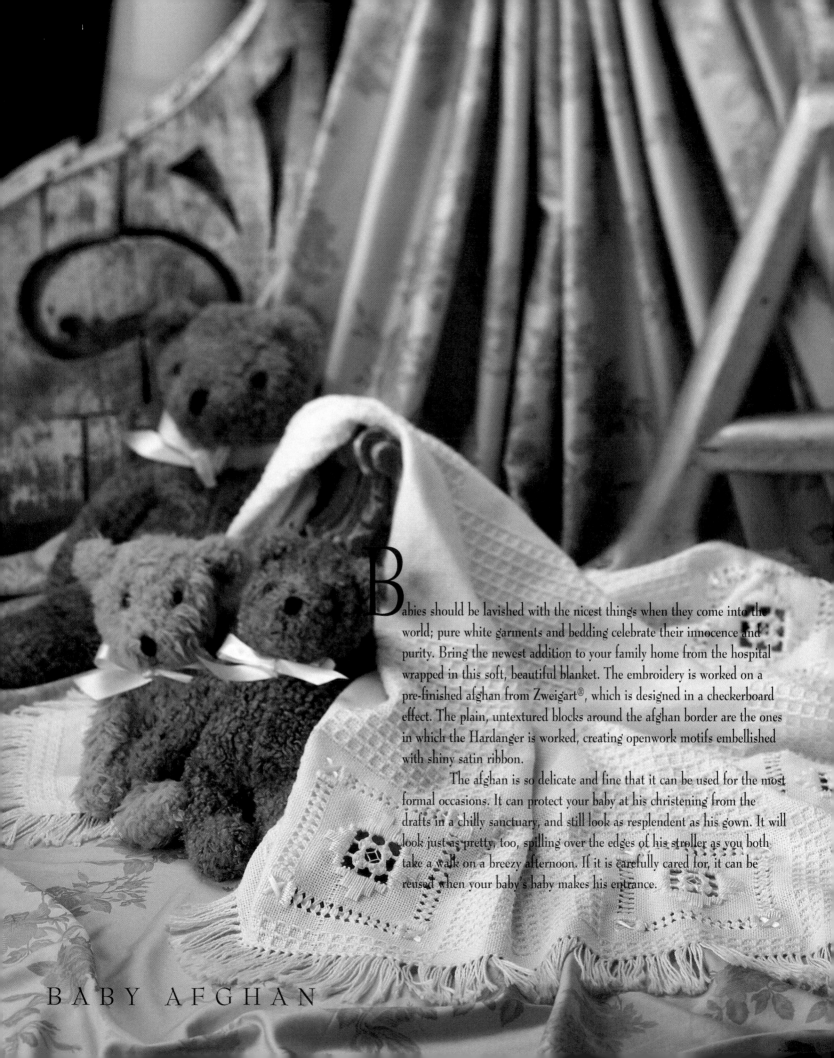

Babies should be lavished with the nicest things when they come into the world; pure white garments and bedding celebrate their innocence and purity. Bring the newest addition to your family home from the hospital wrapped in this soft, beautiful blanket. The embroidery is worked on a pre-finished afghan from Zweigart®, which is designed in a checkerboard effect. The plain, untextured blocks around the afghan border are the ones in which the Hardanger is worked, creating openwork motifs embellished with shiny satin ribbon.

The afghan is so delicate and fine that it can be used for the most formal occasions. It can protect your baby at his christening from the drafts in a chilly sanctuary, and still look as resplendent as his gown. It will look just as pretty, too, spilling over the edges of his stroller as you both take a walk on a breezy afternoon. If it is carefully cared for, it can be reused when your baby's baby makes his entrance.

BABY AFGHAN

BABY AFGHAN

ADDITIONAL MATERIALS
1/8" double face satin ribbon
Size 3 Anchor #1 White Pearl Cotton
Size 5 Anchor #1 White Pearl Cotton
14 count White Augusta Baby Afghan from Zweigart® (43 X 48 inches)

DESIGN NOTES:
1. Each square on the chart represents two fabric threads.
2. This design uses a variety of needlework techniques including Cross, Satin, Interlace, Hemstitch, Kloster, Wrapped Bars, Dove's Eye and 3/4 Flower Petal. Each stitch is explained and illustrated in the Reference Section.
3. The design size for one square is 34 X 34. This design may be used in as many of the squares as you wish. The model shows the design worked in each of the outside areas.

DIRECTIONS:
1. Using Size 3 Anchor #1 White Pearl Cotton, complete the Satin Stitches and the Enlarged Kloster Square.
2. Cut and remove the horizontal fabric threads that run from Satin Stitch to Satin Stitch. Using the 1/8" double face Satin ribbon, work an Interlace stitch over the vertical threads. Work a large Cross Stitch at each corner.
3. Cut and remove the marked fabric threads in the Enlarged Kloster Square. Using Size 5 Anchor #1 White Pearl Cotton, work the 3/4 Flower Petal with the Dove's Eye center.
4. Complete the Hemstitch as follows:
 a. Counting out from the outside edge, remove the 13th, 14th and 15th horizontal fabric threads. By removing only three threads, the fabric will remain stable as you work the Hemstitch.
 b. Using #5 Anchor White Pearl Cotton, work a Hemstitch gathering four threads together and two threads deep.
 c. After all four sides of the outside edge have been Hemstitched, remove the remaining fabric threads.

Interlace Stitch

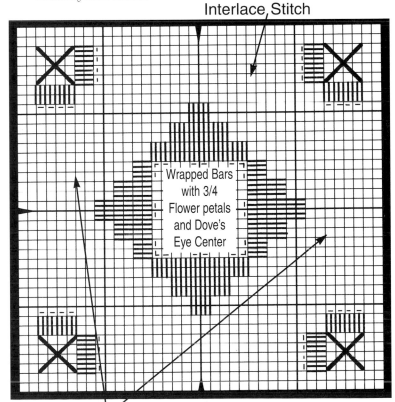

Wrapped Bars with 3/4 Flower petals and Dove's Eye Center

Interlace Stitch

To finish your baby's stylish set, stitch this tiny bib to accompany his vest and cummerbund. Bordered by kloster blocks, it features a little leaf motif at its center that matches those on the other pieces. It is fastened at the back of the neck by two ties, which can be adjusted as your infant grows. Because it is such an elegant, lacy piece, the collar can also be used for a little girl, instantly formalizing a basic dress or top. Rather than buying a new outfit for your baby, simply pair the collar with a garment they already have for a dressy new look.

DRESSY BIB

DRESSY BIB

DESIGN 118W X 102H
28 count 8.42 X 7.28, cut fabric 14 X 13
32 count 7.37 X 6.37, cut fabric 13 X 12
The model was stitched on 32 count White Jobelan from Wichelt Imports, Inc.

ADDITIONAL MATERIALS
Anchor #1 White Pearl Cotton, sizes #8 and #12.
24" of white double fold bias tape

DESIGN NOTES
1. Each square on the chart represents two fabric threads.
2. This design uses a variety of needlework techniques including Buttonhole, Kloster, Satin, Bullion, Woven Bars and Doves's Eyes.

INSTRUCTIONS
1. Using Size 8 Anchor #1 White Pearl Cotton, complete all Klosters, Satin Stitches and the Buttonhole edge.
2. Use Size 12 Anchor #1 White Pearl Cotton for the Bullion stitch leaves just below the Satin Stitch heart.
3. Cut and remove the marked fabric threads.
4. Use Size 12 Anchor #1 White Pearl Cotton for the pattern of Woven Bars and Dove's Eyes.
5. Cut fabric away from the Buttonhole edge.

FINISHING INSTRUCTIONS
1. Trace neck opening pattern on this page on a piece of paper.
2. Cut out the neck opening.
3. Stitch white bias tape to the neck opening.

Neck opening pattern

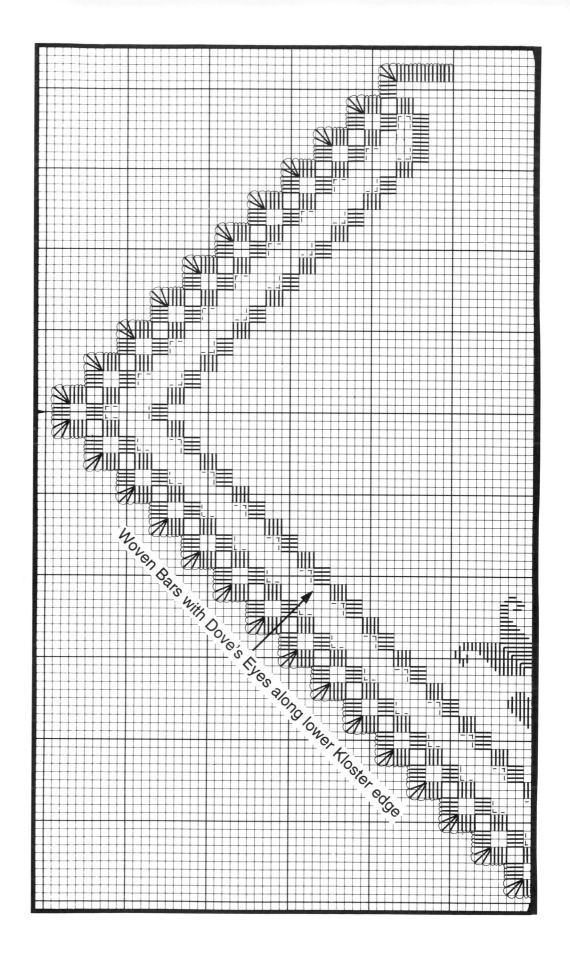

Woven Bars with Dove's Eyes along lower Kloster edge

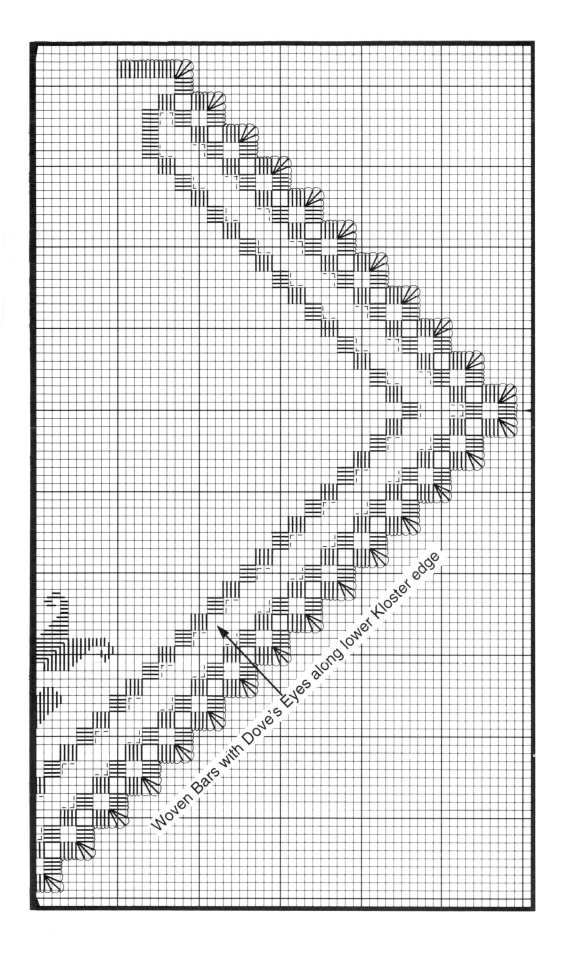

Woven Bars with Dove's Eyes along lower Kloster edge

BIRTH SAMPLER / ANNIVERSARY & ALL OCCASION SAMPLER

This sampler may be completed using a variety of fabric colors and by varying the colors of ribbon and floss.
It can be lengthened or shortened.
PLEASE NOTE: The chart for both the Birth Sampler and Anniversary/All Occasion Sampler appears on pages 130-131. The colors of ribbon used for the flowers in each design are indicated within the circle symbol on the chart.

DESIGN 92W X 128H
28 count 6.57 X 9.1, cut fabric 11 X 15
32 count 5.75 X 8, cut fabric 10 X 14
The Birth Sampler model was stitched on 32 count White Belfast Linen from Zweigart®. The Anniversary All Occasion Sampler was stitched on 32-count Antique White Linen.
ADDITIONAL MATERIALS
Birth Sampler:
6 Rose Quartz Hearts from Access Commodities
#8 DMC Pearl Cotton: 776 Pink, White
#12 DMC White Pearl Cotton
#00145 Pale Pink Mill Hill Beads
YLI 4 mm. silk ribbon #005 Pale Pink, 127 Lt. Pink, 128 Md. Pink, 7 mm. silk ribbon #005 Pale Pink.
Anniversary & All Occasion Sampler:
Substitute #62046 Mill Hill Frosted Pale Blue Beads for #00145 Pale Pink Beads.
Substitute #8 DMC 932 Blue Pearl Cotton for #8 DMC 776 Pink Pearl Cotton.
Substitute DMC Floss 3752 Lt. Blue for 3326 Lt. Pink.
Substitute YLI 4 mm. silk ribbon #90 Pale Blue for #005 Pale Pink; 44 Lt. Blue for 127 Lt. Pink; 46 Md. Blue for 128 Md. Pink.
Substitute 6 Mother of Pearl hearts for the Rose Quartz hearts.
Substitute #8 Ecru Pearl Cotton for #8 White Pearl Cotton.
Substitute #12 Ecru Pearl Cotton for #12 White Pearl Cotton.
DMC floss

x	503 Lt. Green (same for both samplers)	
■	501 Md. Green (same for both samplers)	
o	899 Md. Pink (substitute 932 Blue)	
bs	3326 Lt. Pink (substitute 931 Md. Blue)	
●	00145 Pale Pink beads (Substitute #62046 Frosted Pale Blue beads)	

See page 128 for Design Notes and Instructions.

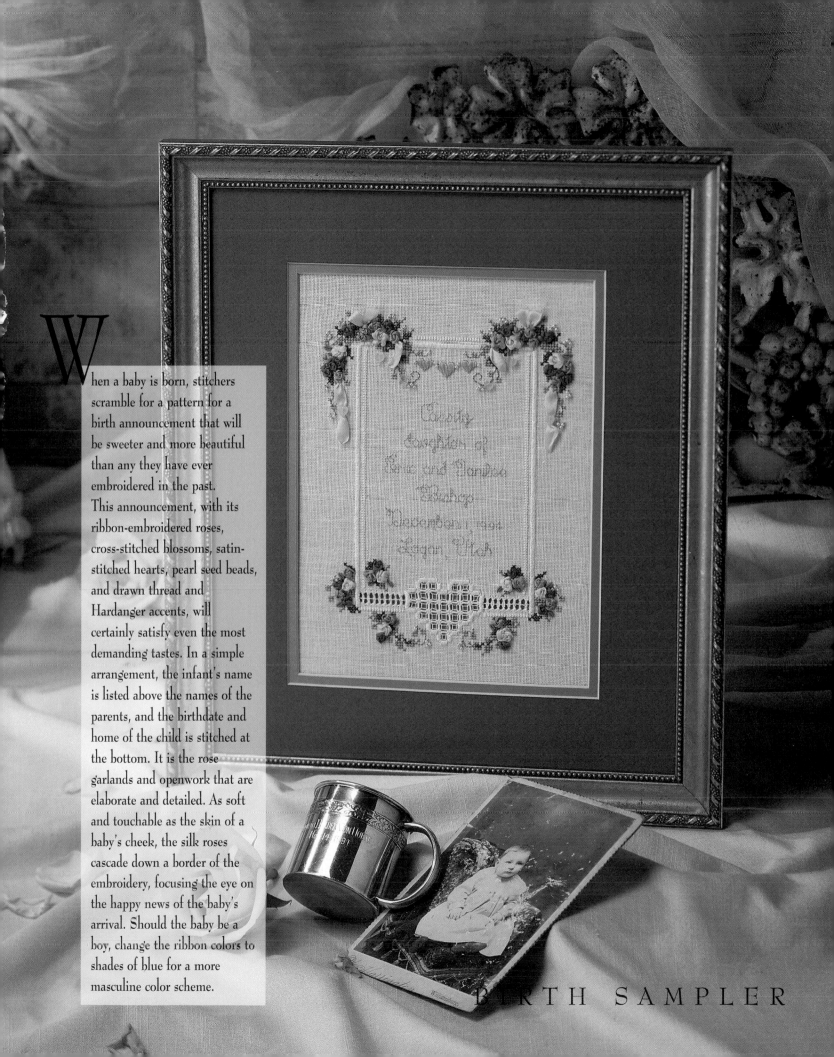

When a baby is born, stitchers scramble for a pattern for a birth announcement that will be sweeter and more beautiful than any they have ever embroidered in the past. This announcement, with its ribbon-embroidered roses, cross-stitched blossoms, satin-stitched hearts, pearl seed beads, and drawn thread and Hardanger accents, will certainly satisfy even the most demanding tastes. In a simple arrangement, the infant's name is listed above the names of the parents, and the birthdate and home of the child is stitched at the bottom. It is the rose garlands and openwork that are elaborate and detailed. As soft and touchable as the skin of a baby's cheek, the silk roses cascade down a border of the embroidery, focusing the eye on the happy news of the baby's arrival. Should the baby be a boy, change the ribbon colors to shades of blue for a more masculine color scheme.

BIRTH SAMPLER

DESIGN NOTES

1. Each square on the chart represents two fabric threads.
2. This design uses a variety of needlework techniques including Cross Stitch, Backstitch (bs), Bullion Stitch, Satin, Long Arm Cross, Ladder Hemstitch, Interlace, Kloster, Wrapped Bars, Corner Dove's Eye. It also uses the following Ribbon Embroidery techniques: Japanese Ribbon Stitch, Loop Stitch, French Knot, Stem Stitch Rose.

INSTRUCTIONS

Note: The following instructions are for the Birth Sampler. Please make the necessary substitutions for the Anniersary/All Occasion Sampler found on page 126.

1. Complete all Cross Stitches using two strands of floss over two fabric threads.
2. All vines are Backstitched using two strands of 503 Lt. Green. Attach #00145 Pale Pink Mill Hill Beads where ● symbols appears using two strands of 503 Lt. Green while working the vines.
3. Satin Stitch the three hearts at the top center using #8 Pearl Cotton 776 Pink.
4. Use two strands of 899 Md. Pink for the Bullion Stitch flowers.
5. Complete the Satin Stitch borders and the Klosters using #8 DMC White Pearl Cotton.
6. Reinforce the Satin Stitches that are between the heart and the two Interlace Stitch areas by touching with Fray Check®. Cut and remove the eight horizontal fabric threads of the Interlace area.
7. Use #12 DMC White Pearl Cotton for the Long Arm Cross Border, the Ladder Hemstitch and the Interlace Stitch.
8. Cut and remove the marked fabric threads inside the heart. Complete the inner pattern of Wrapped Bars and Corner Dove's Eyes using #12 DMC White Pearl Cotton.
9. Use one strand of your favorite color or color #3326 Lt. Pink, for the lettering. Refer to the alphabet on page 137.
10. After all stitching is complete, clean and press the fabric.

Complete the Ribbon Embroidery as follows:

 a. All flowers are stitched using 4mm. size of the color indicated in the circle on the chart. Using the color indicated, complete the French Knot buds and the Stem Stitch roses. Allow the ribbon to twist and turn as you work toward the outside of the flower.

 b. Using the 7mm. size of #005 Pale Pink, complete the Loop stitches. The trailing ribbon lengths are brought to the front then allowed to twist. Take the ribbon to the back using the Japanese Ribbon Stitch. Attach the Rose Quartz hearts over the gathered ribbon.

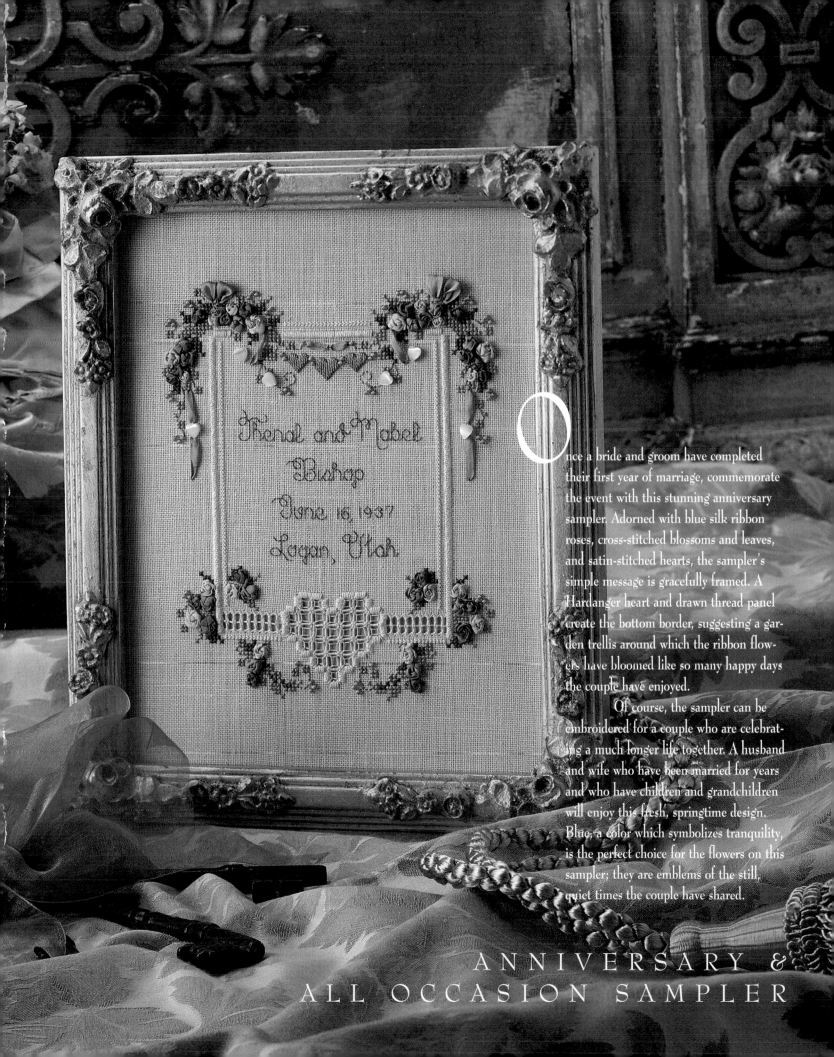

Once a bride and groom have completed their first year of marriage, commemorate the event with this stunning anniversary sampler. Adorned with blue silk ribbon roses, cross-stitched blossoms and leaves, and satin-stitched hearts, the sampler's simple message is gracefully framed. A Hardanger heart and drawn thread panel create the bottom border, suggesting a garden trellis around which the ribbon flowers have bloomed like so many happy days the couple have enjoyed.

Of course, the sampler can be embroidered for a couple who are celebrating a much longer life together. A husband and wife who have been married for years and who have children and grandchildren will enjoy this fresh, springtime design. Blue, a color which symbolizes tranquility, is the perfect choice for the flowers on this sampler; they are emblems of the still, quiet times the couple have shared.

ANNIVERSARY &
ALL OCCASION SAMPLER

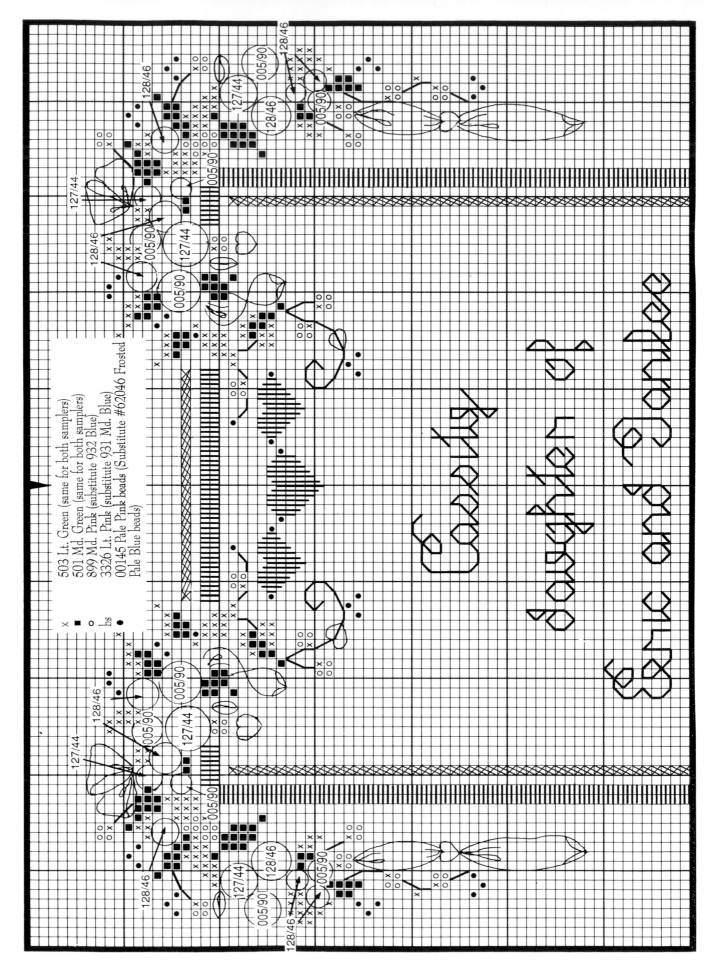

503 Lt. Green (same for both samplers)
501 Md. Green (same for both samplers)
899 Md. Pink (substitute 932 Blue)
3326 Lt. Pink (substitute 931 Md. Blue)
00145 Pale Pink beads (Substitute #62046 Frosted
 Pale Blue beads)

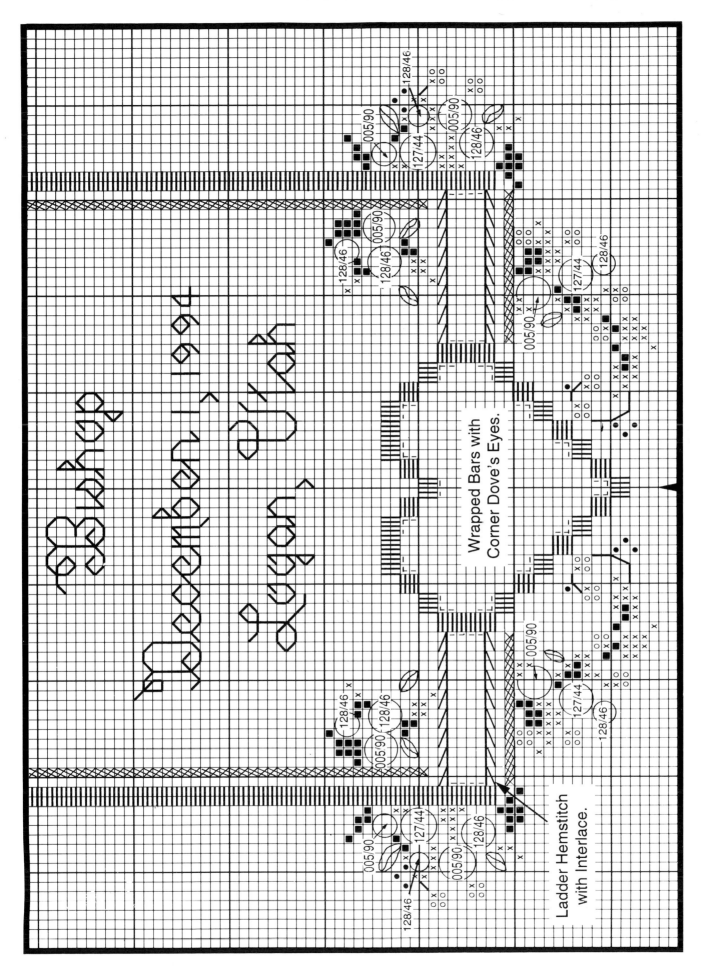

Bishop
December, 1994
Logan, Utah

Wrapped Bars with Corner Dove's Eyes.

Ladder Hemstitch with Interlace.

by Laura Franck

Needlework, aside from producing beautiful pieces of art, enables us to express those feelings and emotions that are often difficult to articulate. Emie Bishop explains, "When we choose different colors and patterns, we display not just our own artistic preferences, but speak of themes and ideas that are important to us." For Emie, *Joyous Occasions* is a book made special by the fact that her family served as a springboard for the beautiful designs. In fact she says, "Most designs I create come from things that happen in and around my family."

Mainly a self-taught stitcher, she also learned techniques from treasured grandmothers, aunts and friends. Twenty-five years ago, Emie had her first introduction with Hardanger when she became fascinated with a friend's work. With the help of this friend and several others, she eagerly learned the cutwork embroidery method. "I do not love one technique more than another, but the thing that intrigues me about Hardanger is that it is lacy and beautiful stitched on linen. It gives elegance without being so impossibly hard that you don't want to try it." She loves any form of counting and withdrawing threads. In her designs, cross stitch will be used to add color or perhaps to include a pictorial element. The two, Hardanger and Cross stitch, work well together and a design that contains both is made beautiful.

For five of the elementary years of her life, Emie lived in Tahiti with her missionary parents. She attended French-speaking schools and spoke Tahitian with the Polynesian children. It was here that she first learned the joy of working with her hands. The native women taught her basketweaving, the making of leis and to knit using a cotton string. When, at age 10, she and her parents moved from the island, Emie was already equipped with a basic knowledge that would enable her to make a lifetime dedication to communicating through stitching. "Needlework is an art that spans cultures and generations, bringing together people of different backgrounds and ages, allowing them to learn from one another. By taking ageless stitches and using them, it ties people together. This also ties us to the women who first stitched them."

Emie's work has clearly touched many stitchers in the needlework community, as she is the recipient of six People's Choice Awards, two Ginnie Awards and the Anchor® Golden Needle Award. Surely, much dedication and talent converged to enable Emie to create such winning designs. With five children, Emie was prompted to get creative, not only artistically, but in setting aside the time necessary to develop her talents as a needlework designer and stitcher. "For years it was impossible for me to work with five children at home. I used to jog in the early mornings and I used this jog to think of designs. I'd even work out the intricate details. This was the only time I had. I'd get back home, send them off to school and begin to put my ideas down on paper." As an afterthought, she adds, "I still jog early every morning and I still am using this

time to design and plan in my head--even now when most of the children are married and have moved away!" Without wanting to forget the role her husband has played in her life, she says, "You have to understand my husband. A busy doctor, yet he has allowed time in his scheduling and life for me to take off and pursue my own interest. He really is a renaissance man--there are not many like him."

Most of her life has been lived in a small valley in Northern Utah, and her in-house studio is where she does much of her work. She describes the studio with only one statement, simply, but it is one that demonstrates the place she calls home. "I have a window that looks out onto the valley and I have a view of a spectacular range of mountains (often snow-capped through June) and there's even a red barn." As if in revelation, she says, "I have had a really good life. I admit, sometimes I just sit there and daydream."

Close family and friends, a cozy and picturesque home, even occasional daydreaming: Each must serve as a rich source of inspiration. With this book, *Joyous Occasions: A Collection of Heirloom Hardanger Designs*, Emie provides stitchers with the tools necessary to build precious family heirlooms and memories. Beginning as a series of designs for Charles Craft, the rights to the series were later purchased by Symbol of Excellence Publishers, Inc. It was at this point that Emie realized the series had a central theme. For example, the ring-bearer's pillow shares the motif of the bridal headpiece, and the pattern repeated on the christening gown is the same one found on the magic hankie and bridal bodice. A singular thread

of similarity connected many of the designs, and what started as a few separate projects, eventually developed into this meaningful 144-page hardbound book. Out of the many beautiful designs featured among these pages, the wedding sampler is Emie's favorite. "I can't explain why--it is just one that means a lot to me." The christening gown is also a special project because two granddaughters were born within the last year and each girl wore a duplicate gown for her own christening.

What does the future bring for Emie? Certainly her 14-year-old company, Cross 'N Patch, will keep her busy selling books, leaflets, chart packs and working on freelance projects. Presently, she is dividing her time between several small projects, and she adds, "right now I'm working on a 17th century English whitework sampler reproduction and presenting it for publication."

Her life is full. Her plate is overflowing. And she admits that she even has more ideas than time. "This doesn't mean they are all good ideas, but one idea can lead to ten more. Eventually you find a good one."

Pictured on preceding page:
A) Scott Bishop
B) Mike and Emie Bishop
C) Cynthia Bishop
D) Scott Bishop
E) Blair and Marion Mumford
F) Cindi, Jeannette and Matt Bishop
G) Mark and Tami Bishop
H) Cassity Bishop
I) Eric, Janilee, Hailey and Cassity Bishop

GENERAL INSTRUCTIONS
For Cross Stitch and Hardanger

Cross Stitch Instructions

Preparing the Floss: Before stitching, rinse individual floss colors in a solution of one tablespoon white vinegar and eight ounces clear water, changing solutions for each floss color. Rinsing in this method should release any excess dye. Follow with a water rinse and continue this process until the water remains clear. Blot the floss and lay it aside to dry, being careful to keep it from tangling. Do not wring. Separate all six strands of floss, reunite the number of strands needed and thread needle, leaving one floss end longer than the other.

Getting Started: To begin in the center of the fabric, find center point by folding the fabric from top to bottom and then from left to right. Mark upper-left corner at junction of folds, using a straight pin. Unfold fabric. Pin will be in center of fabric. Find center on the chart. (Note: For your convenience, center arrows have been included on the chart.) Each square on the chart represents one stitch. When a square contains a symbol (i.e. /, X), a stitch should be made in that space on the fabric. Different symbols represent different colors of floss and may also indicate partial or decorative stitches. Refer to color code for the chart you are stitching to determine floss color to be used.

Working the Design: Stitch the design, completing all full and partial cross stitches first. To achieve a smooth surface appearance, cross all full cross stitches in the same direction. When all full and partial cross stitches have been completed, work backstitches and then any decorative stitches.

Making Decorative Stitches: If the chart you are working on contains Lazy Daisy stitches or French Knots, use the diagram on the chart page for assistance in working the stitches.

Stitching Hints: Do not knot floss; instead, catch floss tail on back of work with the first few stitches. Move the needle closer to the shorter end of the floss as you stitch. When stitching, pull floss through fabric "holes" with one continuous stroke and cease pulling when you feel resistance from the floss. Consistent tension on the floss results in a smoother surface appearance. To end stitching, run floss under completed stitches and clip remaining strands close to surface. It is often necessary to skip a few spaces on the fabric in order to continue a row of stitches in the same color. If the area to be skipped covers more than ¼", end stitching as previously described and begin again at the next point to avoid uneven tension on the embroidery surface, snagging on the back, and having colors show through unstitched areas. Do not carry floss over an area that will remain unstitched.

Finishing the Design: Hand wash the stitched piece with mild detergent in warm water. Rinse thoroughly with cold water. Roll in a terry towel and squeeze gently to remove excess moisture. Do not wring. Unroll the towel and allow the stitched piece to dry until barely damp. Iron on padded surface with design face down, using medium heat setting. A press cloth will help prevent shine.

Hardanger Instructions

Each square on the chart represents two fabric threads. Throughout the book the charts have been presented with no overlap. Each Kloster, including the center Klosters are worked 5 stitches over 4 fabric threads.

Step 1: Using #8 Pearl Cotton, complete the Klosters. Remember that the corner hole is shared and that there is a stitch between each fabric thread.

Step 1

Step 2: Cut and remove the marked fabric threads.

Step 2

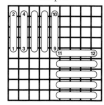

Kloster
Graph lines represent
single fabric threads

Step 3: Secure #12 Pearl Cotton on the back under the Klosters. Bring to the front and weave or wrap the bars. (Weave is shown)

Step 3

1 square equals 2x2 threads

Step 4: When you reach the fabric intersection, turn the corner and begin weaving (page 140) toward the Kloster edge. Weave to the middle of the bar then begin the Dove's Eye (page 141). After completing the Dove's Eye, finish weaving to the Kloster edge. Travel under the back of the Klosters to the next bar to be woven.

Throughout this book the charts have been presented with no overlap. Each Kloster, including the center Klosters are worked with 5 stitches over 4 fabric threads.

GENERAL INSTRUCTIONS
For Silk Ribbon Embroidery

Graph lines represent single fabric threads

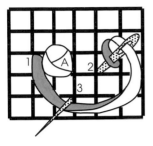 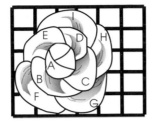

STEM STITCH ROSE
Begin with a French Knot, A. Work from the knot toward the outside of the flower. Bring the needle to the top at 1 and down at 2 and up again at 3. (Point 3 will be midway between 1 and 2.) Gently pull the ribbon to the top at 3. Keep the ribbon loose as you work your way around the flower. (B through I or more.)

JAPANESE RIBBON STITCH
Bring needle to the front at 1. Hold ribbon flat, but not taut, on fabric. Pierce the ribbon in the center at 2. Pull the ribbon gently down through itself until it curls at the top.

FINISHED

LOOP STITCH
Bring needle to right side of fabric at center of flower area. Insert needle back into fabric 1/4" to 1/2" from center. Adjust the loop over a large tapestry needle. Keep the needle in the looped petal until you bring the needle up again for the next loop.

COUCHING
Bring the ribbon that is to be couched to the top at A and down loosely at B. Tack with a perpendicular stitch that crosses it by coming to the top at 1 and down at 2, adjusting the tension of the horizontal ribbon with each perpendicular stitch. Repeat at 3, and 4, 5 and 6. Refer to the chart for the direction and length of the ribbon and the couching stitch.

FRENCH KNOT
Bring the needle to the front. Wrap the needle 1 to 3 times keeping the ribbon flat against the needle. Insert the needle back into the fabric. Pull the needle to the back. The knot will have less chance of pulling through the fabric if you do not go down in the same hole as you came up in.

STITCHING DETAILS
Below are black and white examples of the Hardanger techniques used in the various projects in this book. We hope they will be helpful in completing these beautiful designs.

Top

Bridal Bouquet Holder

Bottom

Boutonniere Holder

Wedding Sampler, Wedding Gown, Christening Gown, Ring Bearer Pillow, Bridal headpiece

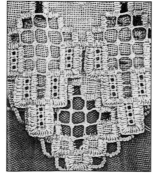

Angel Ornament

Baby Cummerbund

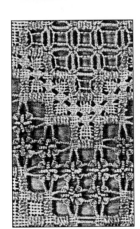

Bless This House Sampler

Tree Topper and Ornaments

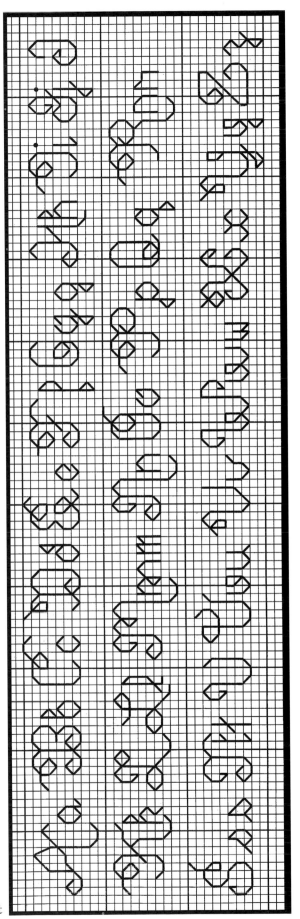

Alphabet

HARDANGER STITCH GLOSSARY

Graph lines represent single fabric threads. These illustrations show the method of working the stitch. The chart shows the placement and size of the stitch.

Algerian Eye
Bring the needle up at 1 and down at 2. Continue all the way around the star.

Connected Wrapped Bars
1. Wrap two fabric threads from the Kloster to the center.
2. Weave from the completed bar to the two threads of the unwrapped bar. Weave three complete weaves. 3. Wrap the remainder of the two threads until you reach the other Kloster.

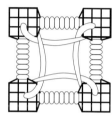

Corner Dove's Eye
This stitch is very much like a Dove's Eye, however, it is worked from corner to corner, after the fourth bar has been wrapped.

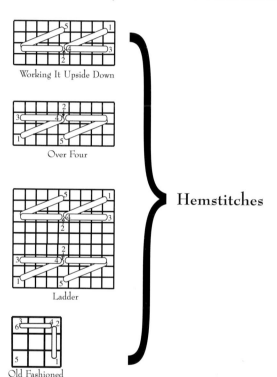

Working It Upside Down

Over Four

Ladder

Old Fashioned

Hemstitches

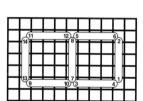

Four-sided
This stitch is shown worked from the right to the left. Bring the needle up at 1 and down at 2. Continue. The stitches run across the lines on the front of the fabric. Properly worked, the working thread will form a cross on the back.

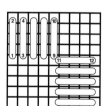

Kloster
This is a group of five Satin Stitches worked over four fabric threads. Bring the needle up at 1 and down at 2. Continue. The corner hole is shared. Do not carry a thread diagonally across a corner. When cutting, cut close to the Kloster block. As the scissors are withdrawn, the fabric threads will work back under the block.

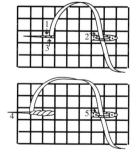

Bullion Stitch
Bring the needle to the front at 1. Down at 2 and back up in the same hole as 1 but do not pull the needle through. Wrap it with the original thread that comes out at 1.
Holding the tip of the wrapped needle firmly between your thumb and pointer finger, pull the needle through. Reinsert it at 2.

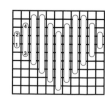

Satin
Bring the needle up at 1 and down at 2. The stitch length may vary. Refer to the chart. Keep the threads untwisted and smooth.

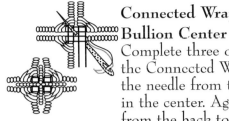

Connected Wrapped Bars with Bullion Center
Complete three of the four sides of the Connected Wrapped Bars. Bring the needle from the back to the front in the center. Again bring the needle from the back to the front in the same hole. Wrap the needle 8 or 10 times. Holding the wraps in place, gently pull the needle on through the wraps. Repeat three times - one for each open space. Continue the connecting weaves of the fourth bar.

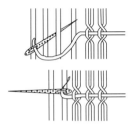

Interlace
Bring the needle to the front. Pass the working thread across two groups of threads and insert the needle from left to right (pointing the needle back to where it came from) under the second group and up over the top of the first group. Twist the second group over the first group by flipping the needle. Then pull the working thread through.

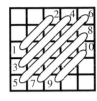

Mosaic
Bring the needle up at 1 and down at 2. Refer to the chart for the direction of the slant.

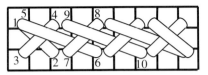

Long Arm
Bring the needle to the front at 1 and down at 2, continue.

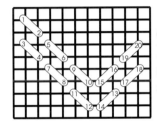

Cable Stitch
Follow the numerical sequence. Up at 1 and down at 2.

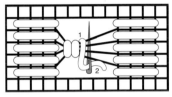

Wrapped Bar
Wrap bars by coming up at 1 and down at 2.

Buttonhole Corner
Step One - Work a Woven Bar to the fabric intersection. Pass the needle from point 9 under the intersection and up at 1. Step Two - Pass the needle over from point 1 to the * position and come up again at point 1. Step Three - Using the * as a "pivot" work a Buttonhole stitch in all 9 points. Slip the needle from point 9 under the back of the Buttonhole corner and come up in the middle of the threads for the next Woven Bar.

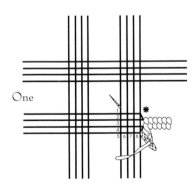

One

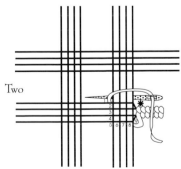

Two

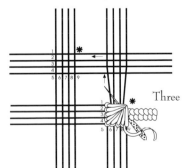

Three

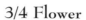

3/4 Flower

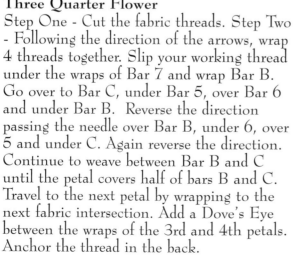

Buttonhole Bar

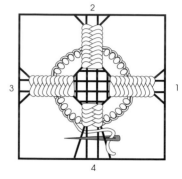

Step One - Weave to the middle of the 4th bar. Form a base for step 2 by coming up in the center of Bar 1, Bar 2 and Bar 3. When you reach Bar 4, reverse the direction, traveling to Bar 3, Bar 2, Bar 1 and then Bar 4. Again reverse the direction. Continue until there is a base of 3 working threads.

Step Two - Buttonhole stitch around the base you prepared in Step 1. After all Buttonhole stitching is complete, finish weaving the last Bar. For clarity, the base threads going in and out of the center of the woven bars are not shown.

Three Quarter Flower

Step One - Cut the fabric threads. Step Two - Following the direction of the arrows, wrap 4 threads together. Slip your working thread under the wraps of Bar 7 and wrap Bar B. Go over to Bar C, under Bar 5, over Bar 6 and under Bar B. Reverse the direction passing the needle over Bar B, under 6, over 5 and under C. Again reverse the direction. Continue to weave between Bar B and C until the petal covers half of bars B and C. Travel to the next petal by wrapping to the next fabric intersection. Add a Dove's Eye between the wraps of the 3rd and 4th petals. Anchor the thread in the back.

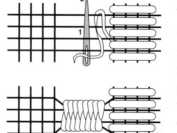

Woven Bars

Cut and remove the fabric threads where indicated. There will be groups of four fabric threads that cross the cut area. These four fabric threads are woven together to form a bar. Secure the working thread and begin by coming up at 1 in the middle of the four fabric threads and down at 2. Continue weaving in a figure eight motion - over two threads and under two. Use a tight tension, and continue until the bar is full. Finish the bar with the thread near to the next bar to be woven. Begin the next bar by coming up in the center of the four threads.

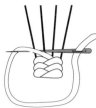

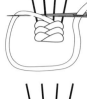

Picots
Weave to the middle of the bar, with the working thread coming up in the middle of the four linen threads. Insert the needle down in the center. Point the needle to the side where the Picot will be. Cross the thread over the top of the needle and then under the point.

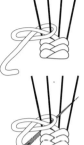

Pull the needle through, holding the Picot as you pull.

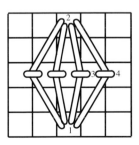

Take the needle to the back and bring up in the middle, pull gently till tight.

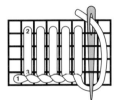

Buttonhole
Bring the thread to the front at 1. Insert the needle at 2, forming a loop. Bring the tip of the needle to the front at 3, catching the looped thread under the top of the needle.

Backstitch
Bring the needle to the front at 1 and down at 2. Continue by coming up ahead of the next stitch.

Queen Stitch
All vertical working threads begin and end in the same hole. Each of these threads is then tied with a tacking stitch to a vertical fabric thread. Work one thread at a time. Come up at 1, down at 2. Tack it by coming up at 3 and down at 4.

Re-weaving
This is the elegant way to start and stop the fabric within a design. It looks better than a manufacturer's selvage edge. Cut thread 1 in the center. Completely remove it. Then cut thread 2 in the center, withdraw it to the edge indicated on the chart then weave it back into the fabric in the position formerly occupied by thread one.

Chain Stitch
Made up of a series of single stitches worked in the "sewing" method. To begin, bring needle back to front at 1, reinsert at 1, forming a loop. Bring the needle up at 2 inside the looped thread. 2 is now the beginning point for the next stitch. To end, catch one fiber to the left of the last stitch.

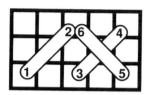

Cross Stitch
Bring the needle up at 1 and down at 2. Continue across the row. Complete the other half of the cross by bringing the needle up at 5 and down at 6.

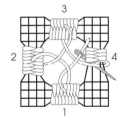

Dove's Eye
This stitch is worked in the cut area at the same time as the bars are woven. Three of the four bars must be finished. Work one half of the last bar. Bring the needle from the back to the front in the center of the 3rd bar. Cross under this working thread and come up in the center of the second bar. Cross under the working thread and come up in the center of the 1st bar. Repeat by crossing under the working thread and then over the working thread extending between the 3rd and 4th bars. Bring the needle up through the center of the unwoven half of the 4th bar. Finish needle weaving.

ACKNOWLEDGMENTS

We would like to thank the following people for their support and encouragement in the production of this book.
Emie Bishop would like to recognize the following:
Stitchers: Linda Finchum, Annette Gertz, Mariann Golich, Jan Hugie, Jan Jensen, Melissa Olson, Dixie Page, Patty Probst
Finishing: Heidi Howlett
We would also like to thank:
Ms. Laurann Figg, Curator of Textiles at the Vesterheim Norwegian-American Museum in Decorah, Iowa
Vesterheim, The Norwegian-American Museum, 502 West Water Street, Decorah, Iowa 52101
Mr.Chip Peterson, Peterson Photography, for photographs of the Vesterheim Museum Hardanger Textile Collection.
The Atlanta Historical Society in Atlanta, Georgia for the use of the Swan House.
Holiday photographs feature the following products:
Mother's velvet dress by Currie Bonner.
Mother's necklace and earrings by Earth Angel.
Mother's vest and fabric colored boxes by The Moon Doggie.
Christening photographs feature the following products:
Mother's hats by The Moon Doggie.
Mother's blue and cream floral dress by Earth Angel.
Wedding photographs feature the following products:
Bridesmaid's dress and gloves, Ring Bearer's clothing by Currie Bonner.
Ring Bearer's stool, Bridesmaid's hat by The Moon Doggie.
Groom's vest and pants by Stephan's.

20th Century (provided still life props)
1044 North Highland Avenue
Atlanta, GA 30306
(404) 892-2065

Currie Bonner
3295 Roswell Road
Atlanta, GA 30305
(404) 231-5441

Stephan's
1160 Euclid Avenue
Atlanta, GA 30307
(404) 688-4929

Village Dolls and Miniatures
704 Swan Lane
Destin, FL 32541
(904) 837-8660

Nordic Needle (brass hearts)
1314 Gateway Drive
Fargo, ND 58103-3596
(701) 235-5231

The DMC Corporation
10 Port Kearny
South Kearny, NJ 07032
To the trade: (201) 589-0606

Anchor® floss (See Coats & Clark)

Coats & Clark
P.O. Box 27067
Greenville, SC 29616

Mill Hill Beads
Gay Bowles Sales, Inc.
P.O. Box 1060
Janesville, WI 53547
(800) 447-1332

The Caron Collection
67 Poland Street
Bridgeport, CT 06605
(800) 862-2766

Access Commodities (Mother of Pearl hearts and beads)
P.O. Box 1778
Rockwall, TX 75087
(214) 412-5253

Earth Angel
1196 North Highland Avenue
Atlanta, GA 30306
(404) 607-7755

The Moon Doggie
3500 Peachtree Road N.E.
Atlanta, GA 30326
(404) 237-6122

Wood'N Accents (provided bellpull hardware)
7333 West Thomas Road #32
Phoenix, AZ 85033
(602) 846-1469

Kreinik Manufacturing Co., Inc.
3106 Timanus Lane #101
Baltimore, MD 21244
(800) 537-2166

The DMC Corporation
(Consumer Orders Only from Craft Gallery, Ltd.)
P. O. Box 145
Swampscott, MA 01907

Charles Craft, Inc.
P.O. Box 1041
Laurinburg, NC 28353
(800) 277-0980

Wichelt Imports, Inc.
RR1
Stoddard, WI 54658

Zweigart®
2 Riverview Drive
Somerset, NJ 08873
(908) 271-0758

INDEX

ARTICLES

PROJECTS

THE HOLIDAYS

YOUR BABY

YOUR HOME

YOUR WEDDING DAY

USEFUL INFORMATION

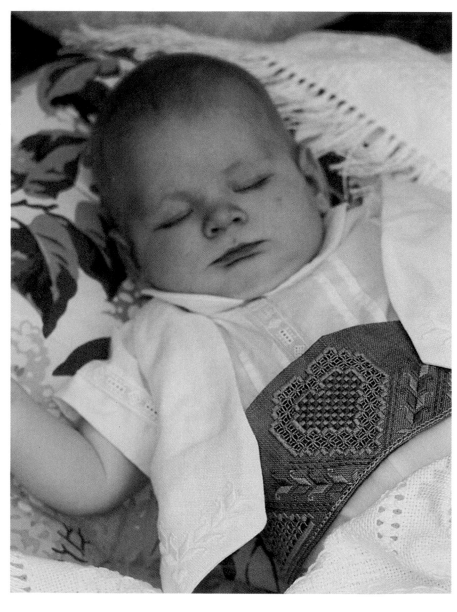

F I N I S